Masters of Deception

Escher, Dalí & the Artists of Optical Illusion

Al Seckel

FOREWORD BY

Douglas R. Hofstadter, Ph.D.

Pulitzer Prize–winning author of *Gödel, Escher, Bach*

FALL RIVER PRESS

To Bruno Ernst, aka Hans Rijk,

and Oscar Reutersvärd,

who helped and encouraged me so

much in the beginning.

CONTENTS

of this form of illusionary art is called *trompe l'oeil* (French for "fool the eye"); the term refers to works of art designed to deceive the viewer, if only momentarily, into believing that the artist's fictitious representation is real. The art form of *trompe l'oeil* originated in ancient Greece and was used widely by the Romans, only to become a lost art during the Dark Ages. It was revived during the Renaissance and flourished again in the Baroque age, when it was used to enlarge and bring an element of fantasy to a room incorporating invented hallways, objects, and people.

No doubt, the high point of this art was achieved in the spectacular work of the seventeenth-century Italian artist Andrea Pozzo in the Church of Saint Ignazio in Rome. When the church was planned, it was to have an enormous dome, but the neighboring Dominican monks complained that the resulting structure would cut their library off from light. Commissioning Pozzo to create a

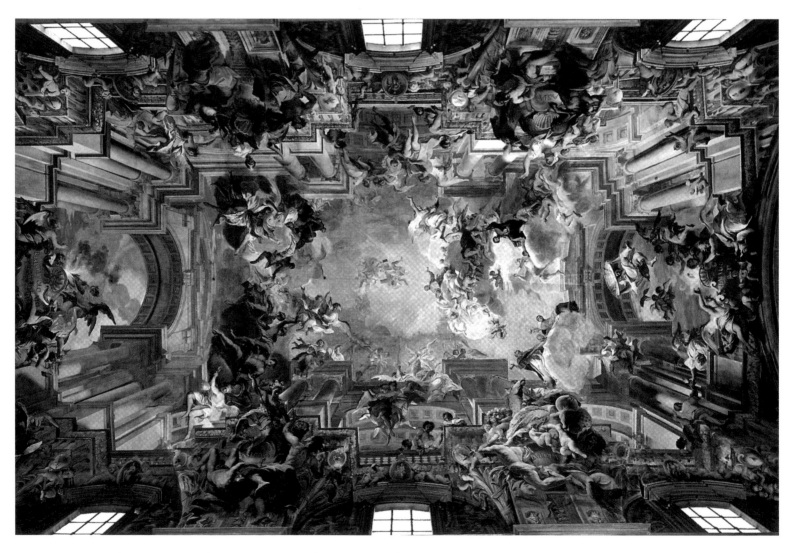

ANDREA POZZO'S VAULT IN THE NAVE OF THE CHURCH OF SAINT IGNAZIO, ROME, 1691–1694

painted dome and an adjacent second story on a flat surface solved the problem. Nevertheless, this clever solution was not without its problems. If you stand away from the correct viewpoint (and there were only two "correct" spots in the very large church), the illusion crumbles. Although many people at the time were amazed by the illusion, Pozzo was severely reprimanded by other architects, who criticized the painted architecture's "physical construction." In his defense Pozzo replied that a friend of his would bear "all damages and costs" should the structure ever fall down!

Closely related to *trompe l'oeil* is the art form of anamorphosis (from the Greek word meaning "transform," and coined in the seventeenth century), which involves the process of greatly distorting an image, only to have it revealed either from a single vantage point or from its reflection in a mirrored surface. A cylindrical mirror is the most common, but reflective cones and pyramids have also been used. The surprising appearance of the undistorted reflection or image is almost always met with wonder and delight.

It was Leonardo da Vinci who first experimented with anamorphic perspective; the first known example of an anamorphic drawing is of an eye, which he created in 1485. During the Renaissance, artists who experimented with the geometry of perspective made great advances and perfected the techniques of stretching and distorting images in various ways, which could be seen undistorted from one well-defined viewpoint.

In the sixteenth through nineteenth centuries, anamorphosis became extremely popular and supplied an ideal means of camouflaging dangerous political statements, heretical ideas, and even erotic pictures. It reached a high point in "The Ambassadors," a portrait of the two French ambassadors Jean de Dintevill and George de Selve, by Henry VIII's court painter Hans Holbein, the Younger. A strange shape was seen in the bottom portion of the painting, which would transform itself into an image of a skull when viewed at an oblique angle relative to the right side of the picture plane. The painting was originally hung on a staircase in Jean de Dinteville's chateau, so that the skull appeared when viewed from below left or down the stairs. Although numerous explanations have been offered about the symbolic presence of the skull, including that it is a play on the artist's name—Holbein, which means "hollow bone" in German, the reason for its inclusion is still unclear.

Anamorphic images were widely reproduced in prints, and, in a more permanent form, adorned the walls of monasteries. It was in the seventeenth century that the first reflective cone and cylinder anamorphoses were created. The technique also became popular in the Orient during the seventeenth and eighteenth centuries.

In the nineteenth century, when color printing became affordable, the technique flourished again as a popular parlor game alongside other optical tricks. In the twentieth century, the Spanish surrealist

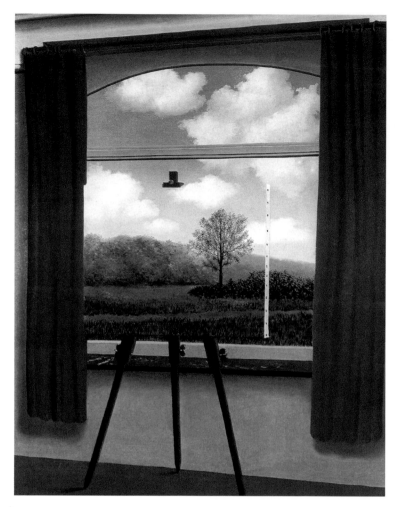

The use of ambiguous imagery to convey ideas about perception was brought to an artistic high point in "Human Condition 1" by Belgian surrealist René Magritte. In this work, Magritte was determined to show the ambiguity that exists between a real object, one's mental image of it, and its painted representation.

In the 1960s, the term Optical Art, or Op Art, was coined to describe the work of a growing movement of abstract painters led by Victor Vasarely and Bridget Riley. Op Art is a mathematically oriented form, usually abstract, which uses repetition of simple forms and colors to create vibrating effects, moiré patterns, an exaggerated sense of depth, foreground-background confusion, and other visual phenomena. With Op Art, however, the rules that the eye applies to make sense of an image are themselves the subject of the artwork.

When most people think of an optical illusion artist, they immediately think of the Dutch graphic artist M. C. Escher (see Chapter 5). Paradoxically, many know Escher's name, but remain unfamiliar with his work. Nevertheless, his popularity throughout the world has grown enormously since his death in 1972. The 1998 exhibition "M. C. Escher: A Centennial Tribute" held at the National Gallery of Art in Washington, D.C., drew record crowds; 364,000 people visited the exhibit, more than for any other print show.

Nonetheless, Escher is summarily dismissed by art historians and critics, and seems destined for nothing more than a footnote in art history books. For example, a visit to any art museum bookstore will reveal hundreds of volumes filling the shelves with known and obscure artists of every variety but barely a volume devoted to Escher's work. This seems an affront to the millions of people—especially scientifically minded ones—who find a special affinity with the works of Escher and how he captures and presents the beauties of mathematics in ways that speak directly to them. They feel that the artistic world does not understand the "high" intellectual concepts that Escher presented, and therefore dismiss him. In fact, the art world has ignored Escher for a number of reasons. Primarily, Escher was a competent printmaker, who did not create any new techniques for the representations of images.

With only a very few exceptions, such as Albrecht Dürer, printmakers have never been able to achieve the status that painters have.

Also, it has often been said that Escher's work holds more appeal for the scientist and mathematician than for the art lover, and that the basis for his examination of the functions of art and design lay in mathematics, or even crystallography— a long way from aesthetics. Shape and form, as well as ideas, dominated his works; aesthetic considerations did not. Art critics admit that he is "clever," but feel that "being clever" is not enough. Clever ideas have not traditionally been a true goal of art; after all, there is no Great Idea conveyed by Vermeer's painting of a pretty girl in a gondola. It is how Vermeer managed to use light and color in a way that trans-

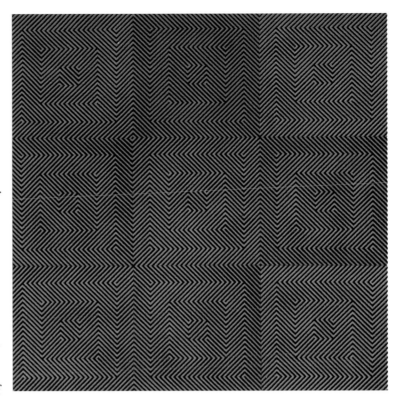

REGINALD NEAL, "SQUARE OF THREE," ORIGINAL LITHOGRAPH, 1965

American artist Reginald Neal was typical of a group of Op Artists of the 1960s, whose work appeared to vibrate, pulsate, or flicker.

figured reality that made him a great artist. This isn't to say that artistic movements tend not to express abstract ideas (Surrealism and Expressionism do, for example), but that they have also placed an emphasis on aesthetics in a way that Escher did not. Escher was aware of this criticism, but it did not concern him; he realized that the audience for his work might not be conventional, or even particularly artistic. In his own words, "Although I am absolutely without training or knowledge, I often seem to have more in common with mathematicians than my fellow artists."

Nevertheless, Escher enthusiasts have a point, too: that the subtle mathematical beauties conveyed by Escher may well have been missed, and therefore he and his intellectual and artistic heirs deserve their own legitimate niche within the art world. And certainly for those of us who love, understand, and appreciate Escher's talents, work in this vein will always appeal to both mind and soul.

Recently, there have been a growing number of artists, illustrators, and designers who have deliberately incorporated obvious optical illusions and optical tricks into their artwork in order to evoke a feeling of surprise, delight, or even humor.

In a sense, many of the contemporary artists in this book can be considered Escher's artistic heirs, even though a good number of their works vary considerably in style, concept, mood, and presentation from anything that Escher ever created. Nevertheless, several of the artists in this book were

directly inspired at some point by Escher's work and wanted to create something in that vein, though true to their own vision. This volume is the first time that these artists have been brought together in a published collection, and many of the works featured appear in print for the first time.

There are about one hundred prominent artists throughout the world who create optical illusion art, but it is beyond the scope of this book to include them all—there is simply too much material. Some difficult decisions had to be made when selecting artists to be included in this volume. Some decisions were obvious, but many were not. Firstly, we decided to present those artists whose work in a particular genre of illusion art—e.g., impossible figures, composite portraiture, anamorphoses, *trompe l'oeil*—was the most original and innovative.

Secondly, we limited our scope to those artists whose illusionary work will have "impact" on a printed page. This was an unfortunate constraint, because it forced us to exclude several truly outstanding optical illusion artists (Patrick Hughes, Ludwig Wilding, Gregory Barsimian, Bill Bell, Rufus Seder, to name a few) simply because the power of their work cannot be captured properly on a page. We suggest that you find actual physical examples of their work for further study.

Indeed, several of the works by the artists in this volume are similarly best seen in a dynamic format. To allow the reader to fully experience the delightful surprise and fabulous impact of some of these pieces, we have set up a website (http://neuro.caltech.edu/~seckel/mod/) where the reader can view the works that require motion or continually changing viewpoints. The artists who have additional works featured on this site will be indicated in the text. The website also features interviews with many of our featured artists, and therefore, it will greatly augment the experience of this book.

In our endeavors we have been encouraged and helped by all the living artists featured in this book, who have so generously given their time, materials, and support so that we could present their work in the best possible light. In addition, we would like to thank Scot Morris for all of his worthwhile comments and suggestions, Mark Setteducati, Keith Kay, Martin Gardner, Ken Rosenthal, and Doris Schattschneider for supplying some valuable source material, as well as graphic artists Alice Klarke and Andish Martensson. It has also been a tremendous pleasure to work with the editors at Sterling: Rodman Pilgrim Neumann, Peter Gordon, Lisa Smith, and Tamias ben-Magid.

We hope that this volume will stimulate interest in the works of many very creative and clever talents, and will inspire future generations of artists, illustrators, and graphic designers to create optical illusion art. It is not intended to be a lofty treatise on art, design, or even aesthetics, but as a fun and delightful book that is only intended as a joyous introduction to optical illusion art for both young and old alike.

—AL SECKEL
Koch and Shimojo Laboratories
California Institute of Technology

Giuseppe Arcimboldo

(1527–1593)

COMPOSITE PORTRAITS

SIXTEENTH-CENTURY ITALIAN ARTIST Guiseppe Arcimboldo is without doubt one of the most bizarre and distinctive painters in the history of western art. His reputation was built on a series of composite portraits made up of a variety of objects, both natural and manmade. Although extremely popular during his lifetime, giving rise to scores of modest and poor imitators, he was soon forgotten after his death, only to have interest renewed in his work toward the end of the nineteenth and early twentieth centuries. Then, he had an appreciable influence on the newly arrived artists of the Surrealist movement, such as Salvador Dalí.

Arcimboldo was born in Milan in 1527 into a highly distinguished and powerful family. His father, Biagio, was an accredited painter, and later they even did some artistic collaboration. Arcimboldo studied art with some of Leonardo da Vinci's well-known students, and made his debut as an artist at the age of twenty-two. No doubt because of high-placed family connections, he easily found work designing stained glass windows for the Milan cathedral and Gobelin tapestries for the Como cathedral. He even decorated organ cases. However, none of these works give even the slightest hints of the bizarre originality that he would later develop.

In 1562 he became a court painter for Hapsburg Emperor Ferdinand I and lived briefly in Vienna. Soon after, he resettled in Prague. In the imperial court, his job was to create court portraits, cata-

log the immense imperial art treasury, and plan parties and design festivals for the emperor. He was in many ways the court showman. Little did he realize that he would stay there for over twenty-five years, serving as an artist to three successions of emperors and kings. It was during this time that he began his series of bizarre composite allegorical portraits, devoting several series to the four seasons and the four elements of nature. These complex images had symbolic references to the events of the time as well as the aspirations of the Hapsburg dynasty. Each animal symbolized some human virtue. For example, the lion is the sign of the King of Bohemia, the two-headed eagle is a symbol of the Holy Roman Empire, and the ram of the Golden Fleece. He formally presented his first series of composites to Emperor Maximilian II on New Year's Day in 1569. Many of these series were rather popular, and one can see that he repeated them with slight variations in later years.

The documents of the time bear witness to the fact that both monarchs and his contemporaries were quite enthusiastic about his art. There is little doubt that he painted a large number of pictures between 1562 and 1593, but only a few of them are known to have survived. Some were apparently destroyed by fire during the siege of Prague in 1648, while others were carried home by the Swedes as war booty.

Arcimboldo died peacefully in 1593, one year after painting his masterpiece—a portrait of the Holy Roman Emperor Rudolph II, who bestowed on him the highest honors by raising him and his family to the rank of the aristocracy for his devoted services.

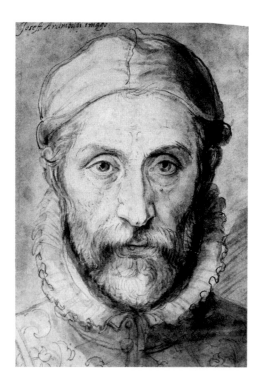

"SELF-PORTRAIT," BLUE PEN-AND-WASH DRAWING, CA. 1575

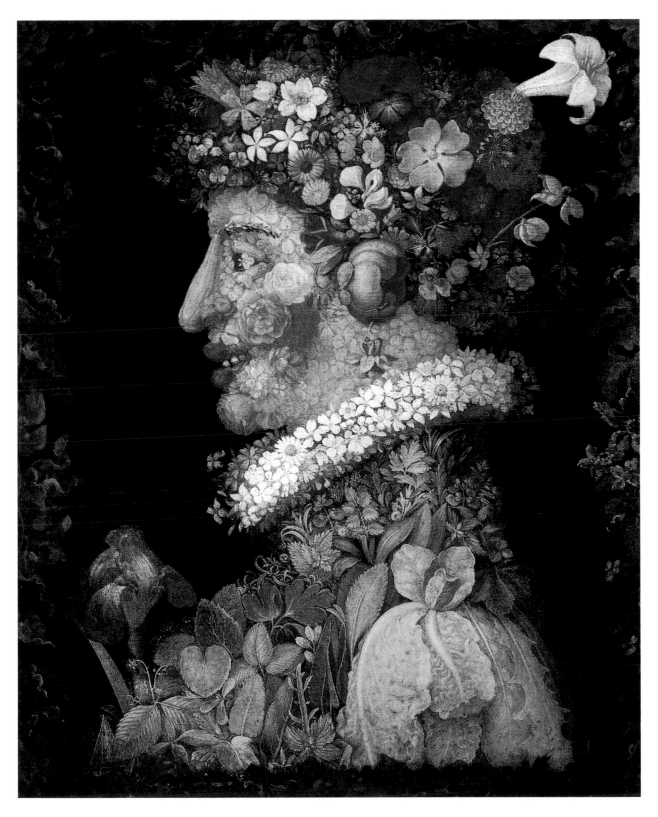

"Spring," oil on canvas, 1573, 30 × 25 inches (76 × 63.5 cm)

This is the first work in a series of portraits dedicated to the cycle of the four seasons. Seasonal fruits and objects symbolically represent each portrait. Each fruit has unique characteristics, significance, and destiny as an element of the Empire. Ten years earlier, Arcimboldo created another very similar set of seasonal portraits, so this must have been a popular theme in his time.

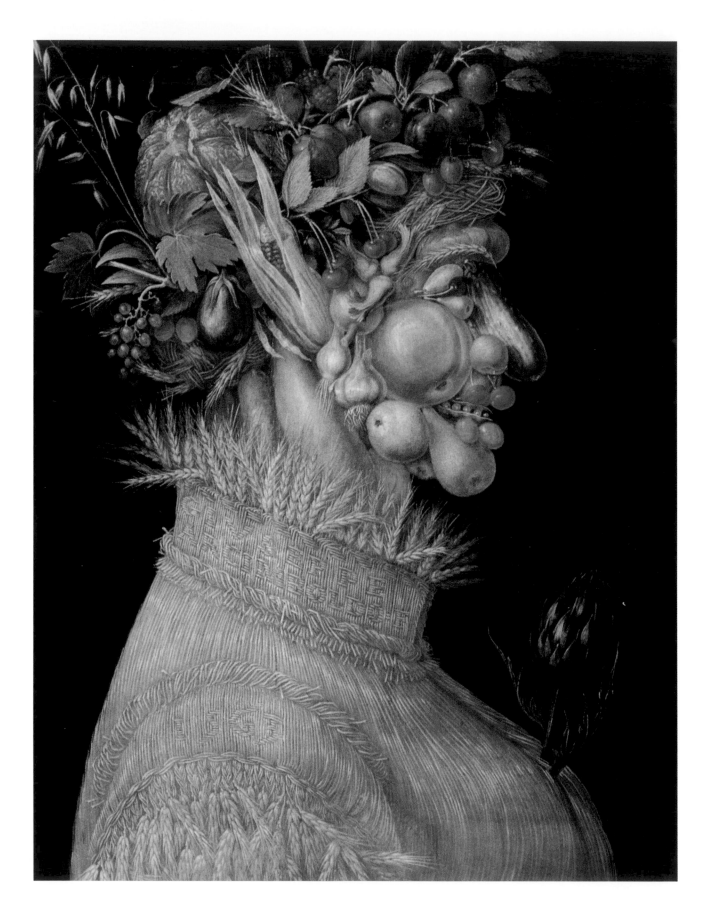

"Summer," oil on canvas, 1573, 30 × 25 inches (76 × 63.5 cm)

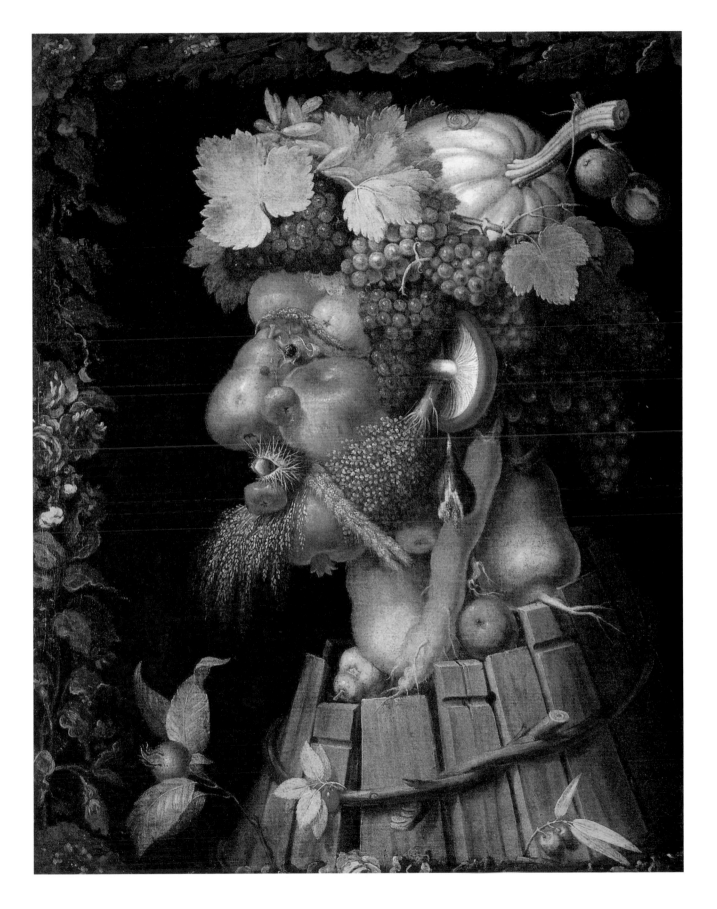

"Autumn," oil on canvas, 1573, 30 × 25 inches (76 × 63.5 cm)

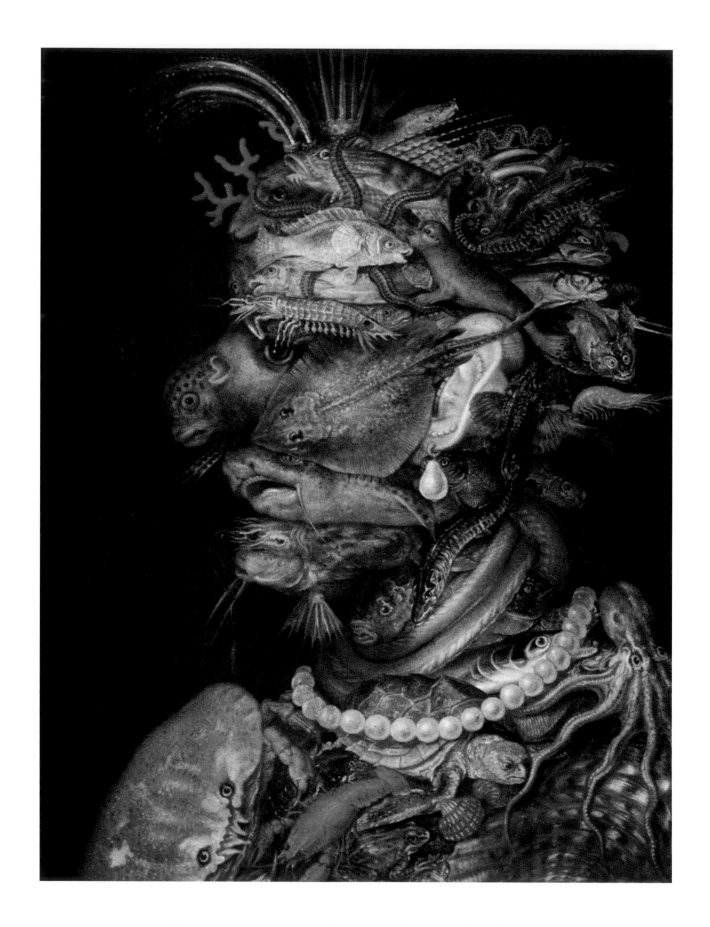

"WATER," OIL ON WOOD, 1566, 26 × 20 INCHES (67 × 51 CM)

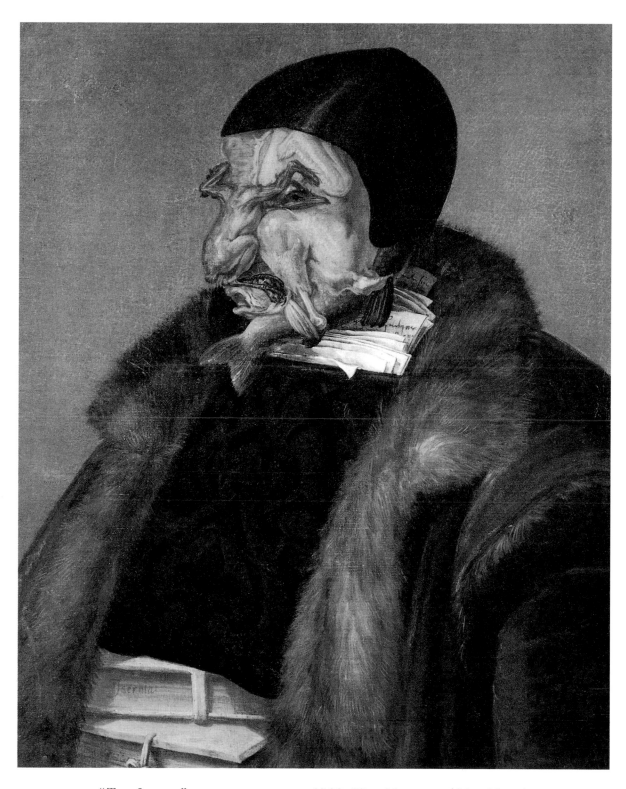

The subject of this portrait was the imperial vice-chancellor Johann Ulrich Zasius, who was one of Maximillian II's closest advisors. A contemporary wrote, "Most ridiculous was the portrait that he did by command of the Emperor Maximillian of a certain Doctor, whose whole face was ruined by the French disease, and only a few miserable hairs were left on his chin. He imagined him as made of various grilled animals and fishes, and he succeeded so well that whoever gazed at it immediately recognized that this was the true image of the good jurist. Of the pleasure it gave the Emperor, and the laughter it provoked in the Imperial Court, there is no need for me to tell you."

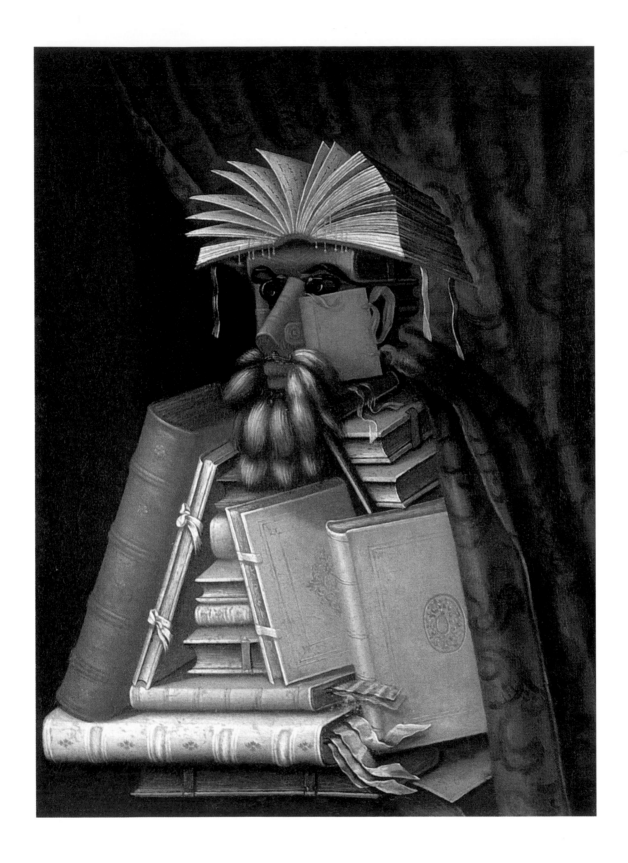

"THE LIBRARIAN," OIL ON CANVAS, 1566, 38 × 28 INCHES (97 × 71 CM)

This is Arcimboldo's caricature of the emperor's historiographer and librarian Wolfgang Lazio (1514–1565), a numismatist and noted bibliophile. Arcimboldo created the portrait of Lazio out of books, his head, nose, but an open book, as his ear. Bookends form his ears, and big heavy books comprise his torso.

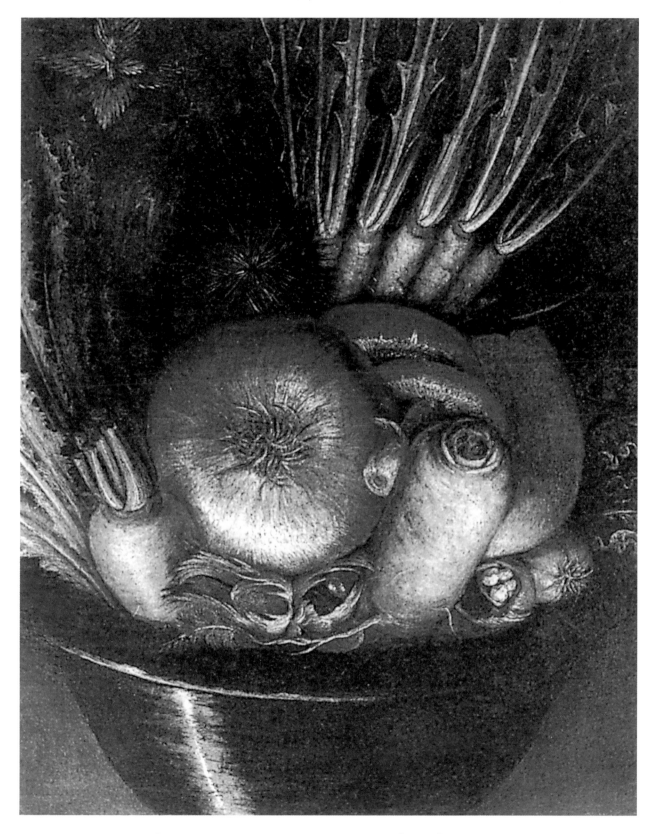

"VEGETABLE GARDENER," OIL ON WOOD, CA. 1590, 13³/₄ × 9¹/₂ INCHES (35 × 24 CM)

This is the second of Arcimboldo's portraits to feature a topsy-turvy image. If you invert the bowl of turnips, you will see a vegetable gardener. Twenty years earlier, Arcimboldo made a similar topsy-turvy portrait of a cook. Topsy-turvy portraits were popular on coins of that period that made fun of the Pope, whose image when inverted would turn into the devil.

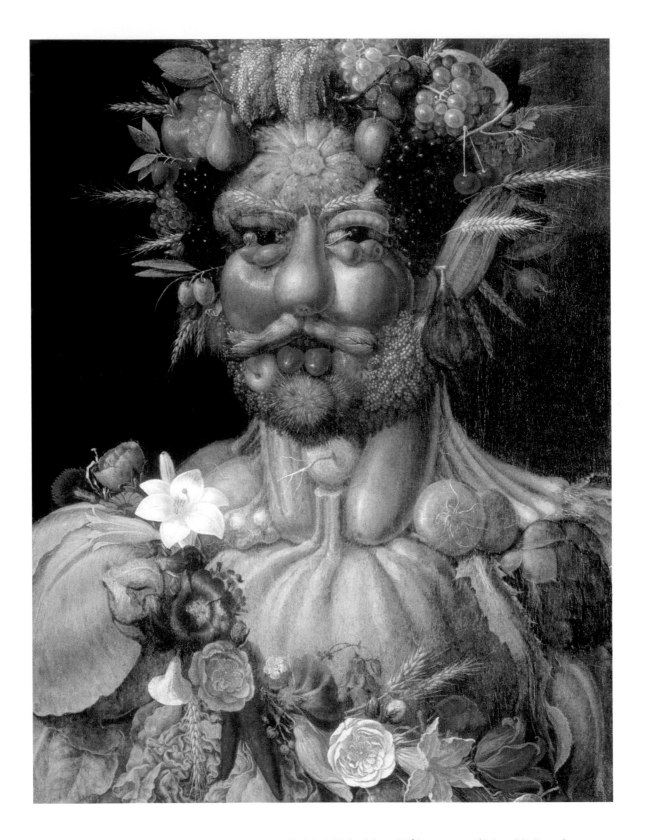

"VERTUMNUS," OIL ON WOOD, CA. 1590–1591, 28 × 22¹/₂ INCHES (71 × 57.5 CM)

This is considered by many to be Arcimboldo's masterpiece of fanciful portraiture. It is an allegorical portrait of his master and patron Rudolf II as the Roman god of metamorphoses in nature and life. Rudolf's face is made up of fruit and flowers, symbolizing the perfect balance and harmony of nature and man that his reign allegedly represented. Everyone, especially Rudolph II, appreciated this work, and Rudolph II awarded Arcimboldo one of his highest orders shortly after the portrait was completed.

Salvador Dalí

(1904–1989)

VISUAL SURPRISE

THE GREAT SPANISH SURREALIST Salvador Dalí was fascinated by optical tricks and illusions. During his illustrious and eccentric career, he experimented with hidden images wherein the meaning could be perceived in more than one way. Between 1929 and 1940, Dalí created thirty-three sketches and paintings based on hidden or ambiguous imagery. The use of such imagery and the element of surprise were central to the Surrealist movement.

Dalí stated that he got his inspiration for double imagery after a discussion with a fellow artist about Guiseppe Arcimboldo's composite portraits. Dalí at times claimed for his "paranoiac" painting a kinship of sorts with Arcimboldo's technique of creating images with double meanings. A comparison between the two types of paintings, however, reveals differences in their technique and composition. Arcimboldo's technique involves the straightforward definition of features. Dalí, on the other hand, used mainly figure/ground reversals, as popularized by the early Gestalt psychologists, who incorporated them into their theories of cognition and perception.

In addition to double imagery, Dalí was keenly interested in more complicated illusions, some of which involved unusual properties of perspective, such as *anamorphoses*. The stretched-out forms of anamorphosis—traditionally used to disguise hidden imagery such as political statements and erotic images—were well suited to Dalí's interest in evoking visual surprise and discovery. In the

mid 1970s, Dalí created a series of five anamorphic images, raising the technique to an entirely new level. Instead of simply distorting or stretching out an image, Dalí manipulated the flat image so that it would have a completely different interpretation from that of the "hidden" one revealed in its reflection on a properly placed cylindrical mirror. Dalí created these images by looking into the cylinder while painting on the surface beneath. This was no easy feat, because when you look into a mirror, your hand motion is reversed: You see what you are doing right side up, but your hand must paint the picture upside down.

In the late 1970s, after disappointment with applying the recently invented process of holography, Dalí went on to experiment with nineteenth-century stereoscopic effects. He created a large number of coupled paintings that, when optically fused by the viewer, would present the scene in three dimensions. In order to see the 3-D image, the viewer needed to look through either angled mirrors or special lenses that were designed to create the effect of binocular vision or stereopsis. It was also possible to view the 3-D effect without using a special apparatus by free-viewing the images to fuse them. Once again, this optical trick fit in with Dalí's passion for creating hidden images and surprise.

It is difficult to overestimate Dalí's importance or to deny him a place as one of the most original and unusual painters of the 20th century. His masterly works, which incorporate a variety of optical tricks, stand out as some of that century's greatest examples of artistic expression and symbolism.

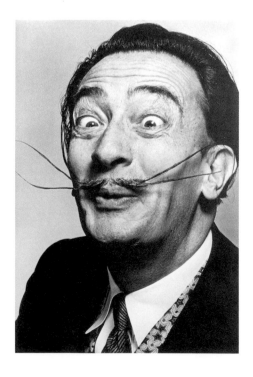

SALVADOR DALÍ IN 1954

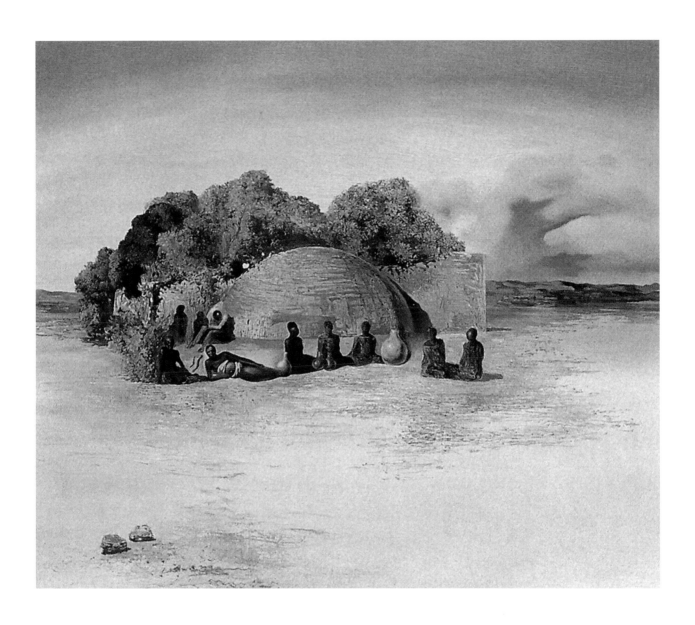

A picture postcard of an African village with natives seated in front of huts inspired this painting.

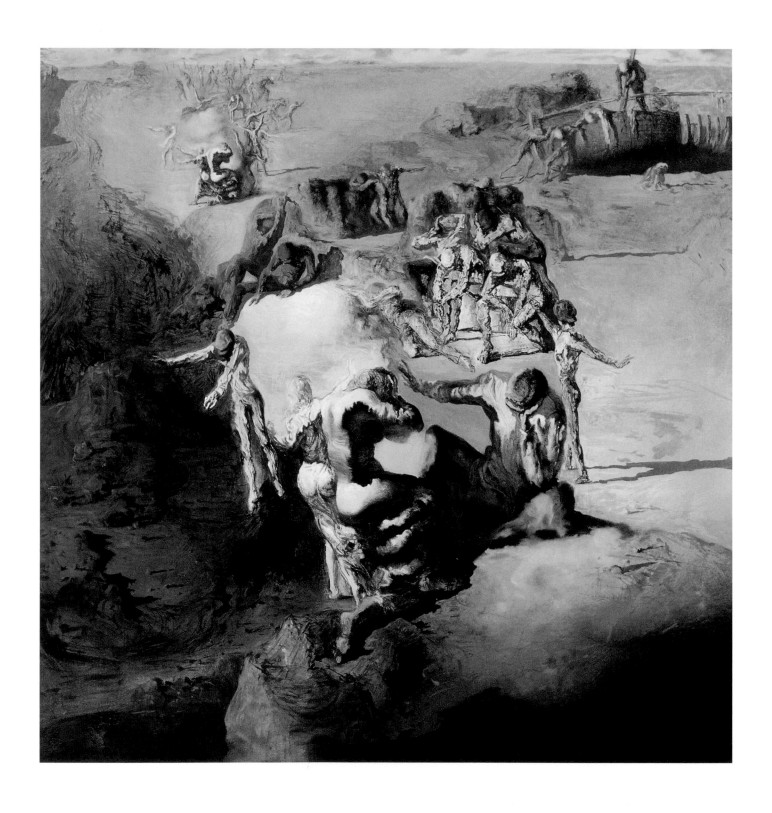

"The Great Paranoiac," oil on canvas, 1936, 24¹/₂ × 24¹/₂ inches (62 × 62 cm)

According to Dalí, "The Great Paranoiac," in which tiny figures are used to create large faces, was painted in order to symbolize the greatest paranoiacs produced by the Mediterranean region.

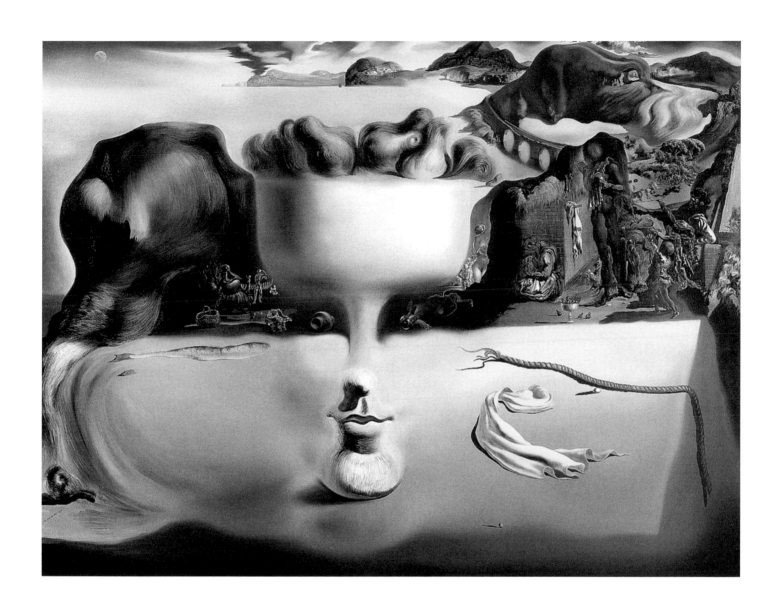

"The Apparition of Face and Fruit Dish on a Beach," oil on canvas, 1938,
44.5 × 56 inches (114.5 x 144 cm)

This composition combines a beach, a dog, a fruit bowl, and a distant landscape. The fruit bowl contains a hallucinatory face (which appeared in several of Dalí's works). The face is said to be that of his closest friend Frederico Garcia Lorca, a well known Spanish poet, who had been shot by the Fascists in 1936. Looking closely at this work, one can see the complex imagery where a tunnel forms the eyes of the dog, and an aqueduct forms his collar. The head is composed of discrete elements: one eye is the end of a pitcher, and the nose, mouth, and chin are formed from an arrangement that combines a fruit with the back of a seated figure.

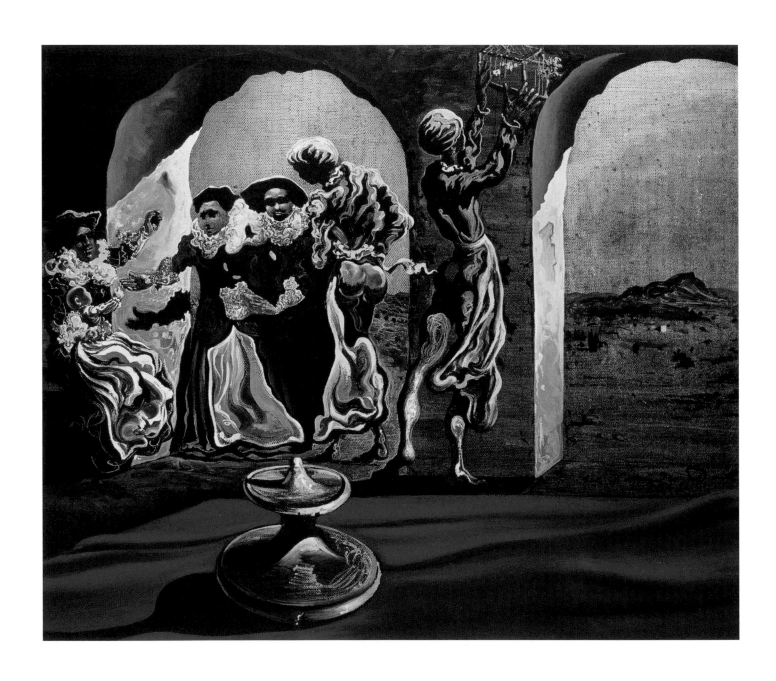

"Disappearing Bust of Voltaire," oil on canvas, 1941, 18¹⁄₄ × 21³⁄₄ inches (46.3 × 55.4 cm)

"Disappearing Bust of Voltaire" was created toward the end of Dalí's period of fascination with ambiguous imagery. Nevertheless, this work is no doubt his most famous example of this technique. In this painting, Houdon's bust of Voltaire, the great 18th century French Enlightenment philosopher, is made up of a group of nuns, which in itself is a humorous reference to Voltaire, who had penned one of the great classics of freethought and atheism.

If you look at the painting from a distance or "de-focus" your eyes, it is easier to see the bust of Voltaire.

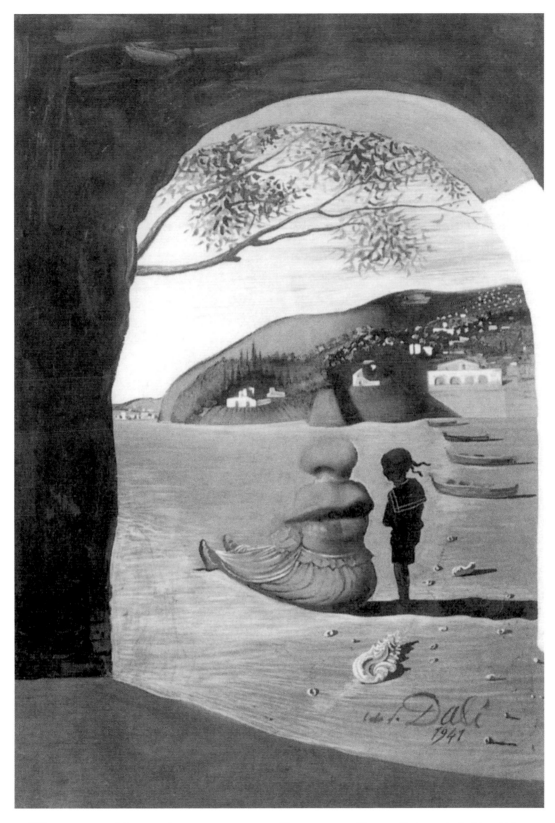

"MYSTERIOUS MOUTH APPEARING IN THE BACK OF MY NURSE," GOUACHE ON PAPER,
1941, 17$^{1}/_{2}$ × 12 INCHES (44.5 × 30.5 CM)

According to Dalí, the nurse's back had a great symbolic meaning for him, and had its roots in his associations with his own childhood nurse.

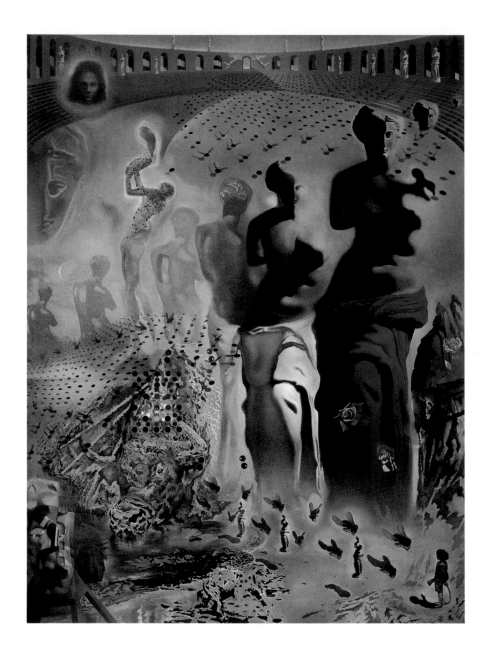

Dalí's idea for "The Hallucinogenic Toreador" was inspired by a second image he perceived after looking at a picture of the Venus de Milo on a brand of pencils. He showed the picture to his wife Gala, and she showed it to others, but no one else could see the image as clearly as he could.

"THE HALLUCINOGENIC TOREADOR," OIL ON CANVAS, 1968–1970, 157 × 119 INCHES (399 × 300 CM)

In this late masterpiece, Dalí depicts the moment, when those who are about to die see their whole lives spread out before them.

The Toreador appears in a receding line of Venus de Milo statues (a recurring image in Dalí's work), from which the Toreador's head is formed, with a single tear falling from his right eye. The death of the Toreador in an arena is a standard subject in Spanish art and life. Some scholars believe that the Toreador, "who is to die, indeed is already dead," represents Dalí's elder brother, who died before Dalí was born.

The painting also alludes to works that Dalí made decades earlier. Dalí appears in the bottom right-hand corner as a young boy. The Voltaire bust, from "Slave Market," floats in front. The flies are the legendary flies of St. Narcisco said to come from his tomb whenever a foreign power invades Spain. Dalí meant to symbolize the "tourist invasion of Cabo Creus, which even the flies of St. Narcisco had been unable to stop."

The painting also shows Dalí's interest in the field of visual perception. The bottom center of the painting incorporates the famous figure/ground photograph of a hidden Dalmatian dog. Dalí's allusion to this well-known perceptual demonstration points out to the viewer that such empty, meaningless images might contain more than is usually supposed.

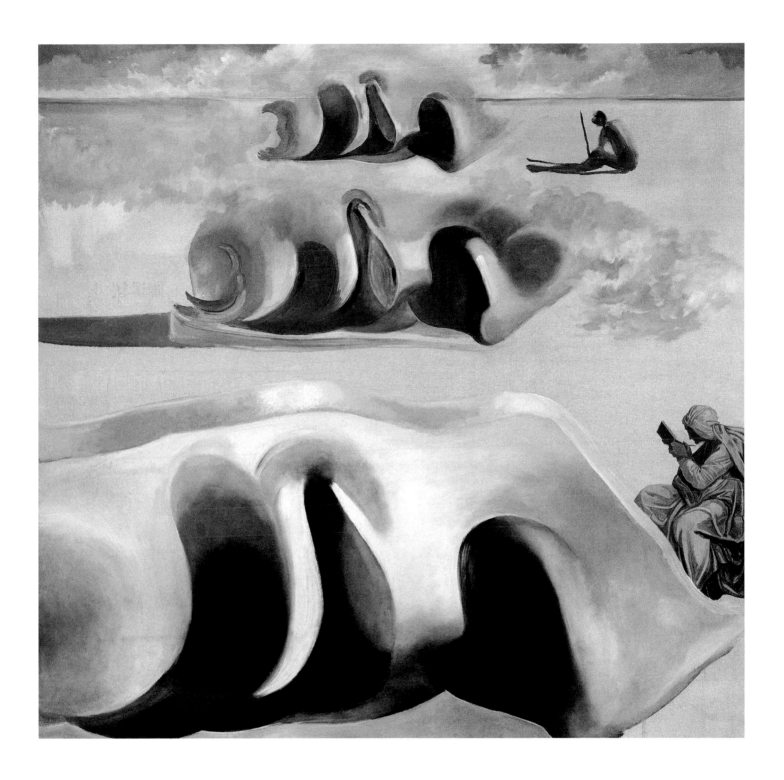

"Three Glorious Enigmas of Gala (second version)," oil on canvas, 1982, 39$^{1}/_{2}$ × 39$^{1}/_{2}$ inches (100 × 100 cm)

This is one of Dalí's last double-meaning images. The repetitious rocky forms can be interpreted as the nose, mouth, and chin of a head.

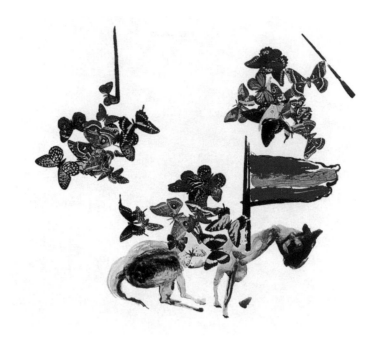

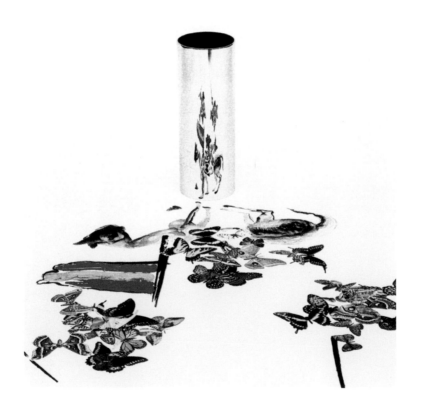

"MATHEW," COLORED LITHOGRAPH WITH CYLINDER, 1974,
34$^1/_2$ × 25 INCHES (88 × 64 CM)

In the image without the cylinder, you can see butterflies, a favorite motif of Dalí's. But look at the reflection of this image in the cylinder and you will see the butterflies transform into two warriors and a horse and rider carrying a flag.

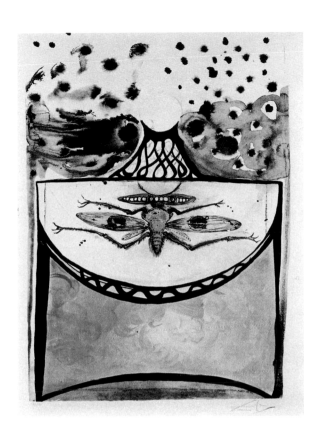

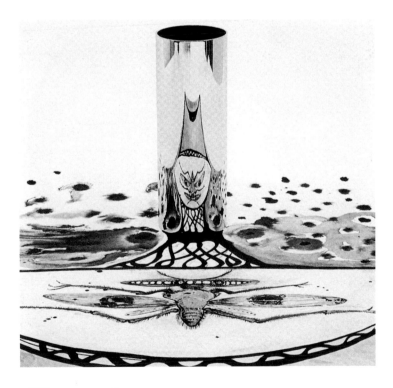

"HARLEQUIN," COLORED LITHOGRAPH WITH REFLECTIVE
CYLINDER, 1974, $34^{1}/_{2} \times 25$ INCHES (88×64 CM)

An insect is transformed into a clown's face.

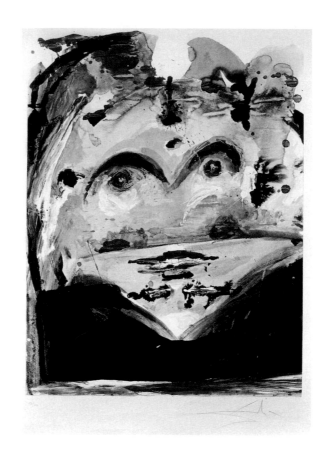

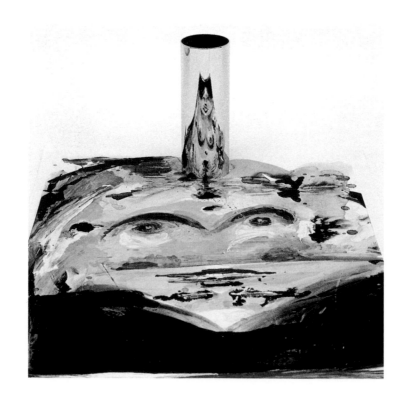

"MAN AND WOMAN," COLORED LITHOGRAPH WITH REFLECTIVE CYLINDER, 1974, 34^1/$_2$ × 25 INCHES (88 × 64 CM)

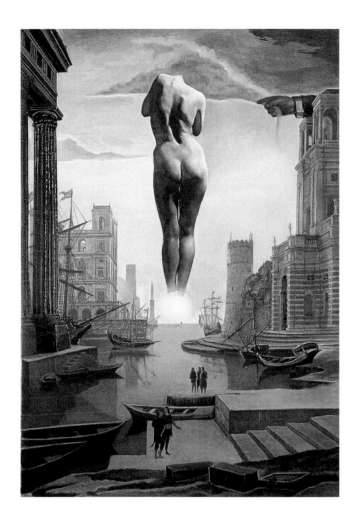 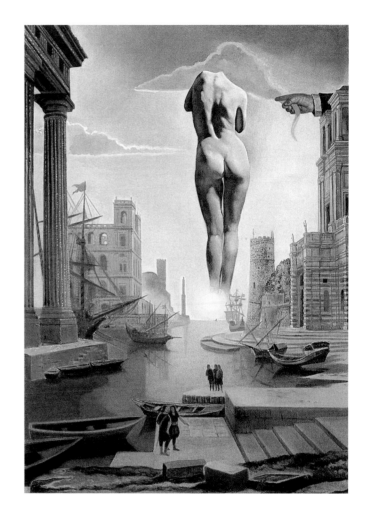

"DALÍ'S HAND DRAWING BACK THE GOLDEN FLEECE IN THE FORM OF A CLOUD TO SHOW GALA THE DAWN,
COMPLETELY NUDE, VERY, VERY FAR AWAY BEHIND THE SUN," TWO STEREOSCOPIC PANELS, OIL ON CANVAS, 1977,
$23^{1}/_{2} \times 23^{1}/_{2}$ INCHES (60 × 60 CM)

If you free-fuse these two images (you should look at them so that a third version of the image appears centered between the left and right views), then the middle version will appear in three dimensions.

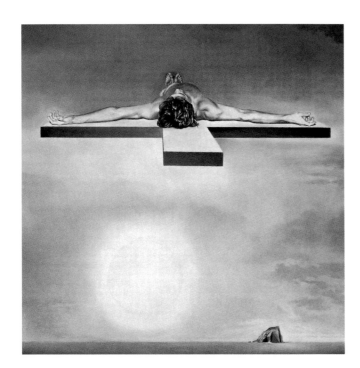 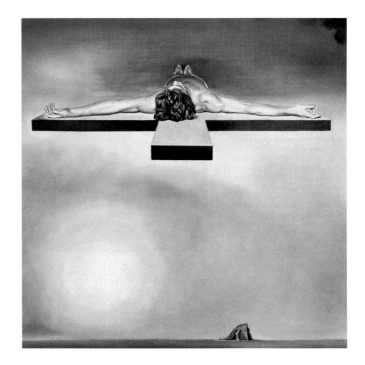

If you free-fuse these two images (you should look at them so that a third version of the image appears centered between the left and right views), then the middle version will appear in three dimensions.

Sandro Del-Prete

(1937–)

A Change of Perspective

"Del-Prete, in a genius manner, materializes the well-known psychological effect, of the difference between 'looking' (usually the first glance of an observer) and 'seeing' (the second glance) when things are appreciated more thoroughly in the mind. It is this specific sensation which gives his works of art the so-called 'added value.'"

—Abraham Tamir

"A sound knowledge of the rules of perspective is absolutely necessary for illusionistic drawing: deciding either to keep to the rules or, on the other hand, to alter them and choose a false line that changes the perspective and cause, to put it simply, an 'optical illusion.'"

—Sandro Del-Prete

SWISS ARTIST SANDRO DEL-PRETE is a master of the art of illustrating figures, situations, and processes that cannot exist in the real world. His works are studies in perception, and he makes us realize how much we are used to looking at things in a particular way. Del-Prete summed up his approach,

I was always absorbed with the question of how the eye makes sight possible. Optical perceptions give us information about the shapes, sizes, movements, and

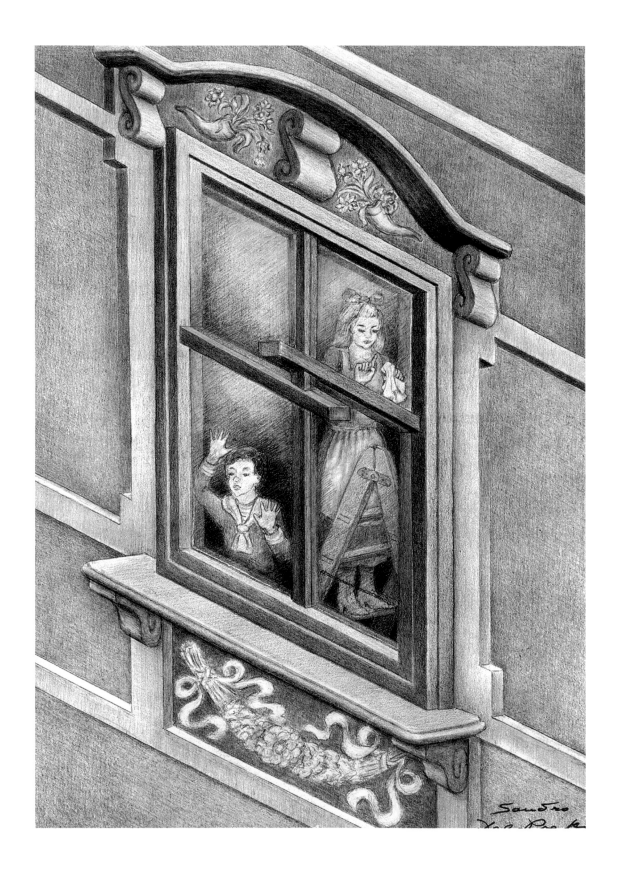

"Window Gazing," colored pencil drawing, 1961

This double-perspective drawing was one of Del-Prete's first attempts at an illusionary scene, and was based on the ambiguous Thiéry figure.

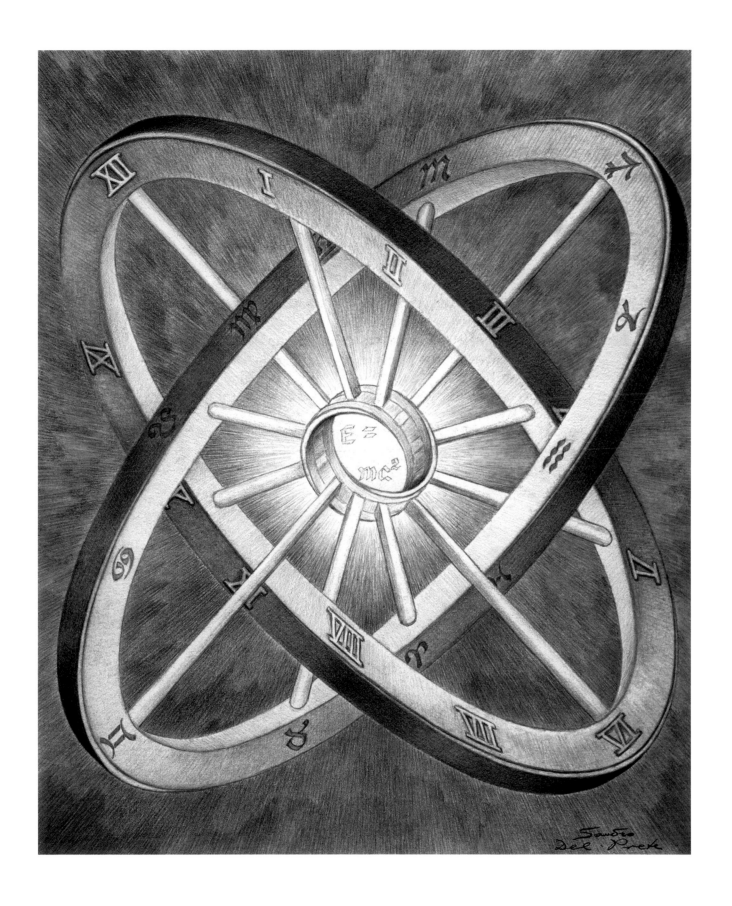

"COSMIC WHEELS," COLORED PENCIL DRAWING, 1961

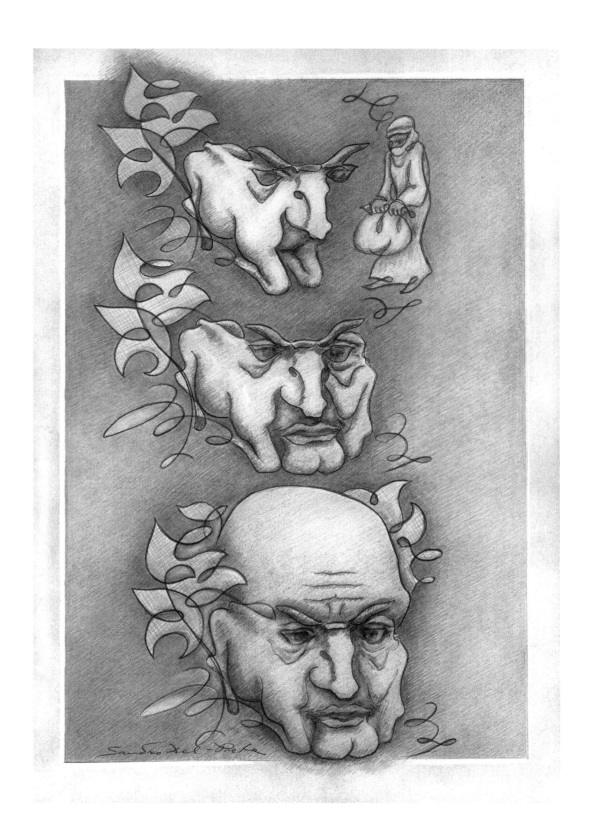

"Nomad," colored pencil drawing, 1973

This is one of Del-Prete's first attempts at transforming an ambiguous image. Although in this picture the same fragment is visible no less than three times, it undergoes a complete change owing to several major additions. At the top, a bullock is resting under a shrub. In the middle, a nomad offers a water bag to the bullock. And at the bottom, one can see the expressive face of a scholar: the difference is made by adding the lines for the top of his head and forehead.

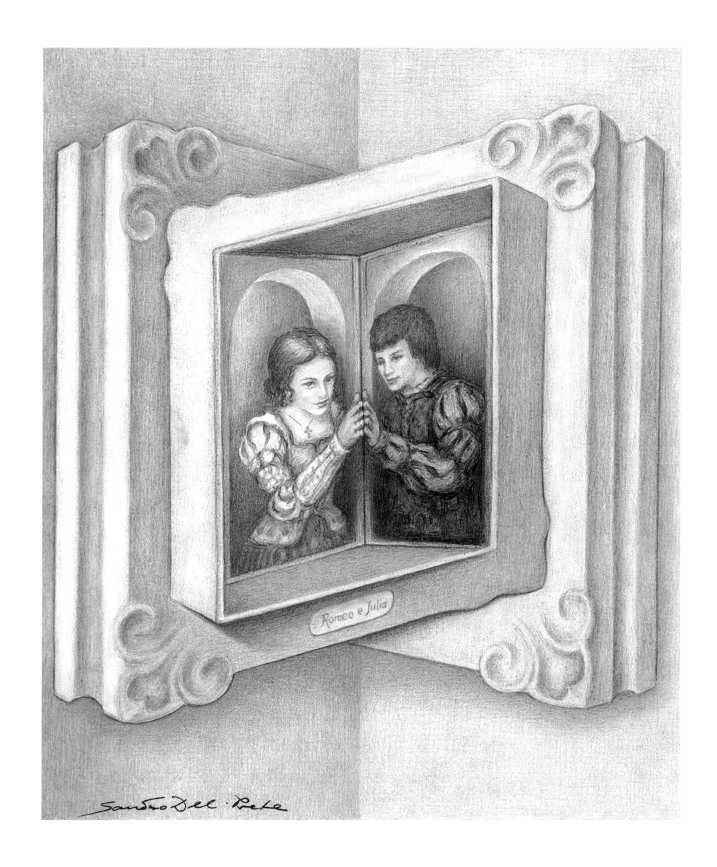

"Romeo and Juliet," colored pencil drawing, 1974

According to Del-Prete, this scene represents "a realistic image of the ancient theme of impossible love." The two hands also meet in an impossible way: they are joined in the corner, which is facing in, yet their fingers appear to be facing away from the corner.

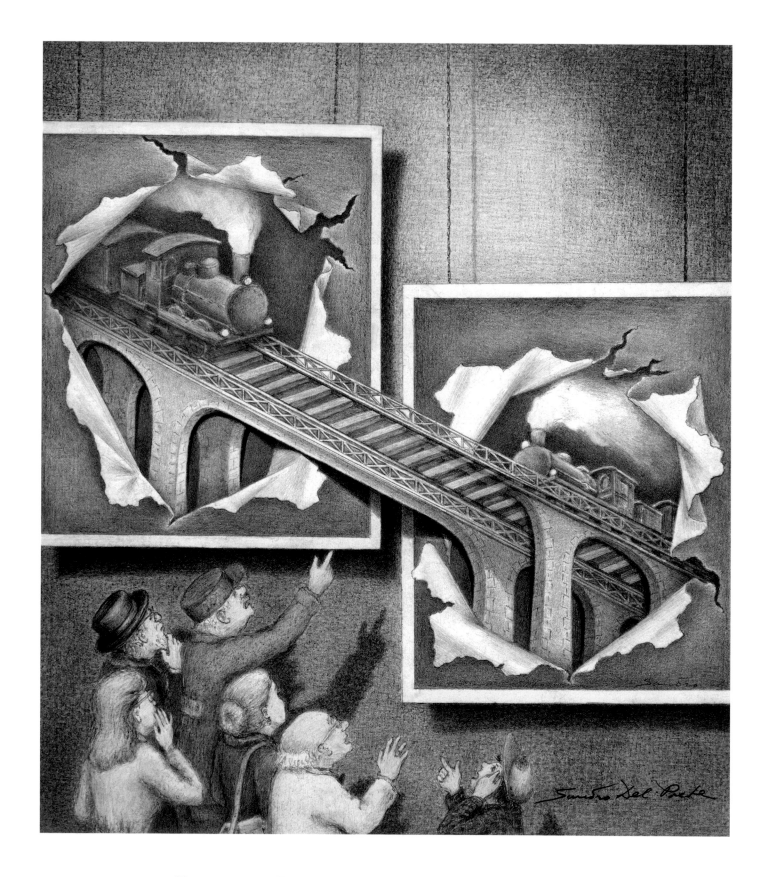

"Incident on a Railway Bridge," colored pencil drawing, 1981

This is another example of Del-Prete's use of impossible double-perspective. Will the trains collide? It also incorporates the artist's whimsical use of a scene breaking out of its own picture frame—which is also a picture.

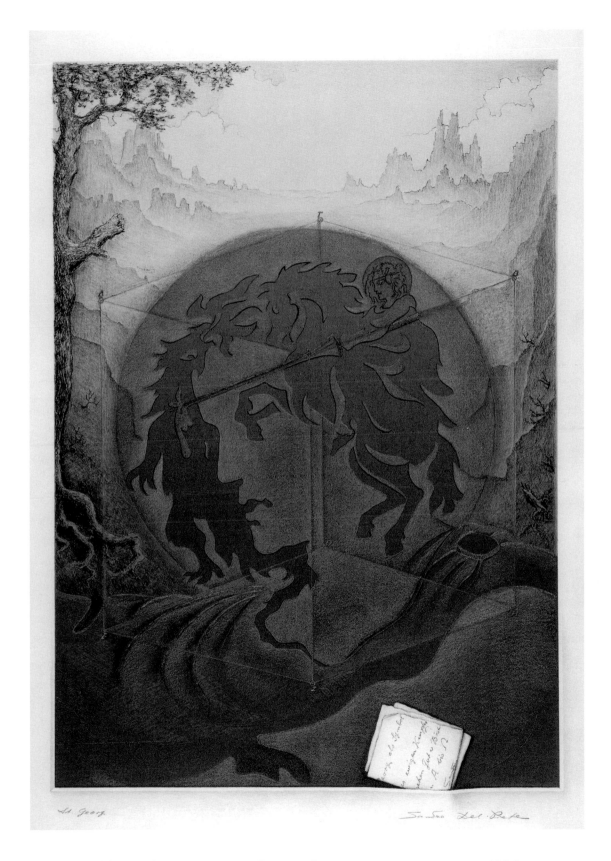

"Saint George and the Dragon," colored pencil drawing, 1986

This image incorporates a figure/ground perceptual reversal. Can you find both a portrait of St. George and a depiction of him slaying the dragon? Look at Saint George's hair to see the battle scene.

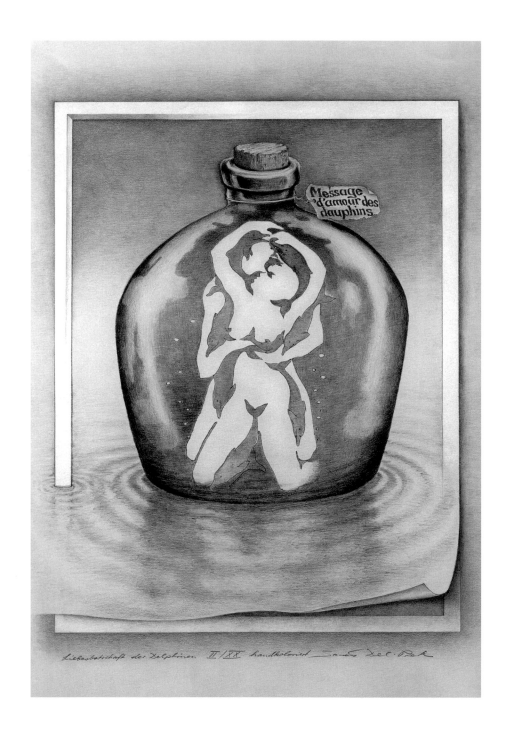

"The Message of Dolphins," colored pencil drawing, 1987

This image incorporates a figure/ground perceptual reversal, and is an excellent example of one's viewpoint being primed by experience. If you are young and innocent, and have not been "ruined" yet, you will likely perceive a group of—yes—dolphins. Adults, on the other hand, will probably see a couple in a suggestive embrace. If you are having trouble perceiving the dolphins, just reverse figure and ground: What normally constitutes the ground (dark areas), becomes a group of small dolphins (the figures).

At a public exhibition that the author held at the University of Cambridge, it was tremendous fun to watch the adults and the very young children argue about the meaning of this image. Adults would exclaim to their children, "What dolphins?" This image was also displayed in an illusion exhibit gallery at the Museum of Science in Boston. When asked if there was any controversy about displaying this image, the curators replied that once a group of nuns had objected, but were quickly silenced when told that one's perception is based upon past experience.

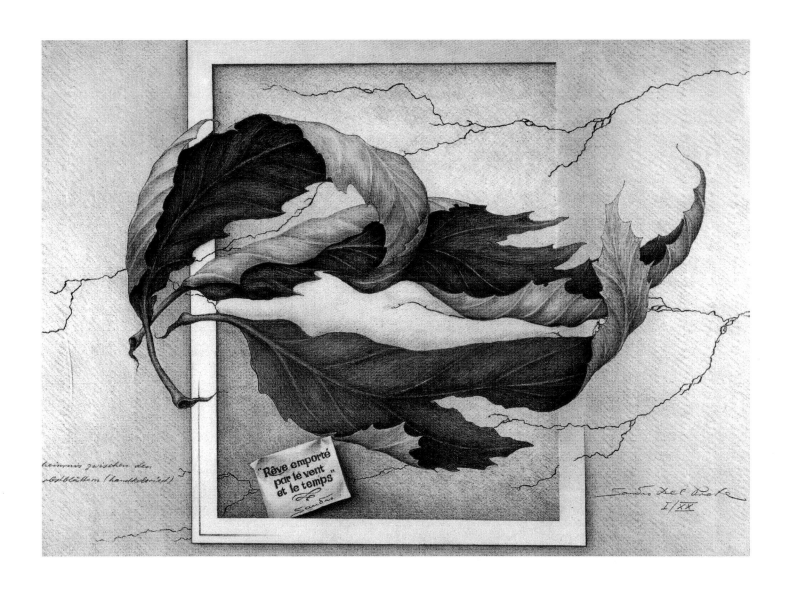

"Secret Between Fall Leaves," colored pencil drawing, 1991

A nude woman is found hidden in the leaves.

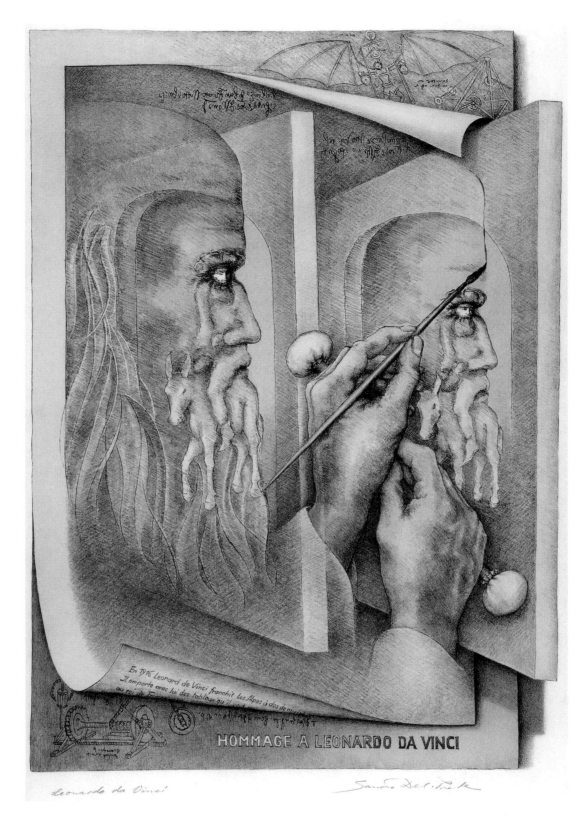

En 1916 Leonard de Vinci franchit Les Alpes à dos de m...
Il emporte avec lui des tableaux qu'il veut
au roi de Fra...

HOMMAGE A LEONARDO DA VINCI

Leonardo da Vinci Sandro Del Prete

"HOMAGE TO LEONARDO DA VINCI," COLORED PENCIL DRAWING, 1992

This ambiguous scene is based on Leonardo da Vinci's trip through the Alps on a mule in 1516. It was on this journey that da Vinci carried with him some valuable paintings, such as the "Mona Lisa," which he intended to give to the King of France. Here, Del-Prete depicts da Vinci's ride, while at the same time da Vinci contemplates working on a painting. The double image, seen in both the profile and the drawing on the right, can be seen as either da Vinci's self-portrait or his ride on a mule through the Alps.

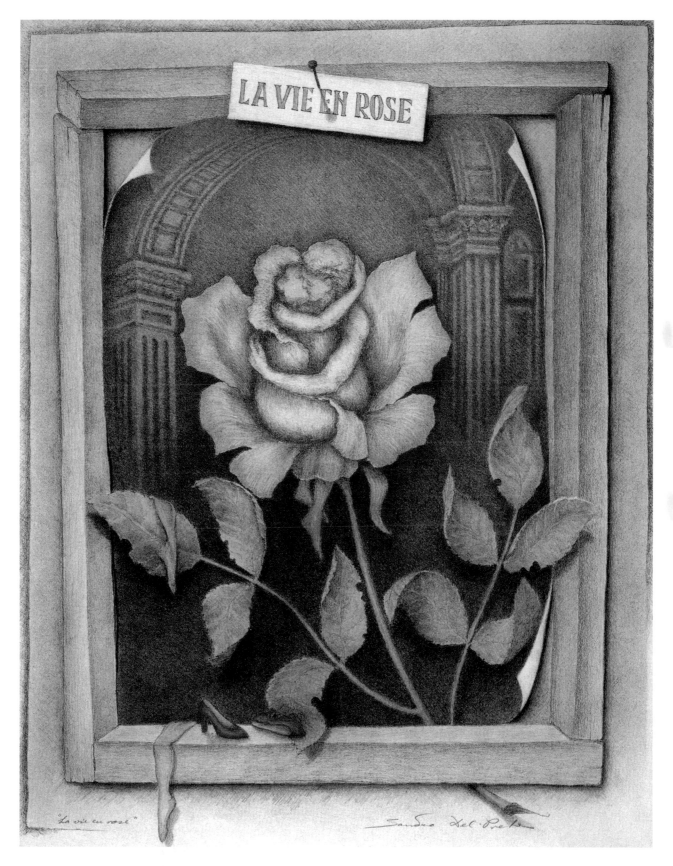

"The Flowering of Love," colored pencil drawing, 1994

Can you see the couple hiding in the rose petals?

Jos De Mey

(1928–)

PARADOXICAL WORLDS

"Art that only satisfies the mind is interesting. Art that only satisfies the eye is superficial. That's why I always look for art that is both interesting and aesthetically satisfying."
—JOS DE MEY

BELGIAN ARTIST JOS DE MEY is a master of creating impossible worlds that can exist only on his canvas. His worlds are simultaneously realistic and unrealistic; therein lies their great paradox.

De Mey is proud of his Flemish heritage, and enjoys creating scenes that evoke a typically Flemish environment. He populates these scenes with figures derived from the works of Pieter Bruegel, René Magritte, and M. C. Escher. The elements of architecture, scenery, figuration, and application of color have strong Flemish roots, in contrast with Escher, whose classic works were for the most part completely devoid of color, and who used primarily Italian architecture and scenery in his images.

Many of De Mey's images portray an owl, a symbolic representation of the artist's alterego. According to De Mey, "The owl, in the Dutch language, is the symbol of theoretical knowledge and at the same time the image of the fool or one who pretends being stupid."

Jos De Mey was born in 1928 in the Belgian village of Sint-Denijs-Westrem. He studied at the Academy of Fine Arts in Ghent, and at the age of twenty-two was appointed lecturer in interior design and color in that same academy. His early work was in furniture design and architecture. In 1956 he attended an exhibition of the works of Escher, which had an enormous impact on him. Escher had not yet branched out into prints with impossible figures, and most of his work at that time involved tessellations or tiling the visual plane. In 1959 one of De Mey's colleagues gave him the classic paper on impossible figures authored by the father-and-son team of Lionel and Roger Penrose (the same article had influenced Escher). Thus, De Mey's interest was similarly piqued to create impossible figures, even though his career at that time still involved designing furniture.

It was not until about 1968 that De Mey decided to leave his successful career of interior architecture and design for the more risky profession of professional artist. In this regard, he wanted to depict things that could only exist as a "painting," and therefore he started to create colorful abstract illusory figures based mainly on those of Armand Thiéry and Joseph Albers. De Mey's early work generally showed objects hanging in a nonexistent space, as seen in his 1979 work "Beautiful Building for a Big Belgian City." They were representations that had neither a bottom or top side, or left or right side, for that matter.

In the same period he started experimenting with impossible figures; in 1976, his works became much more figurative, and he started incorporating them into scenes. He wanted to incorporate

JOS DE MEY, 1996

trompe l'oeil effects, with particular attention paid to light and shadow. This was a twofold challenge for him, because his preliminary training and his teaching profession had always focused on design and not on figurative images. He had to acquire new talents in order to be able to create a realistic environment for his impossible architecture. Furthermore, in his design work, he had worked for years in a disciplined fashion to avoid ambiguities, which he now wanted to promote. By creating impossible yet realistic scenes, De Mey was able to distinguish himself from the anonymous international abstractness in painting that was prevalent. "I could experience the pleasure of being able to represent something that couldn't be and do it in such a convincing way that one is likely to think that it really could exist...If you want to draw attention to something impossible you must try to deceive first yourself and then your audience, by presenting your work in such a way that the impossible element is veiled and a superficial observer would not even notice it."

De Mey's works normally feature long titles that not only give a description of the works, but that very often make them seem even more mysterious. Unfortunately, most of the titles lose their meaning in translation, because they are puns that can be best understood in their native tongue.

"BEAUTIFUL BUILDING FOR A BIG BELGIAN CITY," ACRYLIC ON CANVAS, 1979,
$43^1/_4 \times 37^1/_2$ INCHES (110 × 95 CM)

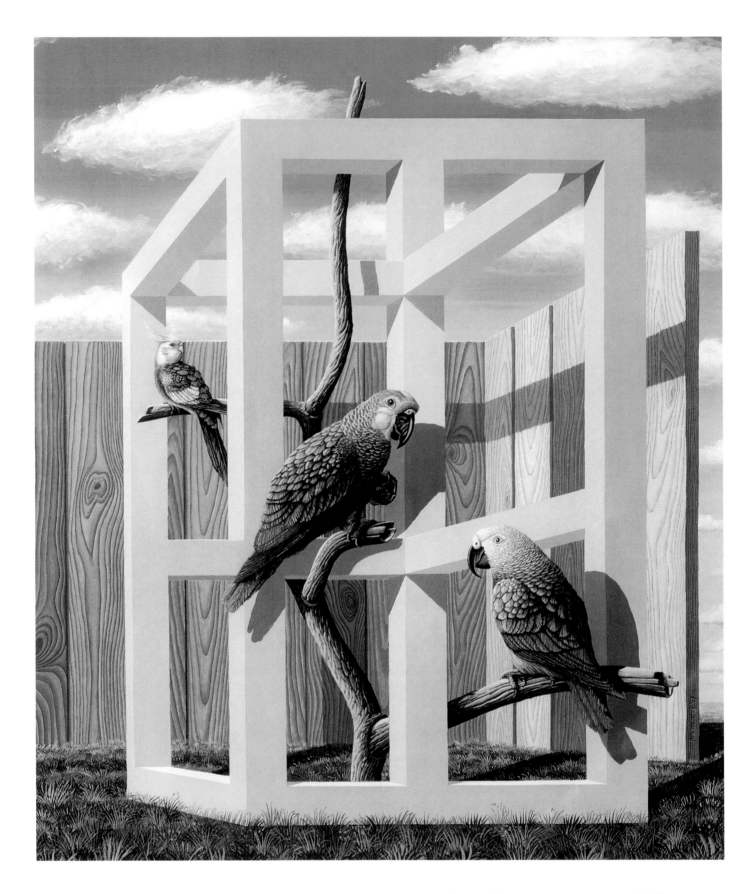

"Strange Panopticon Construction for Parrots and Family," acrylic on canvas, 1987,
$39^1/_2 \times 33^1/_2$ inches (100 × 85.5 cm)

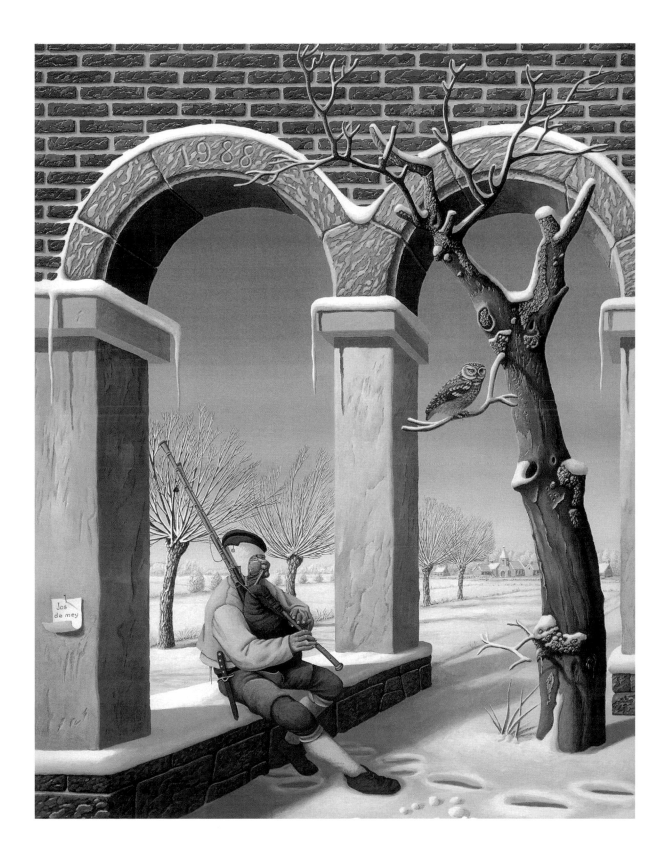

"Melancholy Tunes on a Flemish Winter's Day," acrylic on canvas, 1988,
$35^{1}/_{2} \times 27^{1}/_{2}$ inches (90 × 70 cm)

How does that left column come forward?

"Portrait of an Invisible Man," acrylic on canvas, 1989, 19¹/₂ × 15¹/₂ inches (50 × 40 cm)

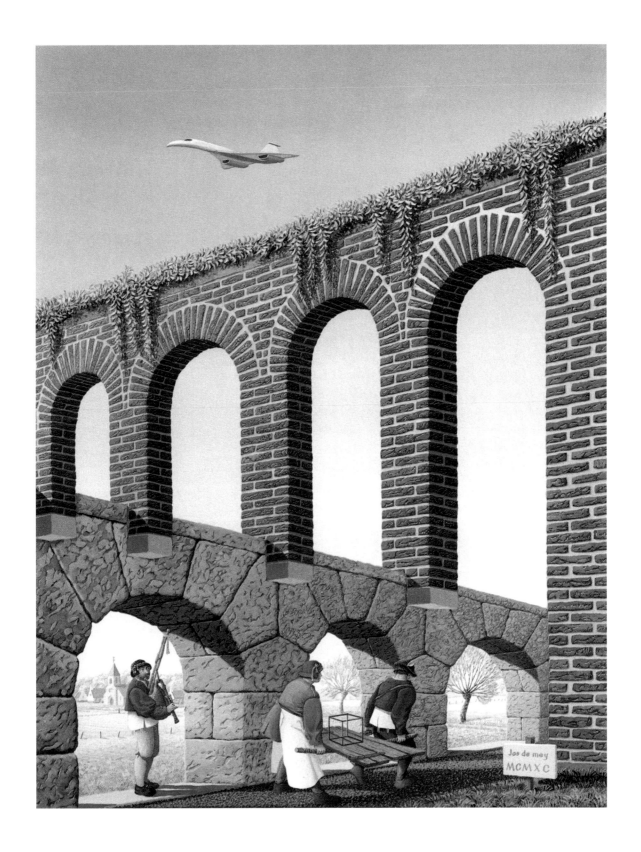

"Two Individuals Take the Long Way Around an Aqueduct," acrylic on canvas, 1990, $31^{1}/_{2} \times 23^{1}/_{2}$ inches (80 × 60 cm)

The bottom of the aqueduct is perpendicular to the top. This is similar to the construction seen in Escher's first impossible print, "Belvedere" (1961).

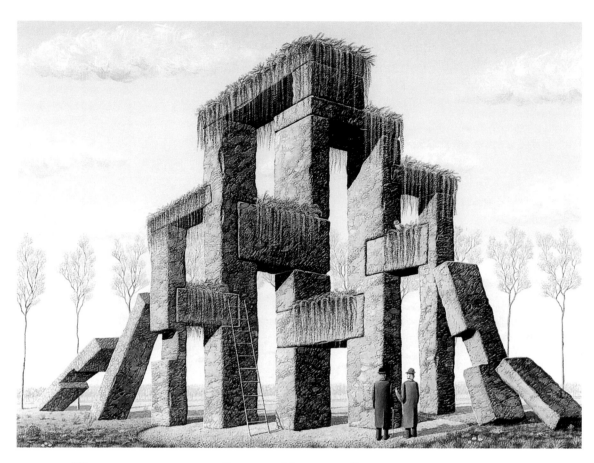

"Reconstruction of a Strange Monolith," acrylic on canvas, 1995,
$27^1/_2 \times 35^1/_2$ inches (70 × 90 cm)

"Botéro-Bird Admiring a Soft Construction
of Jos De Mey," acrylic on canvas, 1996

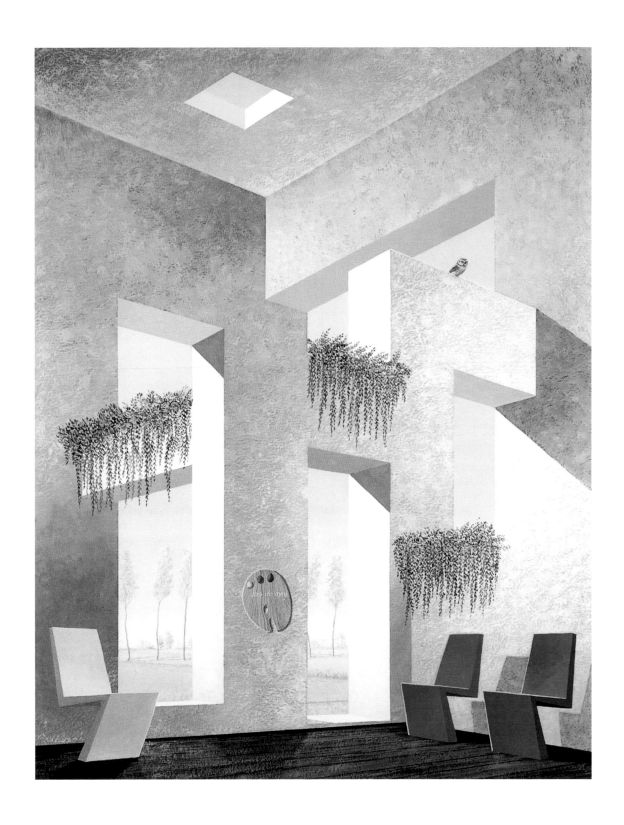

"THE PAINTER'S WAITING ROOM," ACRYLIC ON CANVAS, 1996, 31¹/₂ × 23¹/₂ INCHES (80 × 60 CM)

Escher changed courses and studied with Samuel Jessurun de Mesquita, who was a master print-maker. Mesquita taught Escher how to produce highly proficient woodcuts. For the next seven years, Escher rarely employed any other technique, apart from using pen and ink.

Although Escher was mastering the technique of woodcuts, his work was by no means considered outstanding. The official college report signed by his teachers read, "He is too tight, too literary, philosophical; a young man too lacking in feeling or caprice, too little of an artist." Some years later, Mesquita must have felt a bit of irony when he placed Escher's print "Sky and Water I" on his wall. A family member remarked, "Samuel, I think that is the best print you have ever done."

In 1922 Escher traveled to Italy with two Dutch friends. During this time he took inspiration from the beautiful landscapes of the Italian coast. It was there that his interest in perspective and uncon-ventional viewpoints began to surface. Escher felt at home in Italy and lived there until 1935. During this period he married and had three children.

Each spring, in the company of other artists, he would set off on foot to trek through Sicily, Corsica, and Malta. He would return two months later, tired, but with hundreds of drawings.

Late in life, Escher belittled the Italian landscape prints that he had produced before 1935, describ-ing them as "having little or no value, because they were for the most part merely practice exercises." Nevertheless, without them the later, more famous prints may never have evolved.

In 1935 the political situation in Italy became intolerable to him, and he moved to Switzerland, then to Brussels, and finally set up a permanent home in Holland in 1941.

While in Switzerland, without the southern climate, architecture, and landscapes of Italy, Escher felt bereft of subject matter. He began to look inward and discovered in his mind an even more potent source of inspiration than southern Italy. In 1937 Escher began to experiment with tessellating and morphing figures, and tiling the visual plane. This was to become his predominant style until 1945, and he made hundreds of drawings of tessellating figures. His 1938 woodcut "Day and Night" is perhaps the most famous and admired example of this technique. In addition, Escher became pre-occupied with the notion of two-dimensional figures transforming into three-dimensional ones, as in his 1943 print "Reptiles."

In 1946 Escher began focusing on making unconventional perspective prints. This pursuit occu-pied him until 1956, when he started to explore the concept of infinity with hyperbolic plane tes-sellations, such as "Circle Limit IV."

It was during this time that Escher started investigating impossible figures, the result of an inspir-ing cross-fertilization between a mathematician and an artist. In 1954, the English mathematician Roger Penrose attended a conference of mathematicians, which included Escher's first important

tion. Up until then, Escher's work had been devoted primarily to tiling the plane and depicting odd structures that appeared to defy gravity. Escher had not yet created any impossible figures.

Penrose had never heard of Escher, who in 1954 was not well known. Penrose, however, was absolutely intrigued by Escher's work, and went away inspired to do something of an impossible nature himself, but that would differ from Escher's own creations. Penrose started experimenting with pictures in which the perspective was inconsistent. He gradually worked at the problem until he came up with the now well-known figure of an impossible tri-bar or triangle, which he believed to exhibit the notion of impossibility in its purest form. Penrose showed the figure to his father, Lionel Penrose, a well-known professor of human genetics who enjoyed mathematical recreations and puzzles. Lionel Penrose became deeply intrigued by his son's impossible triangle and began producing all sorts of similar figures of his own, including an impossible staircase that appears to have no bottom or top step as it goes round and round.

The two Penroses couldn't think of what to do with these strange figures but believed that they ought to be published. However, they could not decide to what discipline they belonged. Lionel Penrose knew the editor of the *British Journal of Psychology,* so he surmised that the best chance for getting these figures published was to put them under the heading of "psychology."

The article was eventually published in 1958. Roger Penrose sent a copy to Escher, having acknowledged his exhibition and contributions in it. In the meantime, Escher had produced his first impossible print, "Belvedere," which exhibits a similar type of self-contradictory, illogical structure.

After receiving the Penrose article, Escher was inspired to create various impossible designs of his own, including the now famous prints "Waterfall" (based on Roger Penrose's impossible triangle) and "Ascending and Descending" (based on Lionel Penrose's impossible staircase). Escher was always very explicit about his sources for these two prints. However, in an odd twist of fate, Escher's name became synonymous with the creation of impossible figures, although, in fact, he created only three impossible prints. His oeuvre consists of well over 400 prints (mostly woodcuts and lithographs), and depicts a variety of themes—mostly landscapes and architectural details in his early work, and in his later work, studies of mathematical objects, visual depictions of scientific and philosophical ideas, explorations of perspective, "story prints," and so on, Escher continued working until his death in 1972.

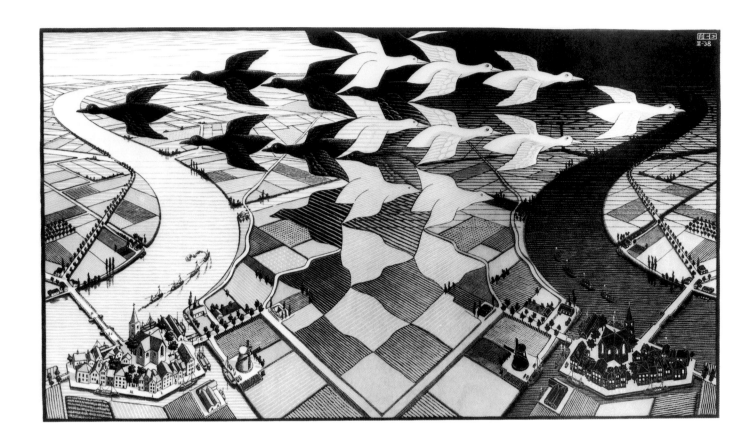

Many people believe that this is Escher's masterpiece, and Bruno Ernst, Escher's biographer, has labeled it "the most admired picture of them all." It represents a turning point in Escher's work. The image is symmetrical; in it the Dutch village is in daylight on the left, and its mirror reflection is in nighttime on the right. The geese, which are black on the left, transform to white geese on the right. This is one of the rare works in which Escher depicted a typically Dutch environment.

"SKY AND WATER I," WOODCUT, 1938, 17 × 17 INCHES (43.5 × 43.5 CM)

In this print, which was done shortly after "Day and Night." Escher plays with figure and ground at the center, either fish or bird can befigure or ground. But the white fish melt into the sky as birds rise, while the black birds dissolve into water as the white fish sink and swim.

"Reptiles," lithograph, 1943, 13 × 15 inches (33 × 38 cm)

Here Escher creates an impression of three-dimensional reptiles coming out of a two-dimensional image, and then transforming back into two dimensions. How two dimensions suggest the third dimension was a theme that Escher explored in many of his prints.

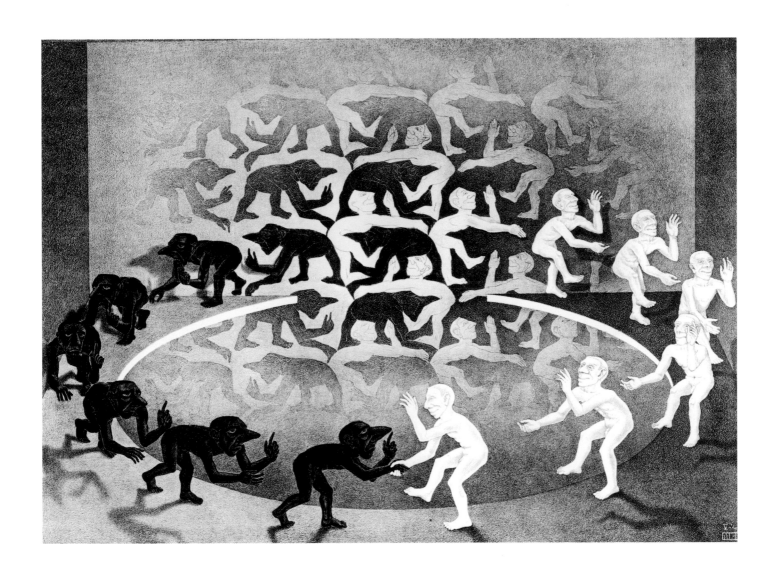

"ENCOUNTER," LITHOGRAPH, 1944, 13¹/₂ × 18¹/₄ INCHES (34 × 46.5 CM)

This is another example of Escher's playing with the concept of two dimensions transforming into three dimensions. In "Encounter," the light optimist and dark pessimist come out of their plane-tiling space to meet and shake hands.

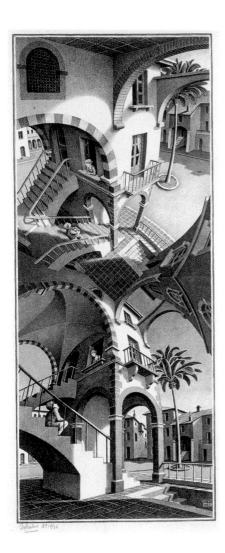

"HIGH AND LOW," LITHOGRAPH IN BROWN, 1947, 19¹/₂ × 8 INCHES
(50.3 × 20.5 CM)

Escher's biographer and friend Bruno Ernst wrote of this lithograph that it is "probably the best print in the whole of Escher's work." In it, the viewer sees the same scene from two different perspectives. In the top half, one looks down into a town square. The lower scene offers the same view, but from a completely different perspective. The square-tiled ceiling seen from below serves as a floor when viewed from above. There are even some steps going down, suggesting that you can enter on the ground floor, but if you peer out of a window, you will find yourself looking out of the top floor.

"CONCAVE AND CONVEX," LITHOGRAPH, 1955, 10³/₄ × 13¹/₄ INCHES (27.5 × 33.5 CM)

In this work, Escher sought to create a complex world where depth cues are ambiguous. The left side of the print is seen from above, the right side from below, and the views are married in the center, which has many ambiguous depictions. Only the lizards, plant pots, and people are unambiguously depicted. Escher struggled with this print for some time, and wrote to Bruno Ernst about it:

> Just imagine, I spent more than a whole month, without a break, pondering over that print, because none of the attempts I made ever seemed to turn out simple enough. The prerequisite for a good print—and by "good" I mean a print that brings a response from a fairly wide public quite incapable of understanding mathematical inversion unless it is set out extremely simply and explicitly—is that no hocus-pocus must be perpetrated, nor must it lack a proper and effortless connection with reality. You can scarcely imagine how intellectually lazy the "great public" is. I am definitely out to give them a shock, but if I aim too high, it won't work.

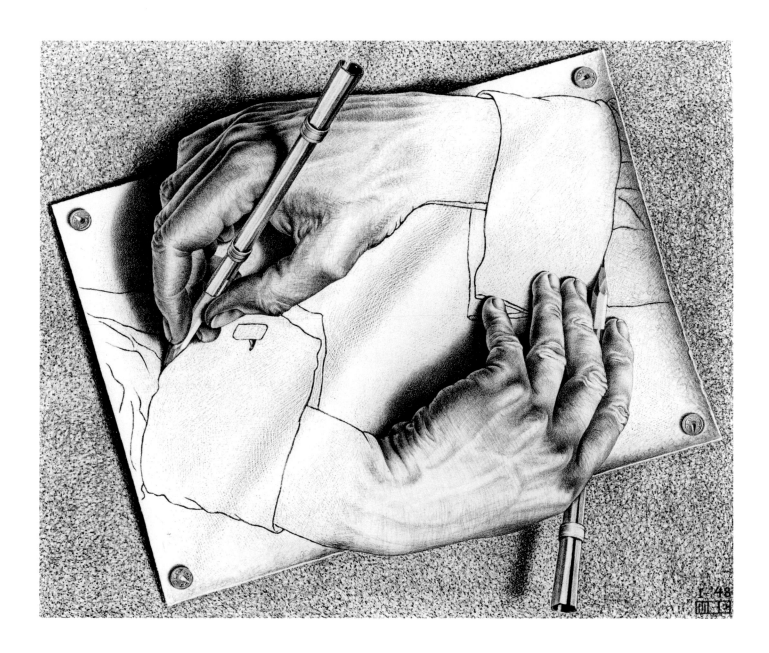

"DRAWING HANDS," LITHOGRAPH, 1948, 11 × 13 INCHES (28 × 33 CM)

This is arguably the most well-known of Escher's great masterpieces, and its essential concept has often been copied by other artists. Escher was drawn to the illusion of two-dimensional drawings in perspective suggesting three-dimensional objects. He was intrigued by this visual conflict, and expressed the transition in a number of prints, such as this one.

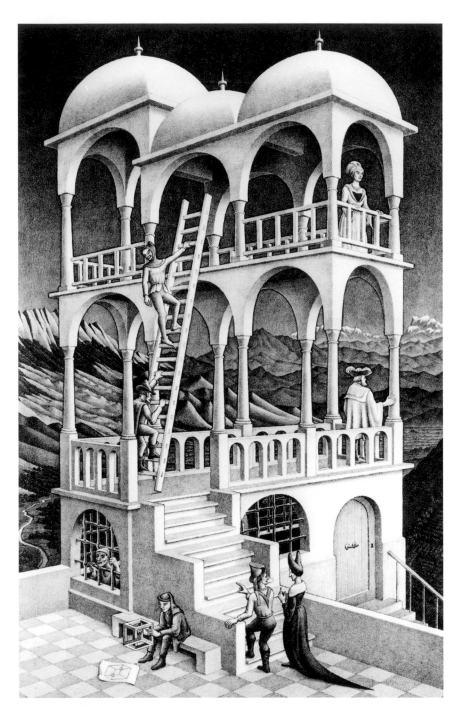

"BELVEDERE," LITHOGRAPH, 1958, 18 × 11¹/₂ INCHES (46 × 29.5 CM)

This is Escher's first impossible print. The top floor of the Belvedere, while parallel to the first floor, is turned 90 degrees, and pillars connect back to front in this most strange construction. The sitting man is holding an impossible cube. In the lower left foreground lies a drawing of the cube. Two small circles mark the places where edges cross each other. Escher asks, "Which edge comes at the front and which at the back? In a three-dimensional world simultaneous front and back is an impossibility and so cannot be illustrated. Yet it is quite possible to draw an object which displays a different reality when looked at from above and from below. The lad sitting on the bench has got just such a cube-like absurdity in his hands. He gazes thoughtfully at this incomprehensible object and seems oblivious to the fact that the belvedere behind him has been built in the same impossible style. On the floor of the lower platform, that is to say indoors, stands a ladder which two people are busy climbing. But as soon as they arrive a floor higher they are back in the open air and have to re-enter the building. Is it any wonder that nobody in this company can be bothered about the fate of the prisoner in the dungeon who sticks his head through the bars and bemoans his fate?"

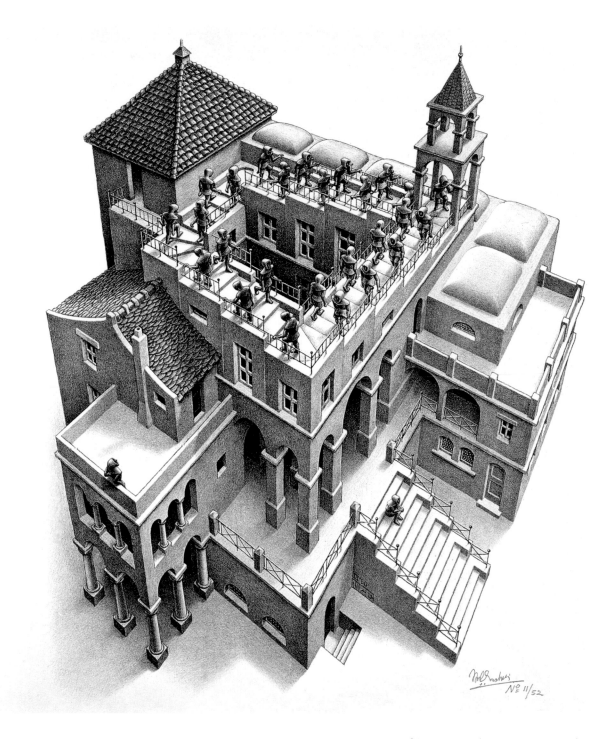

"ASCENDING AND DESCENDING," LITHOGRAPH, 1960, 10 × 11¹/₂ INCHES (25.5 × 28.5 CM)

This work by M. C. Escher is based on Lionel Penrose's impossible staircase. If you follow the steps around, you will locate neither the lowest or the highest step. The figures on the steps are monks. Escher drew the staircase in perspective, which would indicate another size illusion. The monks who are descending should appear gradually smaller, and the ones who are ascending should get larger. They don't. Although Escher was usually very exact in his perspective, in this case he was prepared to cheat a little bit. Escher spoke about the plight of the monks, "The inhabitants of these living quarters would appear to be monks, adherents of some unknown sect. Perhaps it is their ritual duty to climb those stairs for a few hours each day. It would seem that when they get tired they are allowed to turn about and go downstairs instead of up. Yet both directions, though not without meaning, are equally useless. Two recalcitrant individuals refuse, for the time being, to take any part in this exercise. They have no use for it at all, but no doubt sooner or later they will be brought to see the error of their nonconformity."

Shigeo Fukuda

(1932-)

ABSORBI

"We live dangerously in the world that Fukuda fashions. Reassured and satisfied by a first perception, we may be shaken by the second image, which suddenly turns us head-over-heels."
—FRANÇOIS BARRÉ

"Fukuda has effectively created a universal persuasive power by which anyone from any country can understand his message. He presents us with a developed sense of humor through his forms of 'visual scandal' which comprise his own creative originality, visual expression, and power of forms."
—YUSAKU KAMEKURA

Japanese graphic artist Shigeo Fukuda is without parallel in the world of illusionary art and design and is a master of *absobi*—a concept that combines both play and space. His mastery of design and prolific output have earned him an international reputation. His works cover a wide range of media, including illustrations, graphic posters, three-dimensional sculptures, environmental design, and monuments. Many of his works, both two- and three-dimensional, involve optical tricks and illusions, and in this area he has exploited anamorphoses, impossible figures and objects, figure/ground reversals, composite images, shadow sculptures, and accidental alignments.

"MONA LISA'S HUNDRED SMILES," GRAPHIC POSTER, 1970, $40^{1}/_{2} \times 28^{1}/_{2}$ INCHES (103 × 73 CM)

This was a poster for an exhibition of 100 competitive works for Makoto Nakamuru. One "Mona Lisa" was changed graphically in various ways by using several different kinds of photoengraving techniques. This poster uses one of these techniques.

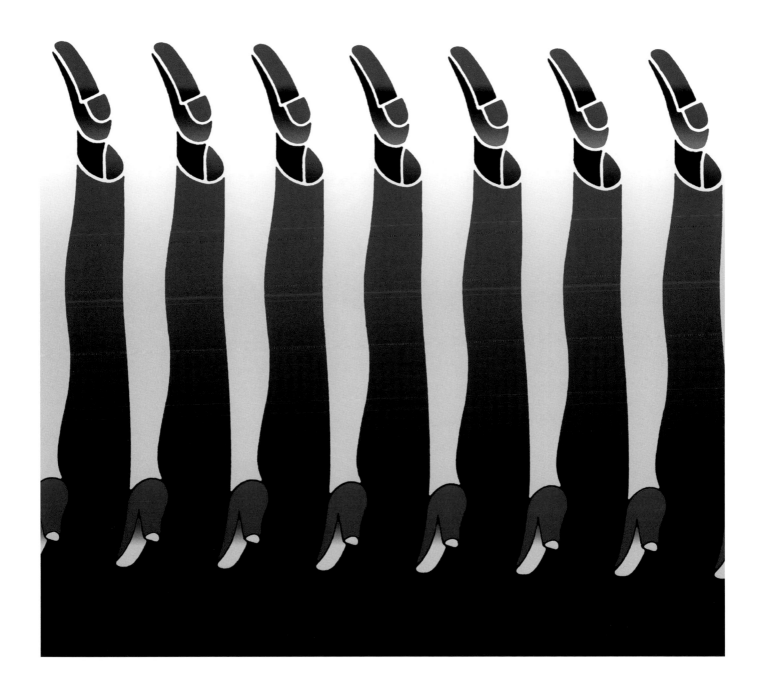

"LEGS OF TWO DIFFERENT GENDERS," SILKSCREEN, 1975, 5 × 28¹/₂ INCHES (13 × 72.5 CM)

Fukuda is internationally renowned as a graphic artist and designer. Lying at the core of many of Fukuda's graphic designs are the fundamental principles of figure/ground relationships, especially ones that are ambiguous. In this work, Fukuda cleverly creates not only an ambiguous figure/ground perceptual reversal, but one that is also simultaneously impossible. This poster was created for his private exhibition at the Keio Department Store in 1975, where he had an early exhibition of his graphic work.

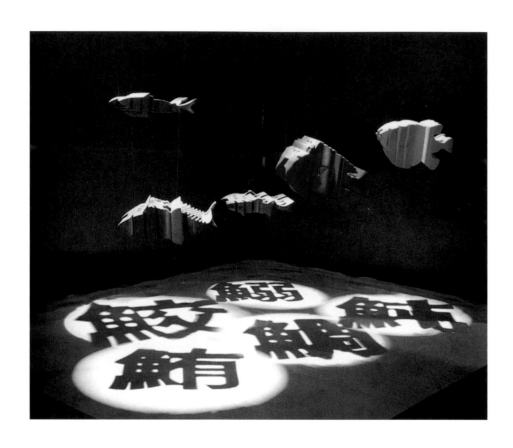

"Aquarium for Swimming Characters," wood, 1988, 122 × 112 × 97½ inches (310 × 285 × 248 cm)

Here the shadow of fish (sea beam, sardine, tuna, globe fish, and shark) reveal themselves in Chinese characters.

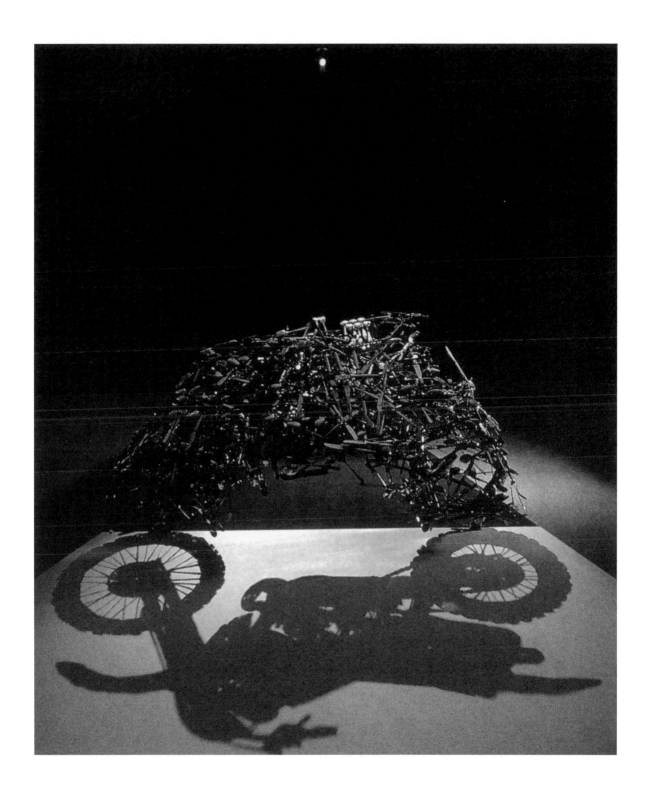

"LUNCH WITH A HELMUT ON," WELDED FORKS, KNIVES, SPOONS, 1987,
73 × 31 × 42¹/₂ INCHES (186 × 79 × 108 CM)

This shadow sculpture of a motorcycle is built entirely out of 848 welded forks, knives, and spoons. It is based on an earlier concept that Fukuda exhibited in his 1965 show, "Toys and Things Japanese." Fukuda wanted to create a three-dimensional object in which the shadow, as opposed to the actual form, represented the object. Fukuda was to remark that it is extremely difficult to create a three-dimensional object in this fashion that allows light to penetrate evenly.

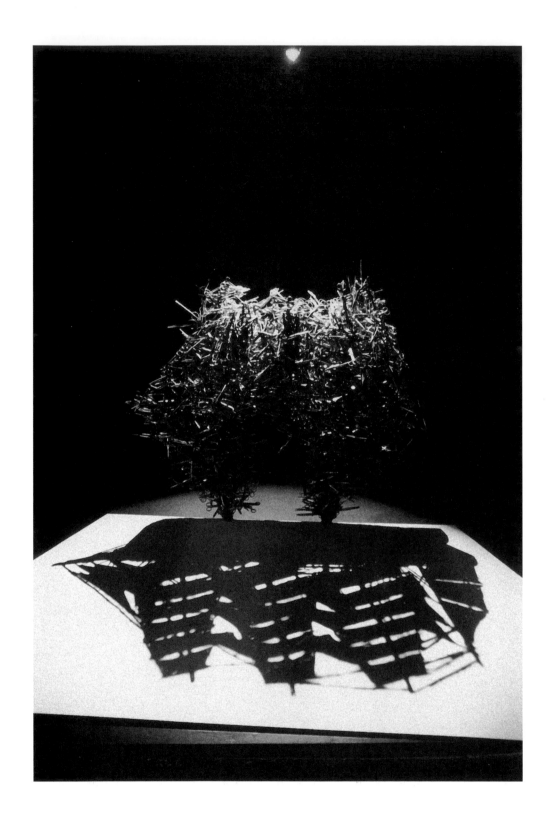

"ONE CANNOT CUT THE SEA," WELDED SCISSORS, 1988, 122 × 112 × 97^1/$_2$ INCHES (310 × 285 × 248 CM)

After the success of his "Lunch with a Helmut On," Fukuda was commissioned to work on another shadow sculpture. He obtained the rigging plan of the M.S. *Shin-Nippon Maru*, and told his collaborator that he wanted to create an image with metal scissors. There was no response for days. Unbelieveably, however, Fukuda completed the work after only one week. He used 2084 scissors to complete the ship.

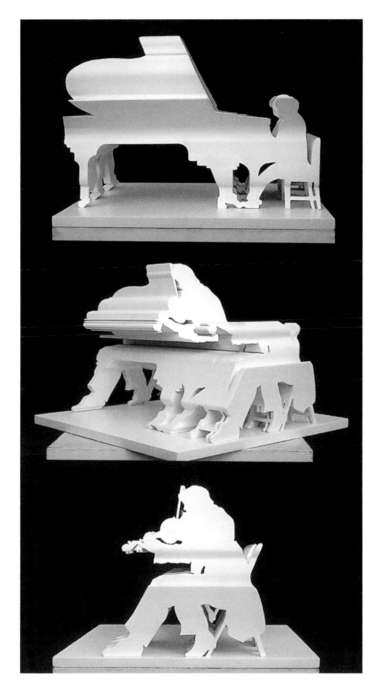

"ENCORE," SCULPTURE IN WOOD, 1976, $19^{1}/_{2}$ × $19^{1}/_{2}$ × $11^{3}/_{4}$ INCHES (50 × 50 × 30 CM)

From one angle, the sculpture depicts a pianist, as seen in the top photo. But if you turn it by 90 degrees you will see a violinist, as seen in the bottom photo. The middle photo shows an intermediate point of view, where you can see how the pianist transforms into the violinist. This wood sculpture consists of two silhouettes (the pianist and the violinist) at 90-degree angles to each other. In fact, you can create an endless variety of these silhouette sculptures simply by carefully cutting a block from two different silhouettes at 90-degree angles to each other. Fukuda has made a large number of sculptures using this technique, and his discovery of this principle led to the first incarnation of his work in three-dimensional forms. "Encore" is part of a series of metamorphosing musicians captured at different stages of a concert.

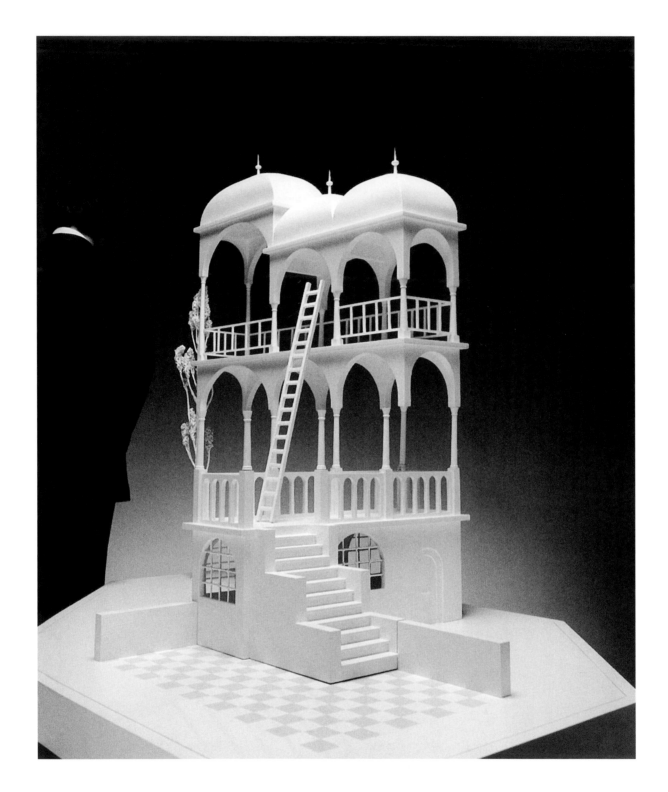

"THREE-DIMENSIONAL MODEL OF ESCHER'S BELVEDERE," SCULPTURE IN WOOD, ACRYLIC PLASTIC, 1982,
$43^1/_4 \times 64 \times 43^1/_4$ INCHES ($110 \times 162.5 \times 110$ CM)

This is Fukuda's first attempt to sculpt an impossible figure. It is a three-dimensional realization of the building depicted in M. C. Escher's classic print "Belvedere."

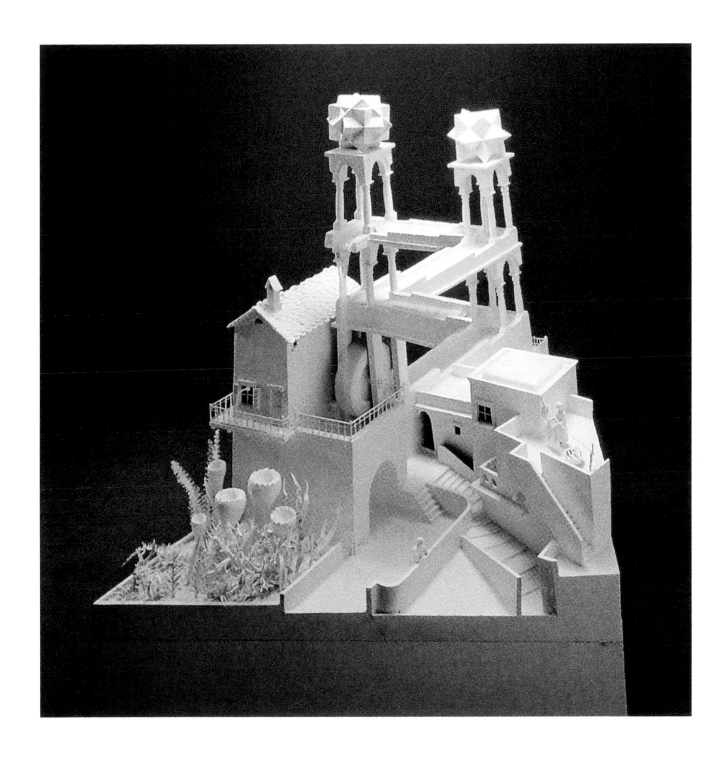

"THREE-DIMENSIONAL MODEL OF ESCHER'S WATERFALL," SCULPTURE IN WOOD, 1985,
59 × 59 × 59 INCHES (150 × 150 × 150 CM)

This is a physical construction of M. C. Escher's famous print of an impossible building, "Waterfall." This sculpture works with flowing water, which appears to run up the ramp and over the turning waterwheel, only to continue the process in a never-ending cycle of redundant motion.

Rob Gonsalves

(1959–)

MAGIC REALISM

"I believe that there is real magic in life. Sometimes the experience of it can be dependent on one's point of view. I have come to see the making of art as the search for that point of view where the magic and wonder of life appears not so much as an illusion, but as an essential truth that often gets obscured."
— ROB GONSALVES

ROB GONSALVES IS A highly original artist without peer in the artistic representation of illusionary worlds. Although one can definitely see the influences of René Magritte, M. C. Escher, Remedios Varo, and Chris Van Allsburg in his work, many of the illusionary perspective concepts as well as the "magical style" of presentation are unique to him. Many people have labeled his art as surrealistic, but Gonsalves believes that his work differs from pure surrealism because it is deliberately planned and makes the viewer think. His ideas are largely generated by the external world (which many surrealists try to ignore) and involve recognizable human activities combined with carefully planned illusionistic techniques. Gonsalves tries to inject a sense of magic into otherwise realistic scenes, thereby expressing the human desire to believe in the impossible. As a result, the term "Magic Realism" has been used to describe his work.

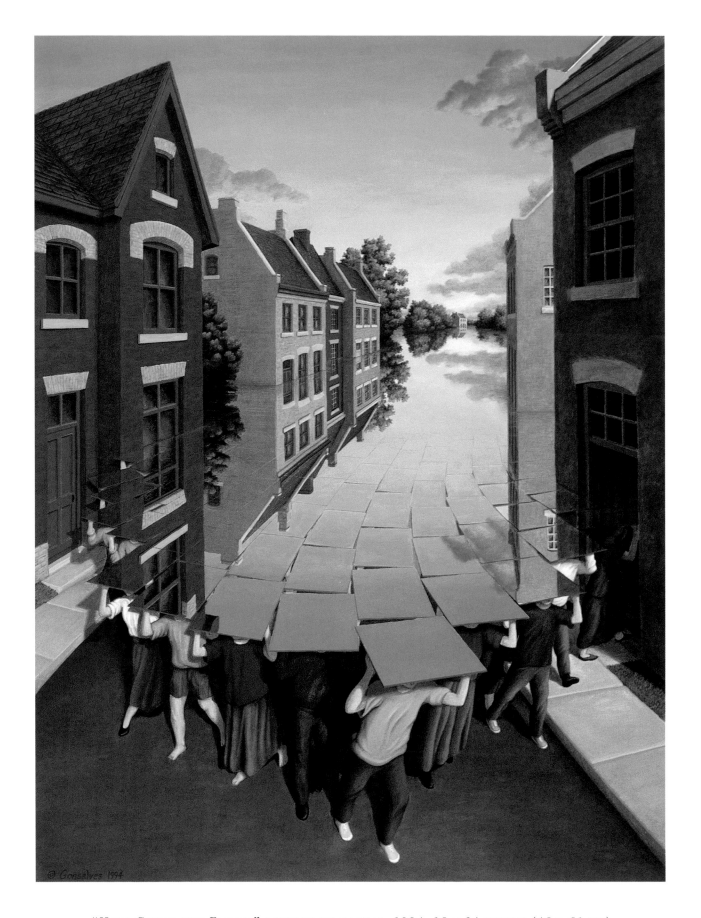

"Here Comes the Flood," acrylic on canvas, 1994, 18 × 24 inches (46 × 61 cm)

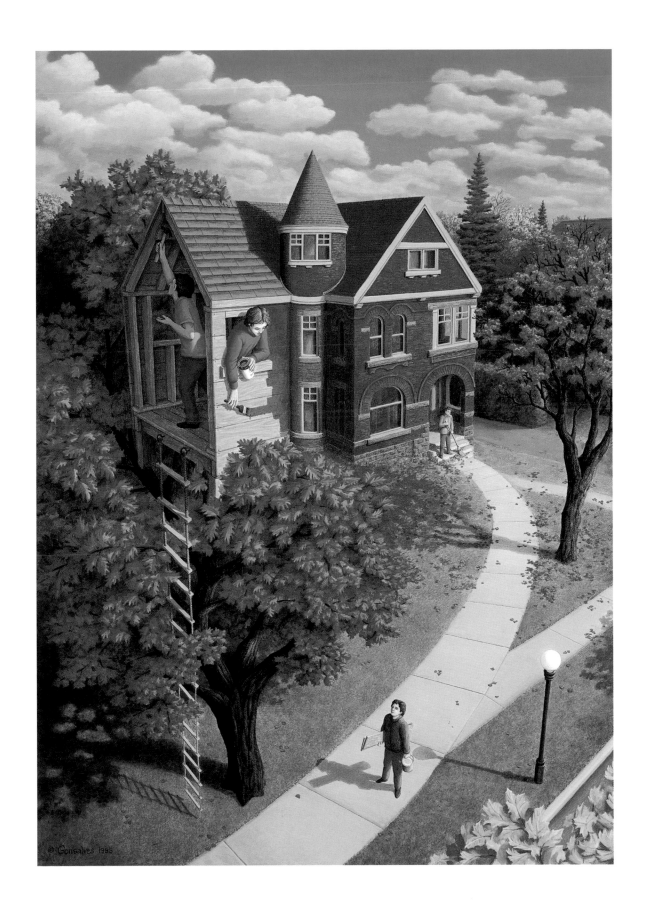

"TREE HOUSE IN AUTUMN," ACRYLIC ON CANVAS, 1995, 20 × 28 INCHES (51 × 71 CM)

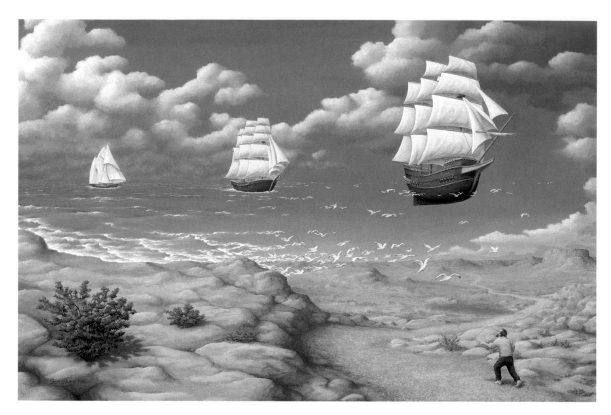

"In Search of Sea," acrylic on canvas, 1995, 34 × 22 inches (76 × 56 cm)

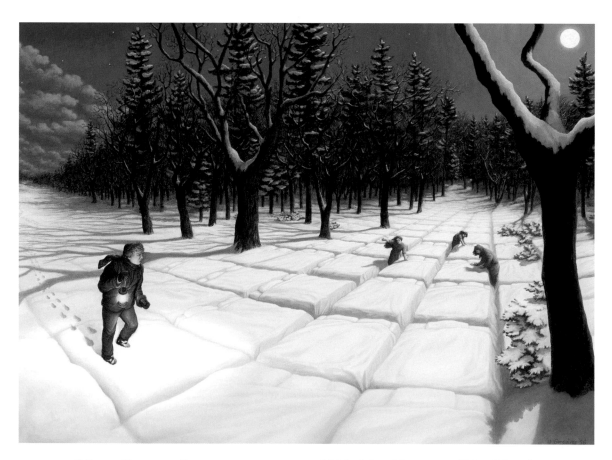

"Cold Comfort," acrylic on canvas, 1996, 34 × 22 inches (76 × 56 cm)

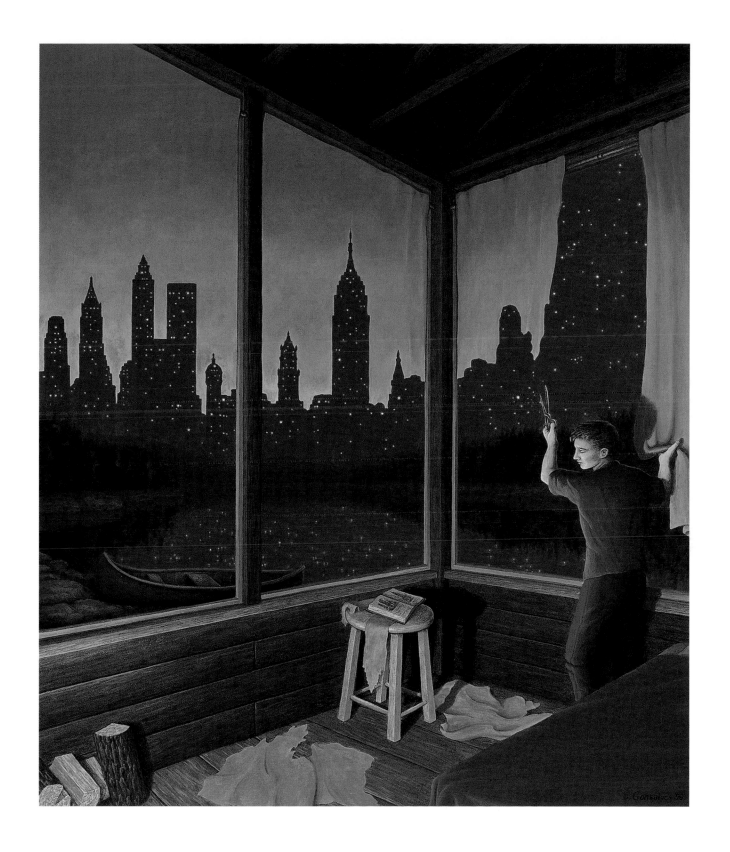

"A Change of Scenery," acrylic on canvas, 1996, 24 × 28 inches (61 × 71 cm)

Outside the windows of the young man's country home, one can see a tranquil setting of a lake, boat, forest, and star-filled night. The young man creates a "change of scenery" by cutting the drapes so that the outline is of an urban city scene. The star-studded night becomes the city lights at night.

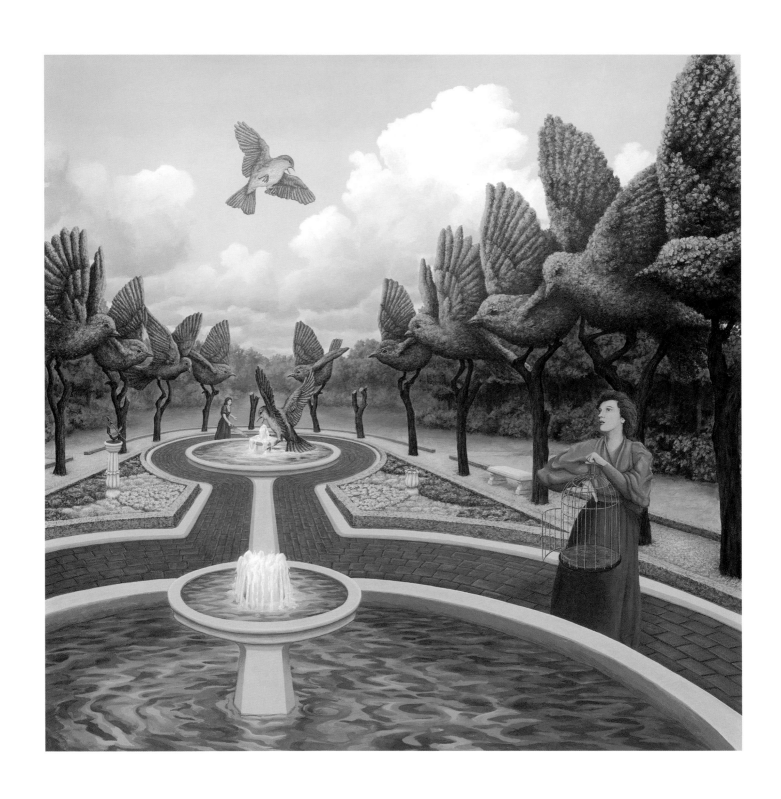

"Roots and Wings," acrylic on canvas, 1997, 26 × 26 inches (66 × 66 cm)

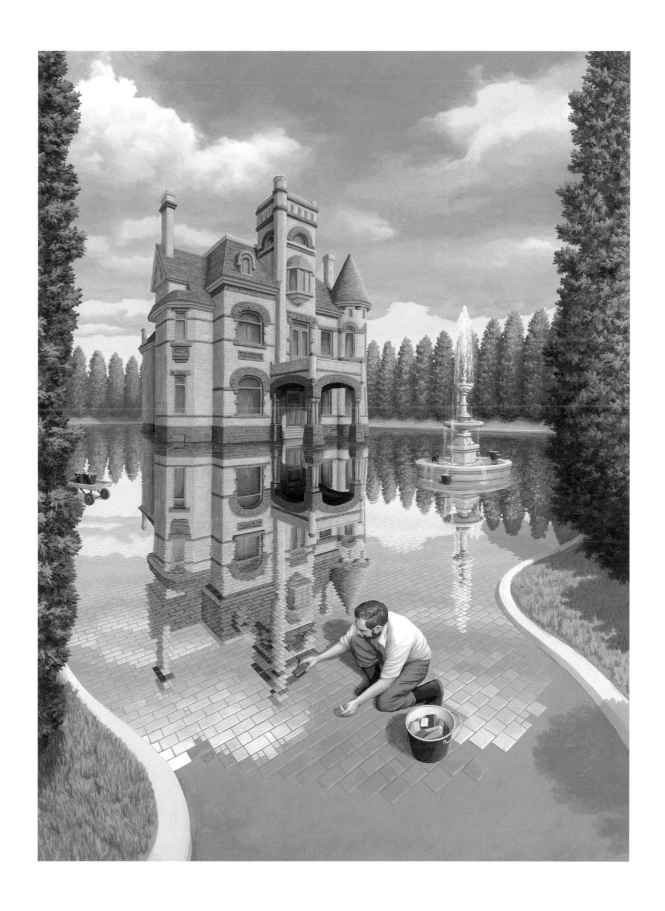

"The Mosaic Moat," acrylic on canvas, 1998, 22 × 30 inches (56 × 76 cm)

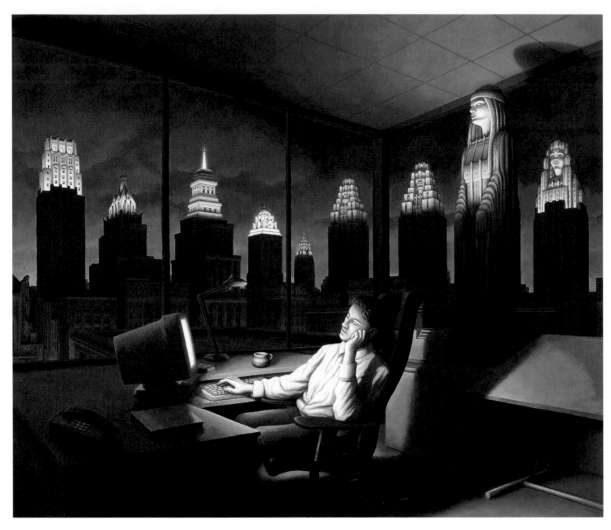

"The Night of the Late Night," acrylic on canvas, 1999, 28 × 24 inches (71 × 61 cm)

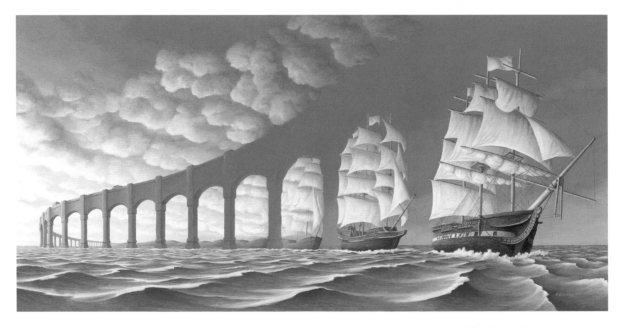

"The Sun Sets Sail," acrylic on canvas, 2001, 40 × 20 inches (101.5 × 51 cm)

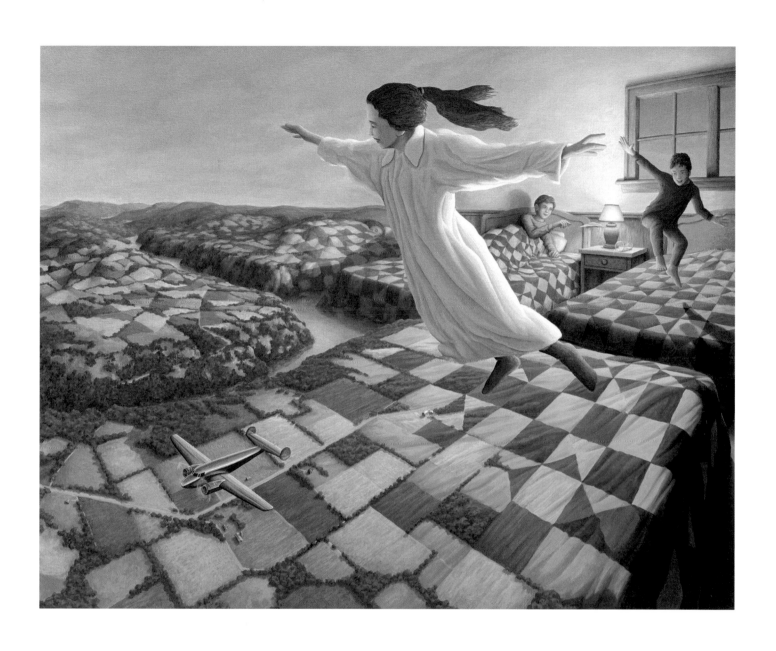

"Bedtime Aviation," acrylic on canvas, 2001, 30 × 24 inches (76 × 61 cm)

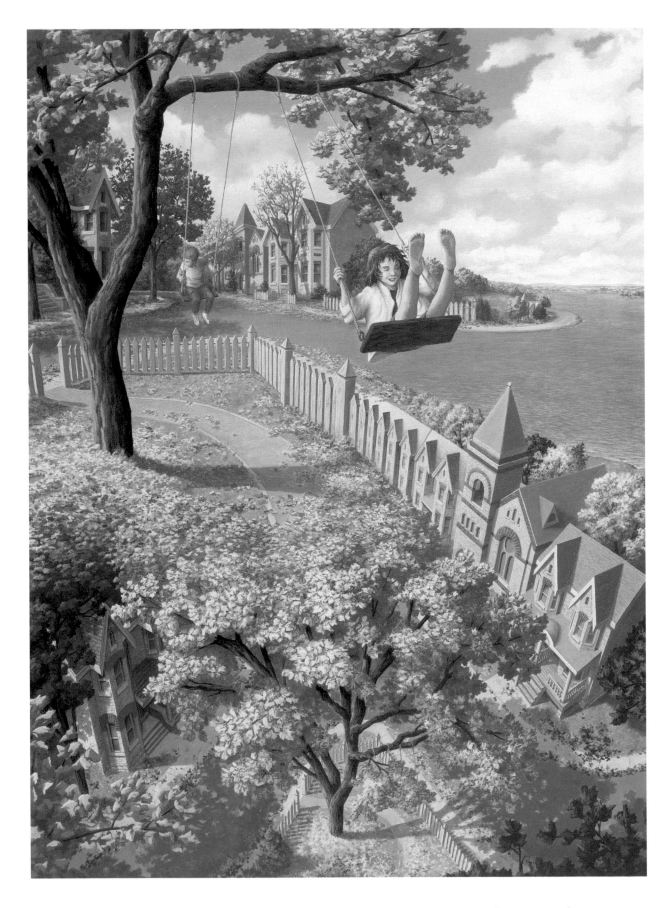

"On the Upswing," acrylic on canvas, 2001, 22 × 32 inches (56 × 81 cm)

Mathieu Hamaekers

(1954–)

OPTICAL CONSTRUCTIVISM

"For me as an artist, it is important that my works are not just a trick or a rational solution of a problem, but that they have a strong aesthetic component."

—MATHIEU HAMAEKERS

BELGIAN ARTIST MATHIEU HAMAEKERS' sculptures really need to be physically seen to be fully appreciated. When you turn the sculpture or walk around it, you will see something totally unexpected. The sculpture transforms itself in a way that you do not expect, leading to a shock or surprise in the viewer, while at the same time remaining a beautiful work of art.

Hamaekers was brought up in an environment that fostered from a young age an appreciation of art and form. His father, a respected carpenter, encouraged him to gain hands-on experience in three-dimensional creativity by building things. His mother strongly influenced his appreciation of aesthetics and the value of form. When he was seventeen, he was deeply influenced by a documentary about the life and work of M. C. Escher, and in particular, his use of the impossible triangle. The next year he decided to pursue a career in art and attended the Academy for Visual Communication and Design in Ghent.

While attending the academy, he created transparent glass structures combined with mirrors as an experiment in perspective. His works at that time showed a deep understanding of perspective, and his talents were immediately recognized. In 1976 he received a National award for Line, Color, and Form for the art he produced at the Academy.

Upon graduation, Hamaekers attended the International University of Lugano. This experience had a tremendous impact on him, and he became deeply intrigued by conceptual and minimal art. It was also at this time that he started to develop his own art form, which he called "Optical Constructivism." During this period, his mind kept being drawn back to the impossible triangle and to other impossible figures. He wanted to see if it was possible to construct these figures in three dimensions. Yet he did not want only to work out an optically correct shape but to build a structure that would be aesthetically pleasing as well. Over the next few years, he developed a mathematical system of projective geometry to hone the shape of these types of structures in three dimensions. He

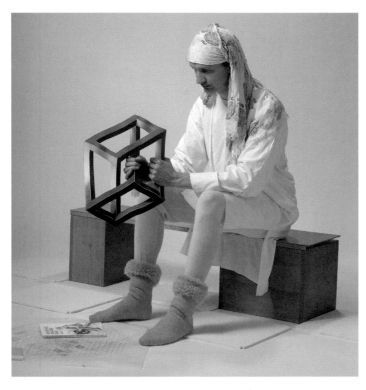

Hamaekers holds an impossible cube, which is based on the figure in M. C. Escher's print "Belvedere," in 1985.

made use of lines, curves, and forms to allow for the most minimal representation of the idea behind the form—not only in its structure, but also in its material. No ornament except color was used. As stated, "It is using this new geometry that I could find new structures, new sculptures that were unimaginable before. My sculptures represent form in its purest essence, and may be the basis for a better and more beautiful form of world."

His first impossible sculpture was based on the impossible cube found in M. C. Escher's print "Belvedere." It was made from colored paper, which at a specific viewing angle would project the image of an impossible cube made out of straight edges, but from any other would reveal its true shape.

Hamaekers's sculptures have been exhibited all around the world, and there is a three-meter-high impossible triangle called "Unity," which he constructed in 1995 outside his studio in Ophoven, Belgium.

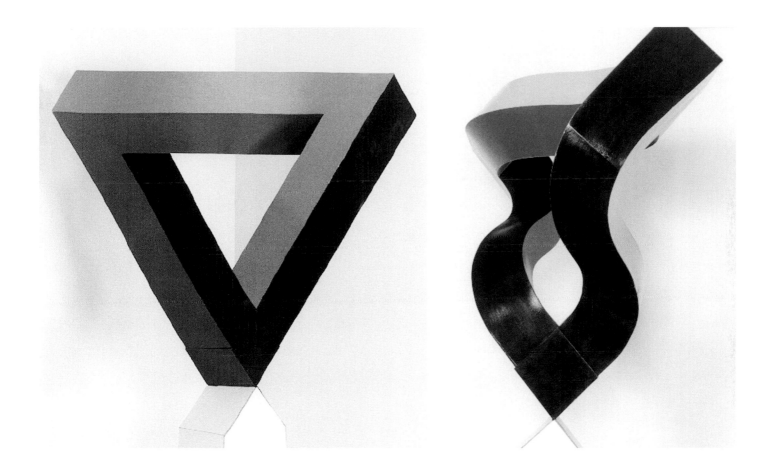

"IMPOSSIBLE POSSIBILITY," PAINTED WOOD AND POLYESTER, 1984

This sculpture is based on the impossible triangle by Roger Penrose. From another angle, its true shape is revealed.

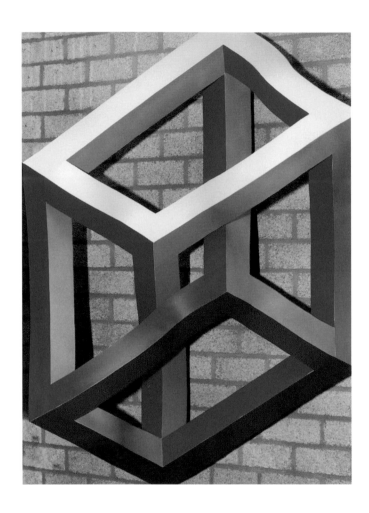 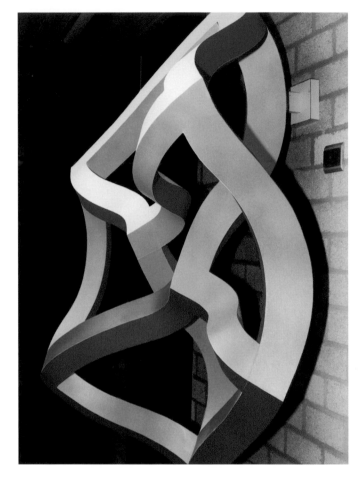

"Impossible Cube," painted wood and polyester, 1984

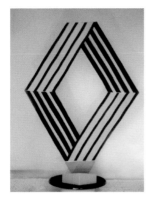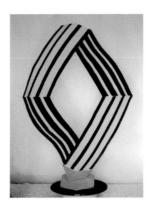

"Impossible Diamond," painted wood, 1984

The sculpture is turned to reveal its true shape.

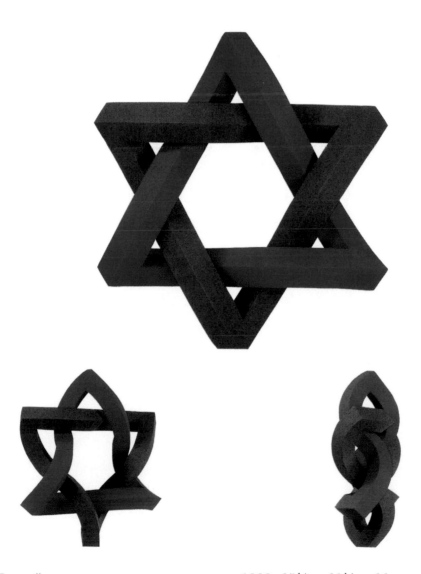

"Geometrical Love," painted wood and polyester, 1989, $35^{1}/_{2} \times 31^{1}/_{2} \times 11$ inches ($90 \times 80 \times 28$ cm)

of visual problem solving guide me into uncharted visual waters. As a print artist, Escher worked with the most basic elements of black and white, line and form, producing work in multiple editions for a wide audience. I work with the stark black and white forms of type, producing work for print, video and software. Like Escher, my work often veers into the realm of graphic design; I often produce work for titling and illustration.

While many ambigrams are verbally symmetric (the word reads the same in both directions, like "mom"), verbally asymmetrical ambigrams (the words are different, like "mom" and "wow") allow the ambigrammist to include a double meaning in the design. In addition, a large number of words have *reflective symmetry*. This term refers to words that can be read normally, and reflected from a mirror. Working with typefaces creates challenges different from working with natural forms. Kim writes,

> Typefaces bridge the worlds of words and the world of images. Names are especially rich subjects for visual treatment, since we identify them so closely with people. Escher produced several works that played visual tricks with language, but he never pursued it deeply.

Kim was born in 1955 and raised in Los Angeles, where in his teens he began designing and creating highly original mathematical puzzles, a number of which were discussed in Martin Gardner's Mathematical Recreations column in *Scientific American*. Kim was accepted into Stanford, University, where he received a bachelor of arts in music and earned a self-designed Ph.D. in Computers and Graphic Design. It was also during this time that he developed an interest in the use of computers for designing typefaces, a field pioneered by his friend and mentor at Stanford, Donald Knuth. Kim's interest and passion for design and typeface led him to experiment with unusual letter formations that displayed various mathematical and unexpected symmetries.

For years Kim amused his friends and acquaintances with his unique talents, but remained relatively unknown until he came to the attention of Scot Morris, who in 1979 publicized Kim's creations in *Omni*. Later that year, in Douglas Hoftstader's classic Pulitzer Prize-winning work, *Gödel, Escher, Bach*, Hofstadter acknowledged Kim's substantial contributions in the preface: "Scott Kim has exerted a gigantic influence on me. If anyone understands this book, it is Scott." Both of these publications led to a tremendous and international interest in Kim's work. In 1981 Kim published his creations in his book *Inversions*.

Since then, Kim has been continuing to create his wonderful ambigrams and "inversions." In recent years, he has used computer animation to break free of the constraints of the static page, to produce

absolutely delightful results with ambigrams and word play. He has also been employed as an independent game designer and has created some of the most original puzzle-solving computer games ever to reach the market. His other pursuits include creating stunningly beautiful educational dance performances about mathematics. He currently lives in El Granada, California (near San Francisco) with his wife Amy and his son Gabriel, and is the author of a monthly puzzle column in *Discover* magazine.

SCOTT KIM, 2001

"Gardner," 2002

Crossing Words. Created for the fifth Gathering for Gardner, honoring science and mathematics writer Martin Gardner. The "G" at the beginning of each "Gardner" becomes an "R" at the end of another "Gardner," and every "N" is also an "R."

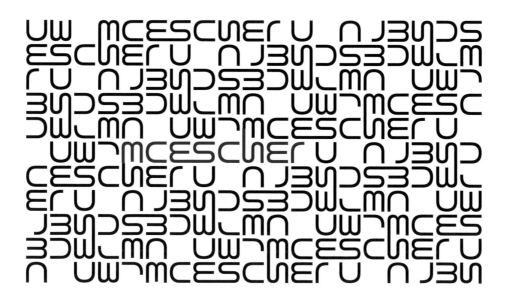

"M.C. Escher," 1981

Crossing Words. This repeating tessellating design contains "M. C. Escher" reading in four different directions. Notice that "M" becomes "E" and "S" becomes "H." Escher himself created several works that feature similar crossing words.

Akiyoshi Kitaoka

(1961–)

ILLUSION OP ART

JAPANESE VISION SCIENTIST AKIYOSHI KITAOKA is a master of optical art. He has extensively studied visual illusions, including geometric ones, light illusions, color illusions, relative motion illusions, and stereoscopic illusions, and has incorporated many new effects into his artistic pieces, creating startling results. Kitaoka views himself as a "self-styled" optical illusion artist. His creed is "a good optical illusion figure (that which gives the largest amount of optical illusion) is beautiful."

Many of his works have been published in Japan under the titles *Trick Eyes* and *Trick Eyes II*. All you have to do to see these wonderful effects is to move your eyes around the image. Most of them work best using peripheral vision, but unfortunately many of the effects also lose their impact when printed, as it is difficult to perfectly control the luminance values in the four-color printing process. It is best to see them displayed on his website, which is listed at the back of this volume.

Akiyoshi Kitaoka was born in 1961 in Kouchi Prefecture, Japan. In 1984 he received his bachelor of science degree in biology from the College of Biological Sciences Second Cluster of Colleges, and then transferred to the University of Tsukuba, where he received his Ph.D. in neu-

"FALL," DIGITAL ART, 2003

If you move your eyes around this image, the middle section appears to drift downwards, and the two outer sections appear to drift upwards.

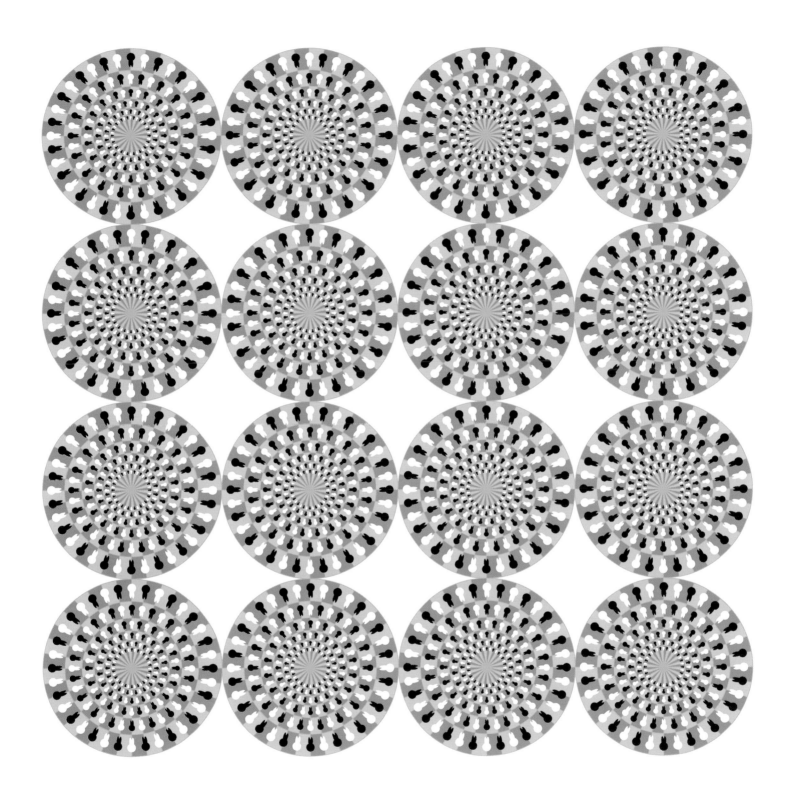

"RABBITS," DIGITAL ART, 2003

The circular wheels appear to rotate when seen in one's peripheral vision.

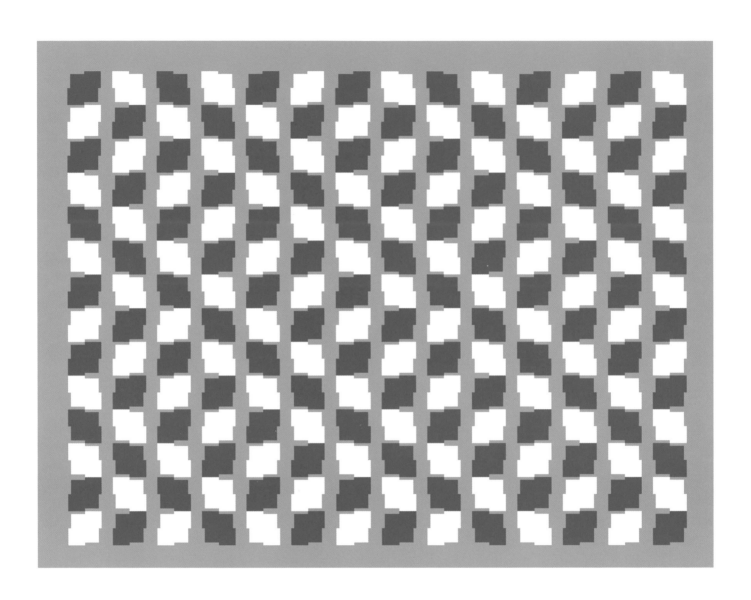

"SEAWEED," DIGITAL ART, 2003

Although the blocks are aligned vertically, the figure appears to show curves.

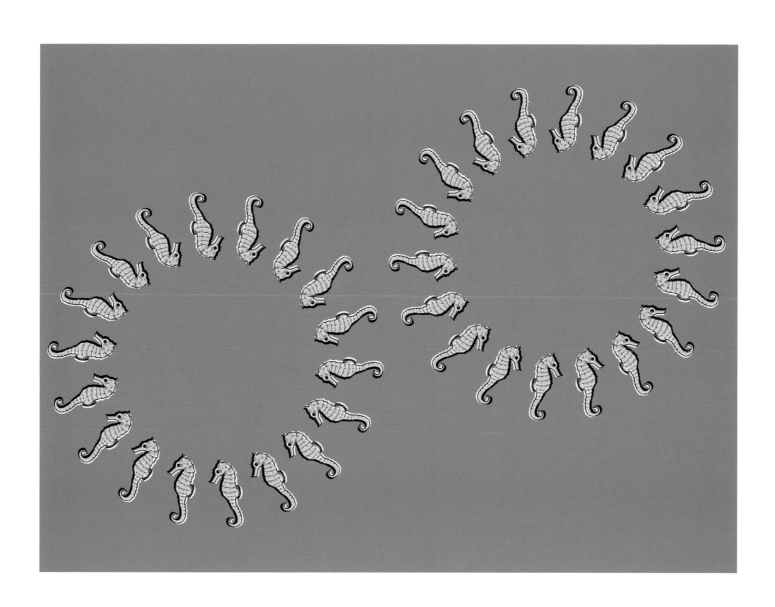

"Seahorses," digital art, 2003

The left ring of seahorses appears to rotate clockwise while the right one goes counterclockwise.

"COLOR-COATED CHOCOLATES," DIGITAL ART, 2003

Each ring of chocolate balls appears to rotate clockwise or counterclockwise.

"ROKUYO STARS," DIGITAL ART, 2003

Six white circles appear to scintillate. Moreover, red circles appear to rotate clockwise while blue ones go counterclockwise.

Rokuyo is a week made up of 6 days: *Sensho, Tomobiki, Sembu, Butsumetsu, Taian,* and *Shakko*. Lucky or unlucky days are fixed for each ceremony. For example, a *Taian* day is preferred for weddings in Japan. This illusion is based on the scintillating luster illusion discovered by Bangio Pinna, Walter Ehrenstein, and Lothar Spillman in 2002.

a different perception: from far away, most of them are portraits, but at close range each one will be perceived in an entirely different manner, where the close-up geometrical pattern is intriguing in its own right.

Since the 1990s, he has been using his own specially designed software to help create his images. Nevertheless, he is wary of this computer-aided method. "When approaching an artistic project, I still consider using the computer with some skepticism. My own advice to everyone, myself included, is to use the machine for those parts of planning and execution if and where it helps; remember that the important things are not the machines, but the artistic goals, and/or what might be learned or demonstrated—about images—or about human perception and experience. These methods should be used selectively, delicately, modestly, and non-intrusively—letting the artist's goals steer the process."

Knowlton started his career in engineering physics and received a degree from Cornell University. Later he received a Ph.D. in Communications Sciences from MIT, and then worked in the Computing Techniques Research Department at Bell Labs for twenty years. There, in 1963, he developed one of the earliest bitmap graphic systems for computer moviemaking.

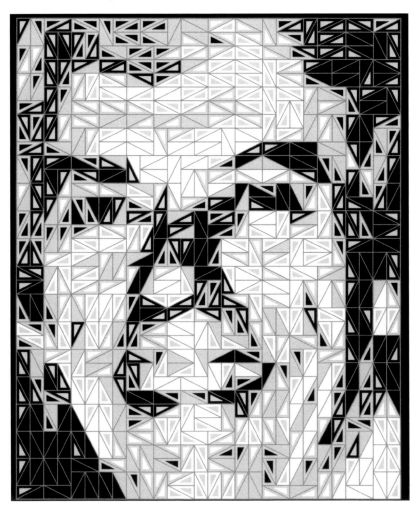

"SELF-PORTRAIT IN TRIANGLES," INK-JET PRINT, 2002

Knowlton became interested in creating mosaics on account of a prank perpetrated at the expense of Ed David, a manager working with him at Bell Labs. One day, his friend and colleague Leon Harmon came to Knowlton with a brilliant idea and wanted Knowlton's help in executing it. While David was away, both Knowlton and Harmon snuck into David's office and covered his wall with a picture made of electronic symbols of transistors, resistors, capacitors, and related components. Stepping back from the image, a viewer could see a crude picture of a reclining nude woman. Harmon and Knowlton's plan worked—perhaps too successfully.

When David came back, he was delighted at the joke, but also wor-

More viewers than they expected were apparently familiar with the subject matter and could therefore "see" the twelve-foot-wide reclining nude from as many feet away. It was therefore judged an unseemly decoration for the distinguished Bell Laboratory, and was quickly retired. Somehow, smaller versions of the image mysteriously started propagating among lab personnel. Knowlton and Harmon were called into the Lab's public relations department. Officials informed the pair that they could not associate the name of Bell Labs with the nude portrait. Later, in 1967, when the *New York Times* reprinted the image

KNOWLTON REVIEWS A LAYOUT FOR AN INTENDED PORTRAIT

(the first time they ever published a nude), the public relations department huddled and decided, so it seems, that since the picture had appeared in the venerable *New York Times*, it was not frivolous pornography after all but "real Art." Their revised statement was, "You may indeed distribute and display it, but be sure that you let people know that it was produced at Bell Telephone Laboratories, Inc."

For Knowlton, this was the beginning of a fascination with composite images that has occupied his eyes, hands, and mind ever since.

Knowlton lives in north-central New Jersey, making art, writing, being a grandfather, and generally keeping a low profile. He can sometimes be coaxed into emerging to speak about his artwork or to join a symposium on art and technology.

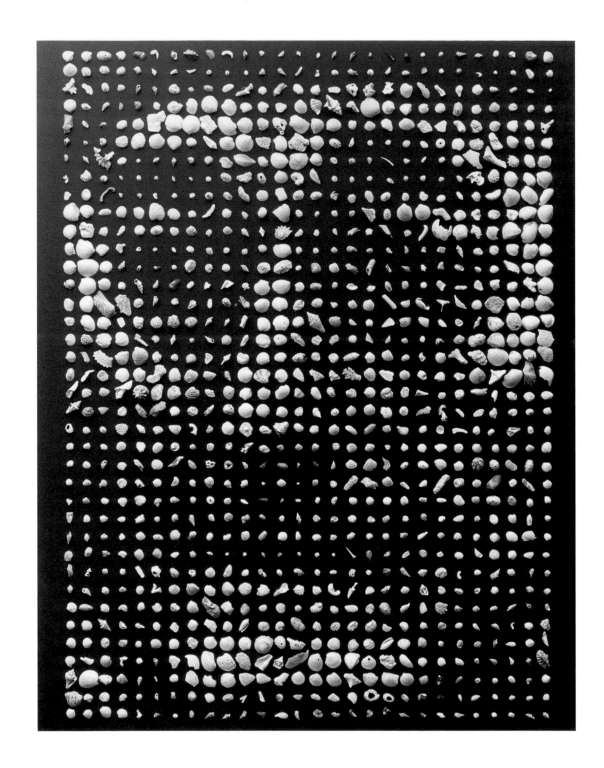

"Jacques Cousteau," unretouched seashells and miscellaneous beach debris, 1987, $59^3/_4 \times 48$ inches (152 × 122 cm)

This portrait of the late famed oceanographer Jacques Cousteau is the first of many seashell mosaics by Knowlton, and was commissioned by the Exploratorium, a hands-on science museum in San Francisco. The portrait consists of seashells and miscellaneous debris (teeth, vertebrae, coral), which were all collected by Knowlton from one small section of beach on the South side of Vieques Island. All the components are unretouched, and essentially all are white. The gray-scale effect is achieved by the percentage occupancy of the local area of the picture.

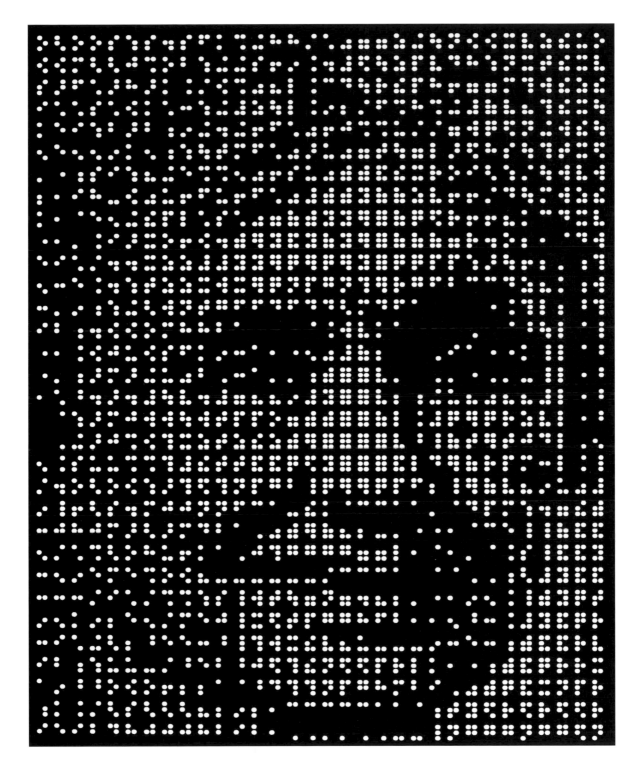

"HELEN KELLER," SIMULATED BRAILLE (PRINT), 1998, 10 × 8 INCHES (25.4 × 20.3 CM)

Visual (simulated) Braille is used by teachers preparing lessons for the blind. Here, Knowlton used its 64 characters, 16 times each, to portray Helen Keller, the second, and most notable, blind and deaf person to become admirably literate. The picture is based on a photo courtesy of the American Foundation for the Blind, Helen Keller Archives.

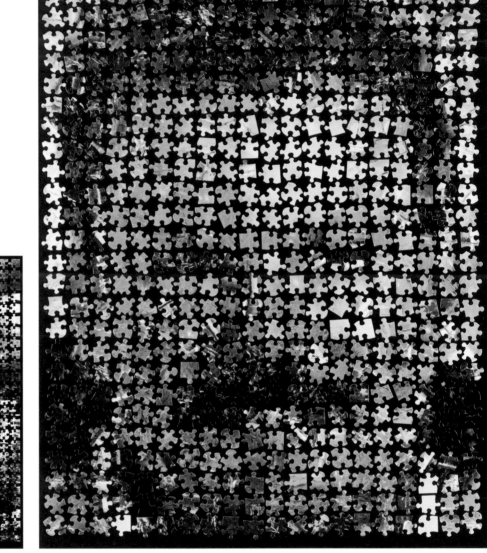

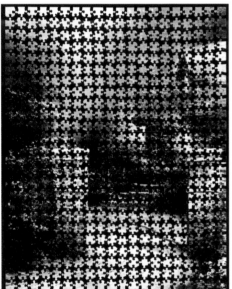

THOMAS KINKADE, "ROSE GATE,"
PUZZLE, 1996, 31 × 25 INCHES
(78.7 × 63.5 CM)

Popular American contemporary artist Thomas Kinkade is known as "the Painter of Light." Kinkade licensed his work "Rose Gate" to an American puzzle company. In the image above, the puzzle pieces are correctly arranged, but not joined together. Knowlton, using another copy of the same puzzle, sorted all of the individual puzzle pieces according to light, color, and value.

"THOMAS KINKADE REVEALED," UNRETOUCHED PUZZLE PIECES, 1999,
31 × 25 INCHES (78.7 × 63.5 CM)

After Knowlton had sorted the puzzle pieces, he rearranged them, against a black background, to form the portrait of Kinkade. In this way, the artist was discovered in his own work.

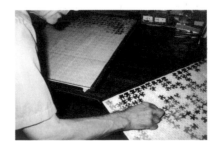

SETTING THE PUZZLE PIECES FOR THE
PORTRAIT OF THOMAS KINKADE

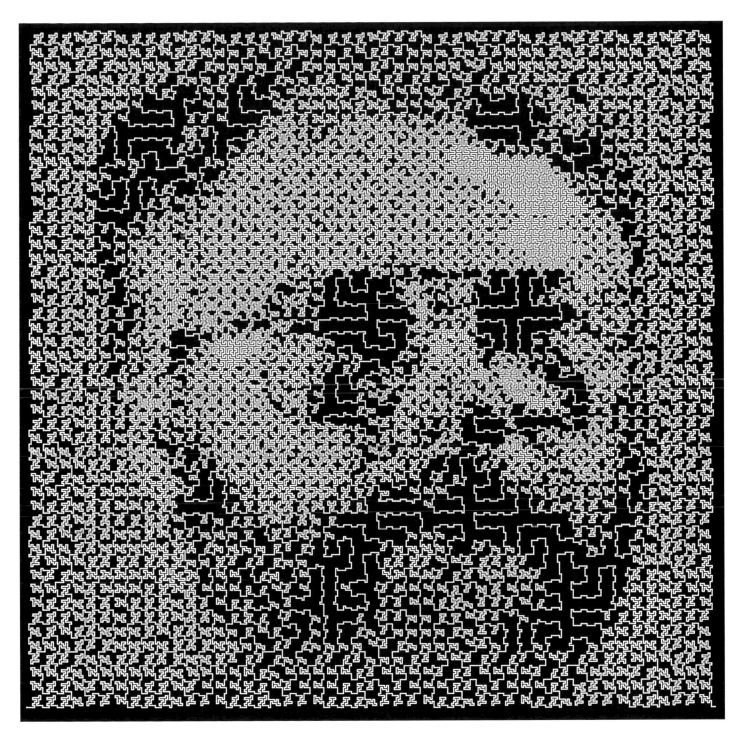

"PORTRAIT WITH A SINGLE LINE," SPACE-FILLING CURVE, INK-JET PRINT,
2000, 8 × 8 INCHES (20.3 × 20.3 CM)

This is a portrait of Douglas McKenna, who discovered several families of strictly tiling, self-avoiding, space-filling curves. Be sure to look at the portrait from a distance, and then as closely as you can. It is composed of 38,291 straight-line segments joined at right angles. The portrait is based on the photo by Jef Raskin.

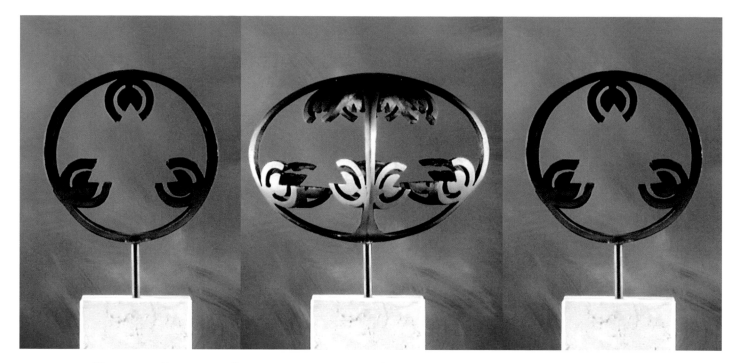

"INVISIBLE PYRAMID 1," CAST BRONZE, 2001, $8^{1}/_{4} \times 8^{1}/_{4} \times 7^{1}/_{2}$ INCHES ($21 \times 21 \times 19.5$ CM)

This sculpture depicts a pyramid with illusory contours. The pyramid can be perceived, even though there are no edges to define it. The Italian vision scientist Gaetano Kaniza first described illusory contours.

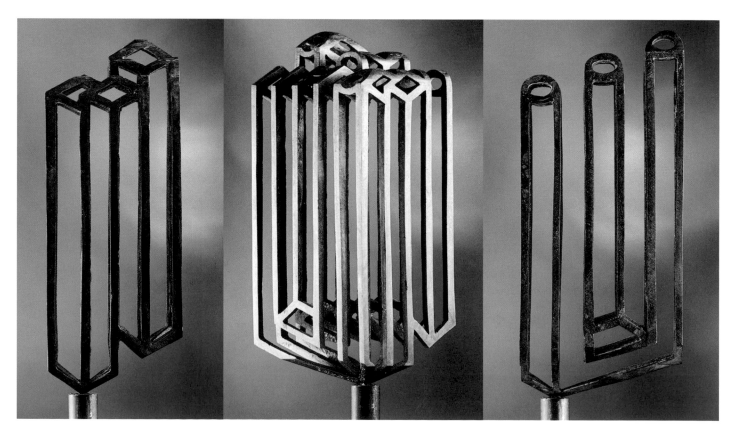

"IMPOSSIBLE PILLARS AND TRIDENT," CAST BRONZE, 2001, $4^{1}/_{4} \times 5 \times 11^{3}/_{4}$ INCHES ($11 \times 13 \times 30$ CM)

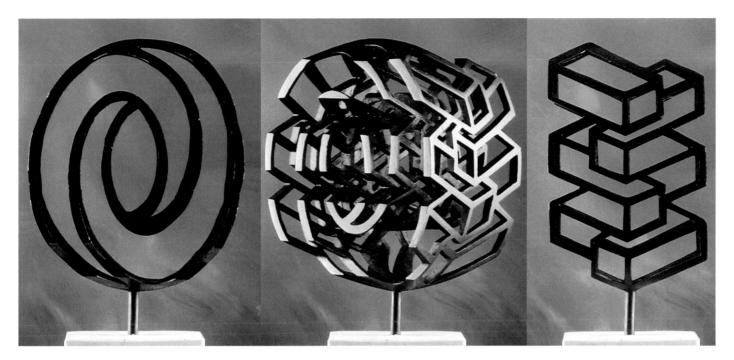

"IMPOSSIBLE OVAL AND PILLARS," CAST BRONZE, 2001, $3^1/_2 \times 7^3/_4 \times 9^1/_2$ INCHES ($9 \times 20 \times 24.5$ CM)

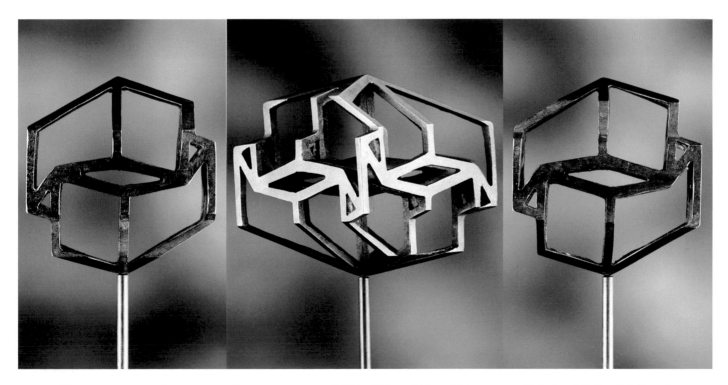

"AMBIGUOUS TO AMBIGUOUS," CAST BRONZE, 2001, $5^1/_4 \times 5^1/_4 \times 5^3/_4$ INCHES ($13.5 \times 13.5 \times 14.5$ CM)

This sculpture is based on the ambiguous and impossible figure by Thíery, in which the bottom can also be perceived as the top.

memory so that the connections are not literal, but intuitive. Muniz wants to depict "pictures of thought"; therefore, his work is not that of a copyist or a virtuoso of pictorial memory. His idea is to use existing images as a kind of cover/camouflage for conveying deceptively simple ideas that in fact raise numerous questions and contain several levels of interpretation—to break in, as it were, to the general storehouse of visual memory. As Muniz says,

> The power of the image lies in its ability to be underestimated. They're sweet, simple things. You think you know what you're looking at. What I wanted to do is make images not transparent, but opaque, using these bad actors—soil, sugar, thread—to create a series of layers and make it a little harder for the viewer to get to the subject. In this way you engage the viewer in an analytical relationship to the image that hopefully will work as a vaccine. These images are like little antibodies; they change the perception of all images in their own class.

Muniz does not view himself as much as an artist so much as a photographer.

> I am a photographer because my work ends up being a photo. For example, the Sugar and Soil series have a lot more to do with photography itself: the idea that the image is composed by a certain logical arrangement of tiny dots that we can't perceive individually.

His choice of materials is meant to be provocative.

> I usually choose to work with perishable or unstable materials because I want to emphasize the temporal element in every picture. They are records of short performances, about a second long, enacted exclusively for the lenses of my camera . . . I don't try to attract any attention to the mundane aspect of the materials I use. I just don't discriminate. All materials are good for something in a picture, be it oil paint or elephant excrement. It's interesting how people become amused by a shift in medium.

> Art for me is not about saying things. It's about discovering ways to say them. Basically, I am trying to compound an epistemology of flattened visual forms. All these things, while they remain photographic objects, they attempt to make the viewer examine the role of representation as an exchange and interaction of forms rather than an improvement on a specific one. There's no way to discover without being involved in the making of it, and through the process, you start to realize the mechanics of representation and you start to use them better. I think the end result is just the beginning of a narrative that moves backward in time. For

me, an interesting work of art has to have this quality that when you look at it for the first time, you wonder how it was done.

Vik Muniz was born in 1961 and grew up in São Paulo, Brazil. Although he drew compulsively as a child, he was reared in a working class family, so it never occurred to him to become an artist. He spent his early years doing a variety of menial odd jobs, which were later to become an important influence on his life and work. In Brazil, he studied advertising, and worked for an advertising agency. In 1983, he moved to the United States with the insurance money that he got from an accident—he had tried to intervene in a fight and was shot in the leg. At the time, he could not speak a word of English.

Muniz's early work consisted of sculptural installations, but in the late 1980s, he started to incorporate photography into them. The year 1991 brought a breakthrough, when he created a photographic series called *The Best of Life*, in which he made pencil drawings, from memory, of several world-famous photographs and then photographed his drawings. In 1993 he started a series of photographs of cotton that he had formed into ambiguous, cloudlike forms. He has also worked on large installations in earth, which can only be seen from a vast height. Over the past decade, he has been featured in innumerable international shows, and has been the recipient of as many prestigious awards. Most recently he has been making art that his mother likes, but Muniz admits, "I don't know if this is good or bad."

Muniz lives and works in New York City.

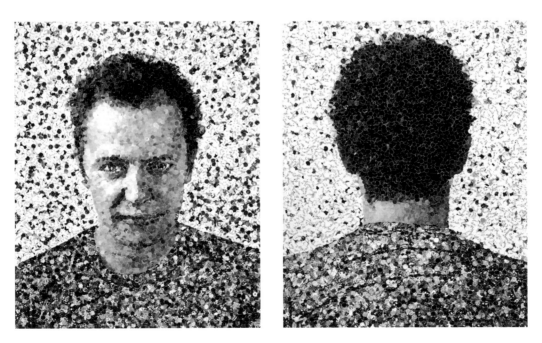

SELF-PORTRAIT OF THE ARTIST, FRONT AND BACK, MADE OUT OF MAGAZINE CONFETTI, 2003

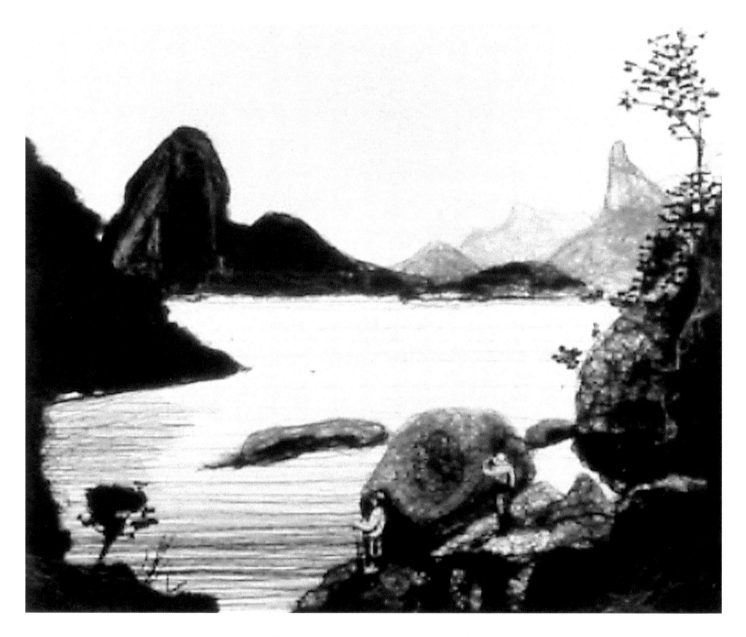

"GUANABARA BAY SEEN FROM NITEROI, AFTER MARK FERREZ," GELATIN SILVER PRINT, 1996,
20 × 24 INCHES (50.8 × 61 CM)

Muniz's series of powerful landscapes, utilize the medium of hundreds if not thousands of yards of sewing thread. They developed out of his frustration to properly depict with wire the depth relationships in a landscape. Muniz stated,

I wanted to try different subjects, but I discovered by changing the material in which I was drawing that each material could only render certain things well. I needed something more fluid, so I began working with sewing thread. The process is very similar to the wire objects except that it allows me to build up the material and create volume. In one hand you have a drawing and in the other you have the photograph of the "actor" responsible for the enacting of that landscape. When you perceive the one, you lose the other. It works like a visual illusion, like the Necker cube or Rubin vase.

Muniz's Pictures of Thread series are not direct copies of the images that inspired them, but were recreated from Muniz's memory of those artistic works. Twenty-four thousand yards of thread were used in this landscape.

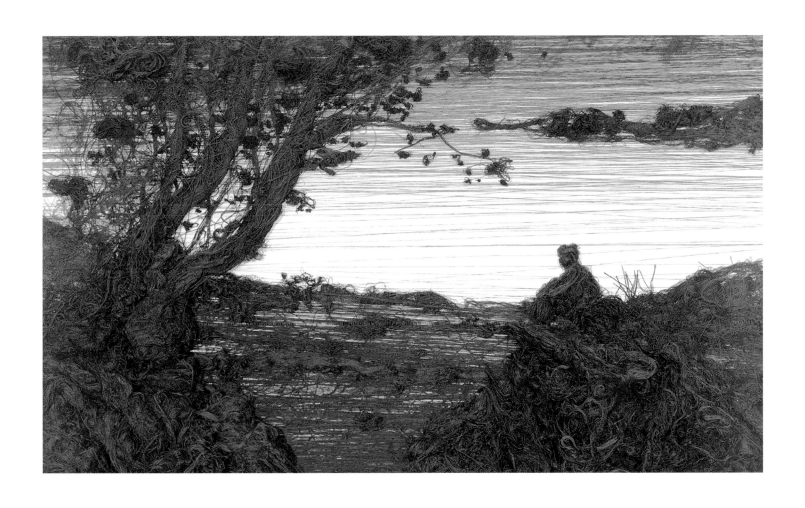

"Le Songeur, After Corot," toned gelatin print, 1996, 20 × 24 inches (50.8 × 61 cm)

Sixteen thousand yards of sewing thread were used to create this image.

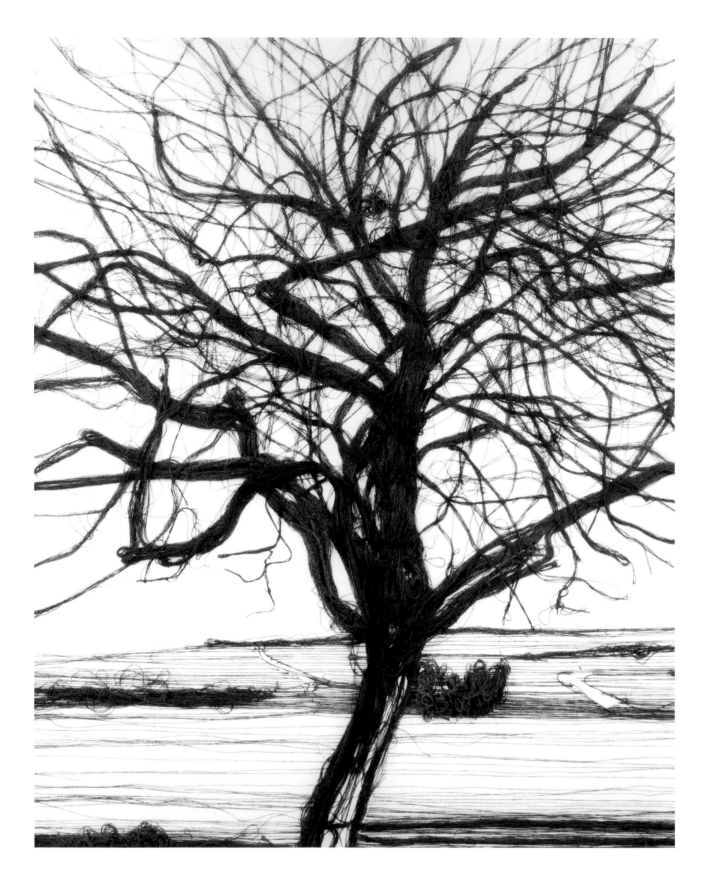

"200 Yards (Apple Tree, after Atget)," toned gelatin print, 1998, 20 × 24 inches (50.8 × 61 cm)

Two hundred yards of sewing thread were used to make this print.

"20,000 YARDS (THE CASTLE AT BENTHEIM, AFTER JACOB VAN RUISDAEL)," TONED GELATIN PRINT, 1999,
20 × 24 INCHES (50.8 × 61 CM)

Twenty thousand yards of sewing thread were used to create this image.

"The Helminghan Dell, After John Constable," toned gelatin print, 1999,
20 × 24 inches (50.8 × 61 cm)

This image comprises eleven thousand yards of sewing thread.

"Church on a Hilltop at Varerngeville, after Claude Monet," toned gelatin print, 1999,
20 × 24 inches (50.8 × 61 cm)

Nine thousand yards of sewing thread were used to create this image.

"Burgos Cathedral," cibachrome print, 2003, 60 × 48 inches (152.5 × 122 cm)

"Cathedral of Leon," cibachrome print, 2003, 60 × 48 inches (152.5 × 122 cm)

"DONALD JUDD, 'UNTITLED,' 1965, BARNETT NEWMAN, 'HERE III,' 1965–66, AND CARL ANDRE, 'TWENTY-NINTH COPPER CARDINAL,' 1975, INSTALLED JULY 14–SEPTEMBER 5, 1982, AT THE WHITNEY MUSEUM IN 'SCULPTURE FROM THE PERMANENT COLLECTION,'" SILVER DYE BLEACH PRINT, 2000, 64 × 51 INCHES (162.5 × 129.5 CM)

In 2000, Muniz created a series of nine large-scale photographs based on iconic minimalist and post-minimalist artworks that had been featured in the Whitney Museum in New York. Muniz selected works from the Whitney's collections that were prime examples of the minimalist art movement using materials that first got very real and then began to fall apart. Muniz reasoned that, if Minimalism stripped art down, reducing it to bare, self-referential elements, why couldn't minimalism itself be pared down in the same way?

To create his series, Muniz collected dust from the floors of the museum. He would later state in an interview, "Dust was the hardest substance I've ever worked with, because it's disgusting. Dust is pieces of hair and skin. I think people scratch their heads a lot in museums; that gets mixed in with the residue from the artworks themselves. That's the ultimate bind between the museum visitors and the artwork. If you do a DNA profiling of the material I used, you would end up with a great mailing list." After Muniz recreated the works out of dust, he photographed the drawings and enlarged them; the results were reproductions of reproductions, several times removed from the real thing. The pictures are quite dramatic in their bleakness, more than simple black-and-white photographs of sculptural installations.

"Ad Reinhardt," silver dye bleach print, 2000, 44 × 66 inches (111.5 × 167.5 cm)

"THE GOTHIC ARCH, AFTER PIRANESI," CIBACHROME PRINT, 2002, 100 × 72 INCHES (254 × 183 CM)

Muniz here recreates from memory the work of the 18th century etchings of Giovanni Piranesi's famous Imaginary Prison series, which displays a kind of impossible architecture and strange perspective. Each image took about a month to finish, and is composed entirely out of strings, pins, and shadows, which were re-inscribed into photographs.

"The Drawbridge, After Piranesi," cibachrome print, 2002, $39^{1}/_{2} \times 28^{1}/_{4}$ inches (100 × 72 cm)

"The Smoking Fire, After Piranesi," cibachrome print, 2002, $39^{1}/_{2} \times 28^{1}/_{4}$ inches (100×72 cm)

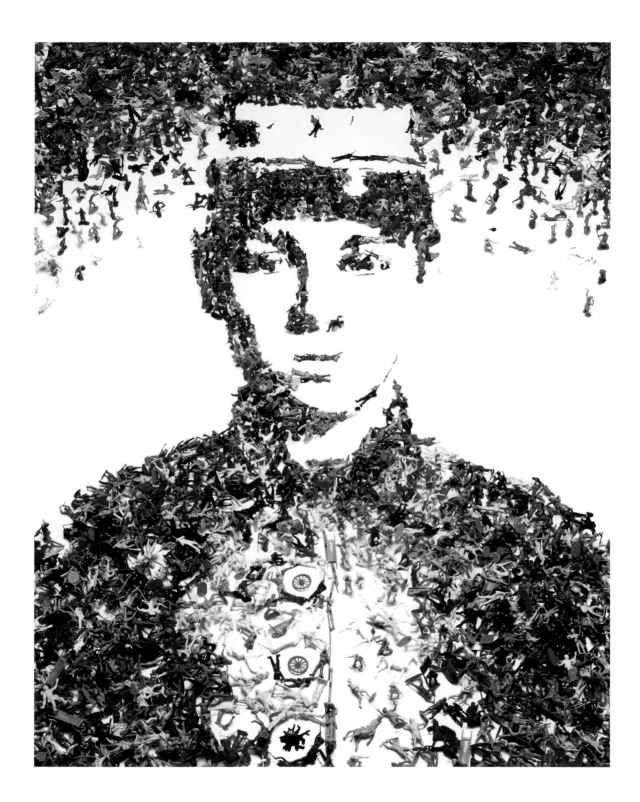

"Toy Soldier," cibachrome print, 2003, 92 × 72 inches (233.7 × 182.9 cm)

"I would like people to walk toward a picture, to see how it changes as they walk. Pictures mean different things at different distances. There are always micronarratives being played." Here the soldier is constructed entirely out of plastic war toys.

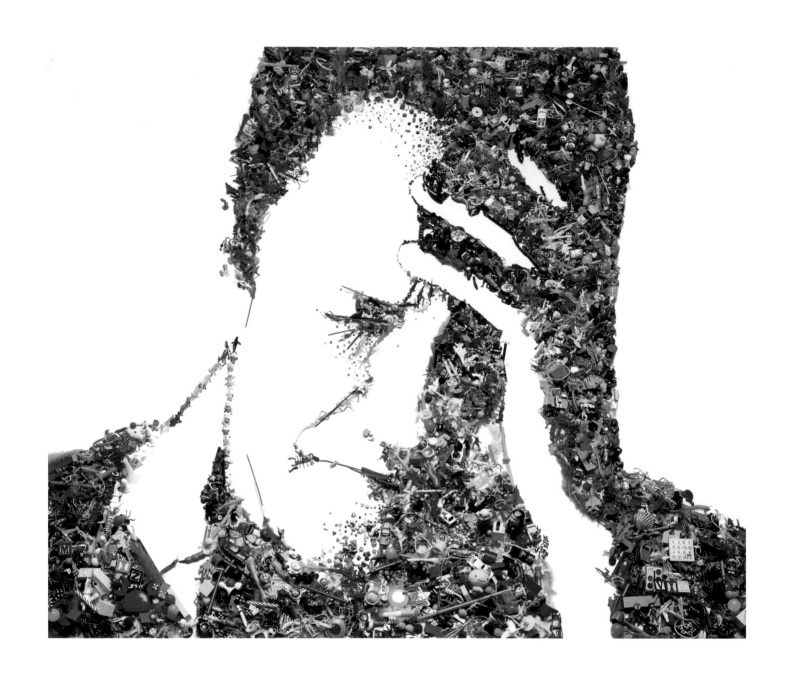

"SELF-PORTRAIT, I'M TOO SAD TO TELL YOU, AFTER BAS JAN ADER," CIBACHROME PRINT, 2003,
72 × 92 INCHES (182.9 × 233.7 CM)

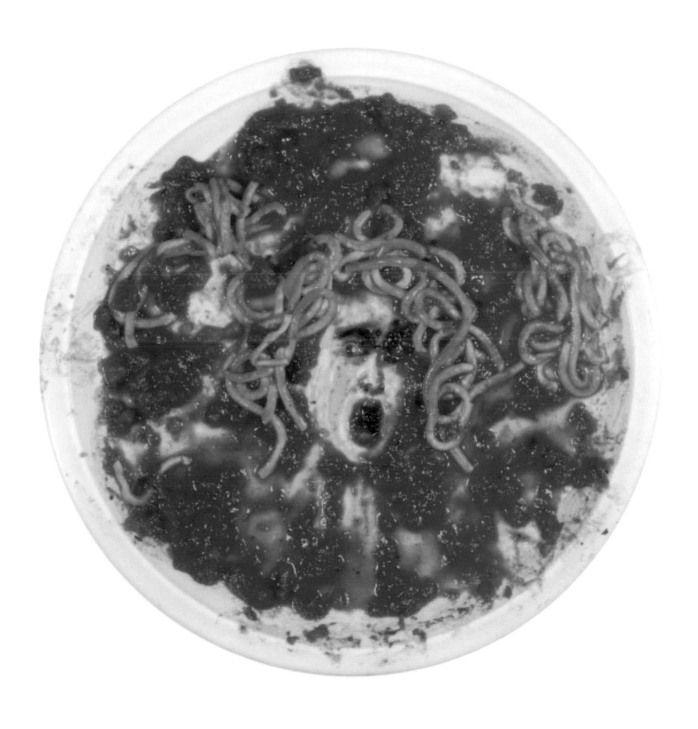

"Medusa Marinara," cibachrome print, 1998, 30-inch diameter (76.2 cm)

The head of Medusa made out of marinara sauce.

Octavio Ocampo

(1943–)

METAMORPHIC ART

AMBIGUOUS IMAGES, WHICH SEEM to flip-flop in meaning, have been popular for well over a hundred years, and there are even examples that date back several hundred years. Most of the traditional types of ambiguous images involve reversal of the figure/ground relationship, but there is also a different variety, which is not so reliant on figure/ground reversal. In the latter, the contours of the figure are deliberately made ambiguous, and one's perception of it reverses based on how the eye groups those contours into meaningful relationships. It is difficult to perceive both possibilities simultaneously.

Mexican artist Octavio Ocampo has specialized in creating portraits and religious scenes that perceptually "flip-flop." The longer one looks at his work, the more content is revealed: Flowers become faces, mountains speak to each other, and mourners over a coffin become the face of Christ. A devout Catholic, Ocampo imbues his works with religious and secular symbolism.

Ocampo lives in Tepoztlan, a mountainous region southwest of Mexico City. He was born in Celaya, Guanajuato, Mexico in 1943 and started studying art an early age under the influence of his parents, who were in the design business. In the local art school he attended as a young man, Ocampo constructed "papier-mâché" figures for floats, and ornaments that were used during carnival parades and other festivals. It was here that he learned firsthand about art composition, mate-

rials, and techniques. In high school, Ocampo painted murals for the preparatory school and the city hall of Celaya. Ruth Rivera (daughter of famed Mexican artist and muralist Diego Rivera) and Maria Luisa "La China" Mendoza saw his work and encouraged him to attend the School of Painting and Sculpture at the National Institute of Fine Arts.

His talents were not limited to painting and sculpture, but extended to acting and dancing as well. While at the San Francisco Art Institute, he studied all these disciplines and pursued both a film and theater career, graduating in 1974. In 1976, he began to devote himself solely to painting and sculpture. He now works primarily in what he calls a "metamorphic style," using a technique of superimposing and juxtaposing realistic and figurative details within the images that he creates. He explained how it evolved: "When I was looking for a definition of a specific style in my work, I did some experimenting. I realized that the metamorphic elements were emerging more frequently in my compositions, so I adopted it as something wonderful—important enough to be regarded as a serious matter in the art fields." Ocampo finds his metamorphic inspiration everywhere: in clouds, trees, water, people, movies, books, photographs, and more. "I may find my resolution awake or sleeping," he said. "Once it is completed in my mind, only the technical aspect remains, that of transferring the idea to materials."

Ocampo states that he lures the viewer in with an intial impression of, say, beauty or horror. But that's just the first image. "Then they realize there is a second image, then a third, and often these carry a different emotional message altogether from the first image."

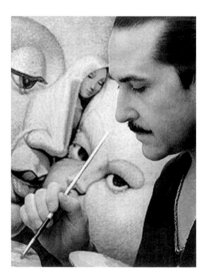

OCTAVIO OCAMPO AT WORK

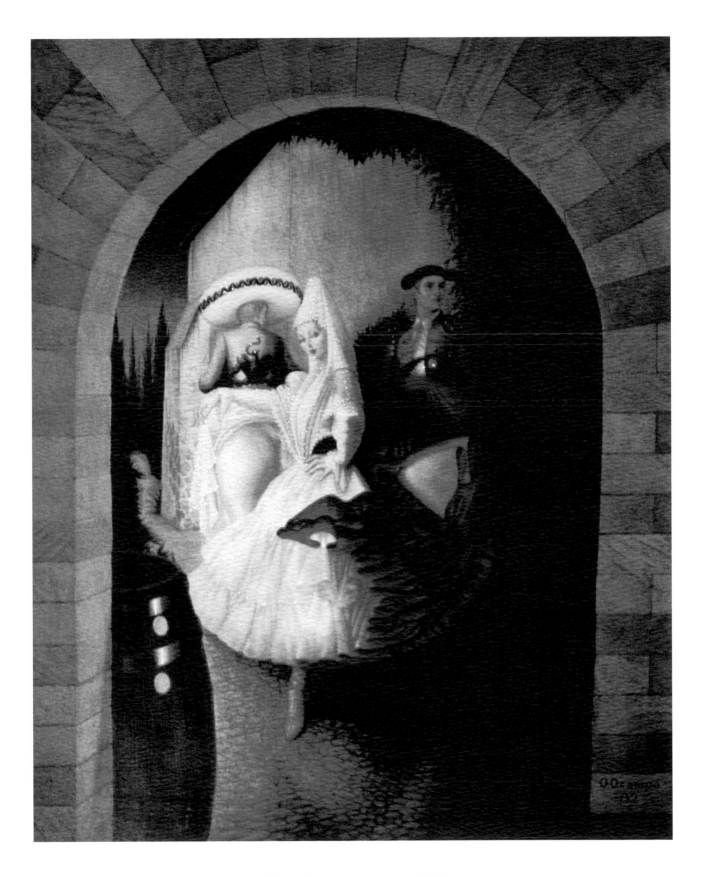

The life of the tragic and tempestuous 1930s Mexican film star Lupe Velez is portrayed.

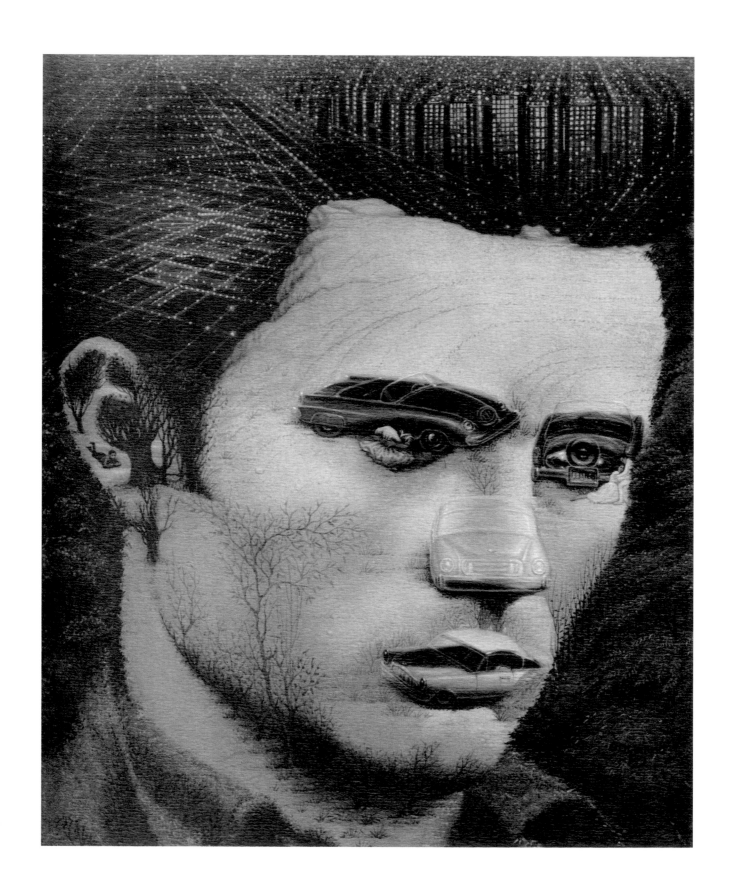

"HOLLYWOOD LIGHTS," OIL ON CANVAS, 1982

Hollywood screen idol James Dean is captured in this portrait.

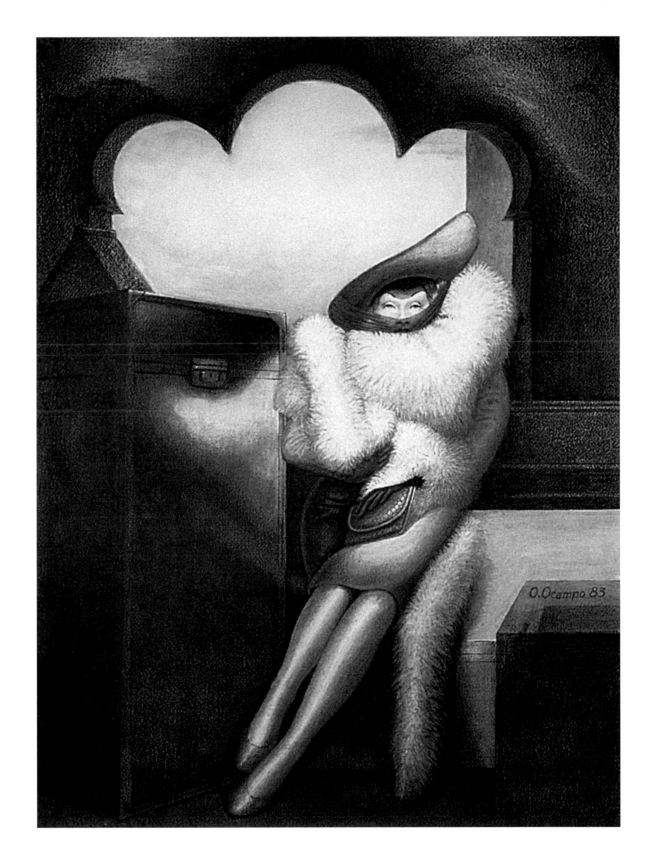

"MARLENE," OIL ON CANVAS, 1983

Ocampo's portrait of 1940s film star Marlene Dietrich is a mastery of ambiguous imagery. The details of her fur coat, trademark hat, and purse blend beautifully into her face.

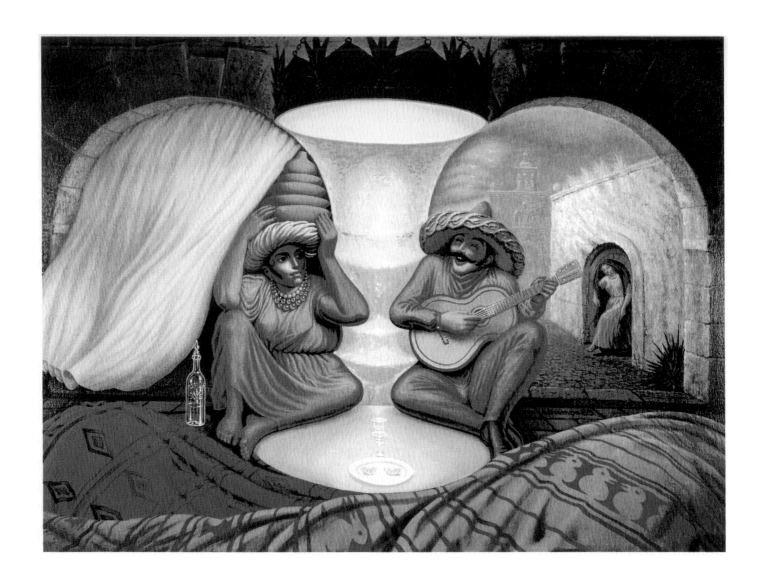

"FOREVER ALWAYS," OIL ON CANVAS, 1989

In this image, Ocampo depicts a life well lived or one that will be well lived. Those who see the older couple note that they share the Cup of Life (center of the picture) and the crown of fidelity (above the cup). Both of these are symbols of the life they have shared together and the love that fills the cup with a golden light.

The older couple sees each other as they were when they were much younger, when they courted with serenades while drinking tequila with limes (lower center). The viewer is able to look into the older man's mind to note that he always sees his chosen as beautiful and desirable. Those who view the younger couple see that they are looking forward to sharing a cup full of love and happiness. This commitment becomes their crowning achievement, symbolized by the ring (crown) they wear. The young man remembers how his love came out of her house in response to his serenades.

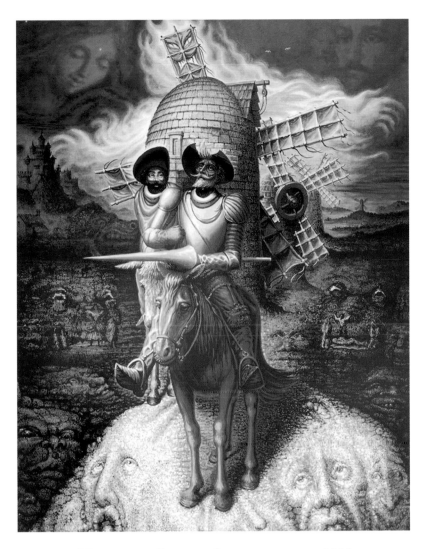

In this image, Ocampo tells the story of Don Quixote by the use of a single picture.

From afar, the viewer sees an old man with a faraway and dreamlike expression on his face. Wild yellow hair and a strange beard serve to complete the man's odd demeanor. Drawing closer, the viewer is transported to the Spanish countryside, where one notices that the windmills in the center of the picture look like they are about to come to life.

Two proud heroes occupy the center of the picture and are backed by windmills: Don Quixote on his faithful steed Rocinante and Sancho Panza on Dappie. They are surrounded by the world that lives in Don Quixote's mind.

In the middle of the right picture, Don Quixote is immortalized, crying out in protest that a deceased man still lives, and readying himself to hijack his body to save him from an untimely funeral. If you focus on the area around this scene, you will see the face of a dog—a symbol of Quixote's madness.

The middle left of the picture shows Xarifa working in the fields. Again this scene appears to be the face of a dog, to show the madness of imagining her to be Dulcinea (pictured in the upper left-hand corner). Above Xarifa in the fields, the village of La Mancha is pictured surrounded by mythical dragons and sea monsters.

Above the village, sits the Duke's castle (upper left) with the Duke's face pictured in the castle's wall. Careful observation will reveal a skull outlining the left side of the castle, a hint of the Duke's sinister plans for our heroes. The upper right side of the painting shows Miguel de Cervantes' ghostly face watching over his work. While the hills, rocks, and dates alter with the power of the Man of La Mancha's madness.

"CELESTIAL BODIES," OIL ON CANVAS, 1994

Angels comprise both the head and the hands.

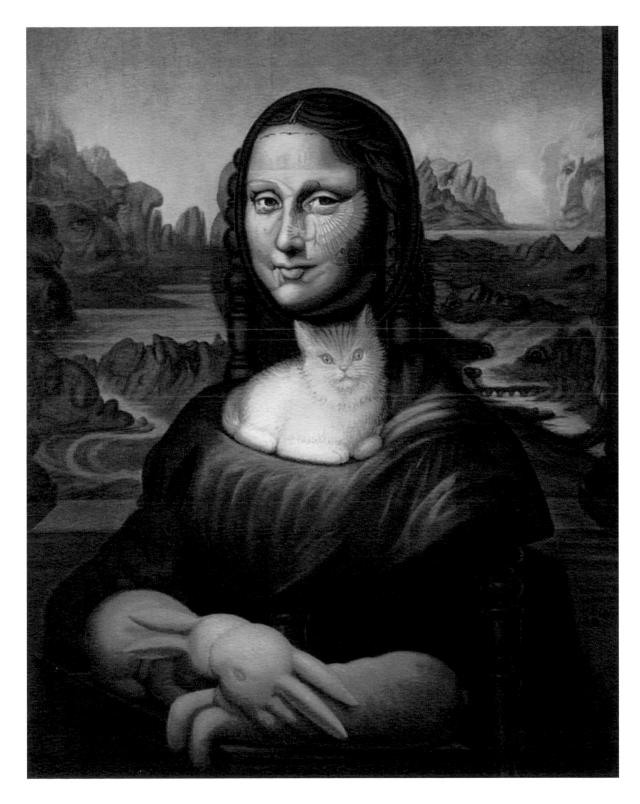

"MONA LISA'S CHAIR," OIL ON CANVAS, 1988

The picture consists of a chair occupied by three rabbits, one black (on the lower left) and two whites (in the lower center). A cat sits on the chair's upper cushions (middle center) and watches the viewer of the piece. The chair has a mirrored back, that at first glance appears to be the face of Mona Lisa, but upon closer inspection actually consists of two women, a man, an angel, as well as a skyline. The background in "Mona Lisa's Chair" is a study of the subconscious mind as face turns into forms and nothing is really what it seems at first.

"PALM SUNDAY," OIL ON CANVAS, 1994

In his vision of Palm Sunday, Octavio Ocampo depicts Christ's entry into Jerusalem.

"MIRACLE OF THE ROSES," OIL ON CANVAS, 1996

"Miracle of the Roses" is a depiction of the culmination of the story of Our Lady of Guadeloupe, the Virgin Mary. Pictured in this painting is the culminating scene of the story where Juan Diego comes into the Bishop's presence bearing the proof from the Virgin. He lets go of his tabard showering the astonished Bishop with roses, only to find that the symbol of the Madonna is now indelibly marked on the front of his tabard. His tabard can still be seen in the cathedral that was built to honor the Virgin.

István Orosz

(1951–)

ANAMORPHOSES

"István Orosz is in many ways Escher's artistic heir—a master of graphic technique, a keen observer with a sly wit, a conjurer who can make the impossible believable, an artist who can harness difficult visual and mathematical tools to achieve breathtakingly clever effects."

—DORIS SCHATTSCHNEIDER

"The mysterious world of illusions in Orosz's pictures draws you into a perfect world, the irrational construction of which is hidden behind the aesthetics of the imagination and the lyricism of forgotten beauty."

—MARTA SYLVESTROVA

HUNGARIAN ARTIST ISTVÁN OROSZ is a master of the anamorphic technique. He is incredibly adept at hiding portraits and other objects within a scene. Growing up under Communist rule, Orosz became quite familiar with the art of crafting images with hidden meanings. Throughout his career, Orosz has always been drawn to tricks of perspective and optical illusions, and incorporated many illusionistic concepts into his graphic posters. At a 1996 international graphic design symposium, he stated,

Advertising and publicity try to show the things better and more desirable than they actually are, so people are beguiled. A majority agrees that this is the task of

advertising because it is needed for business. The ethical problems are often overlooked. This question looks even greater in the case of works that use optical illusions and paradoxes. Or does not? Maybe these visual tricks just call attention to the "whopping lies."

In his spectacularly executed engravings, Orosz has explored ambiguous imagery, impossible figures, inverted figures, and anamorphoses, which he brings to life in works that display his admiration for classical antiquity. In many of his nonanamorphic illusionistic prints, you can see conceptual inspiration from the illusionistic works of Shigeo Fukuda, Giuseppe Arcimboldo, M.C. Escher, Sandro Del Prete, Roger Shepard, Salvador Dalí, and René Magritte.

Orosz frequently uses the pseudonym ΟΨΤΙΣ, which in Greek means "nobody." Orosz explains the use of his pseudonym:

> When years ago Andras Torok gave me this pseudonym, I obviously did not have a clue how relevant my new name would turn out to be. Before me was the most cunning of all Homer's heroes, Odysseus, who was given this name in his fight against the Cyclops. As we all know, the Cyclops lost his sight in this battle. Much of my work at that time fell into the domain of *trompe l'oeil*. The person who gave me this name must have thought that *trompe l'oeil* was also an

A STRETCHED SELF-PORTRAIT, 2001

Odysseus-ΟΨΤΙΣ, attitude. It represented an attack against the eye, more gentle certainly than that of crafty Odysseus, being nothing more than a trick of the eye.

István Orosz was born in Kecskemét, Hungary in 1951. He was trained as a graphic designer, not in painting proper, at the Budapest Academy of Applied Arts. He also learned animated film techniques at Pannonia Film Studios. Stage design for various theaters in Hungary was his first area of professional practice. Later, when the poster became his prime avocation, he created them for theaters and movies, and during the pro-democratic movement in Hungary, political posters as well. His progressive political posters brought him great acclaim and international recognition.

A self-reflective pun: An image of Orosz hanging up a poster for his own poster exhibition in Budapest, 1979

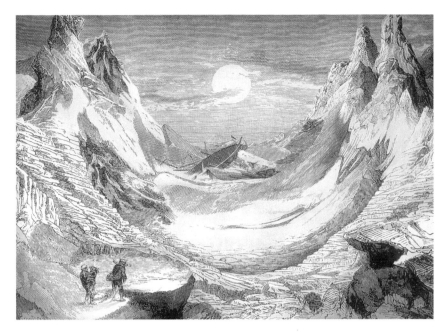

"A MAGICALLY APPEARING PORTRAIT OF JULES VERNE ON THE MYSTERIOUS ISLAND," ETCHING, 1983,
17 × 24 INCHES (43.2 × 61 CM)

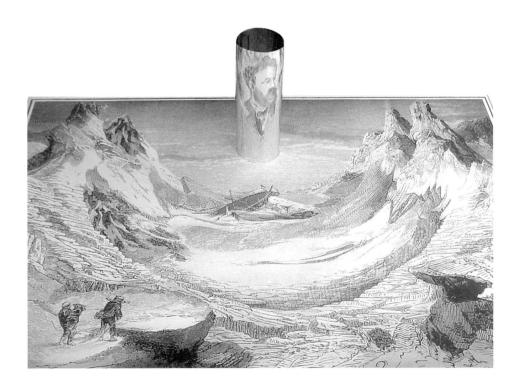

This is considered by many to be Orosz's masterpiece of hidden anamorphosis, and it was his first attempt at using this technique to conceal a portrait. It depicts a shipwreck scene in the frozen North based on the novel "The Mysterious Island" by the famous 19th century French science-fiction author Jules Verne. The portrait is visible only when you look at the reflection on the cylinder when the latter is placed over the moon.

"Self-Portrait with Einstein," aquarelle colored pen and ink drawing, 2002, $23^1/_2 \times 31^1/_2$ inches (60×80 cm)

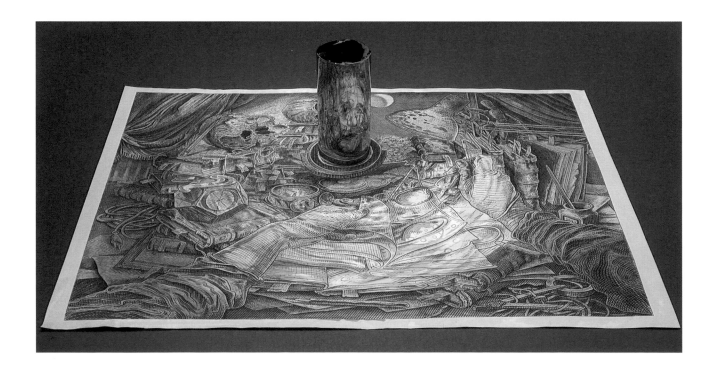

A portrait of Albert Einstein, which is revealed when placed on the image of a mirror in the center. There is much in the sense of play in this drawing, as Orosz's own face can be seen reflected in the mirror that is drawn on the image.

"Dionysius Theater," etching, 1986, $15^{1}/_{2} \times 23^{1}/_{2}$ inches (40×60 cm)

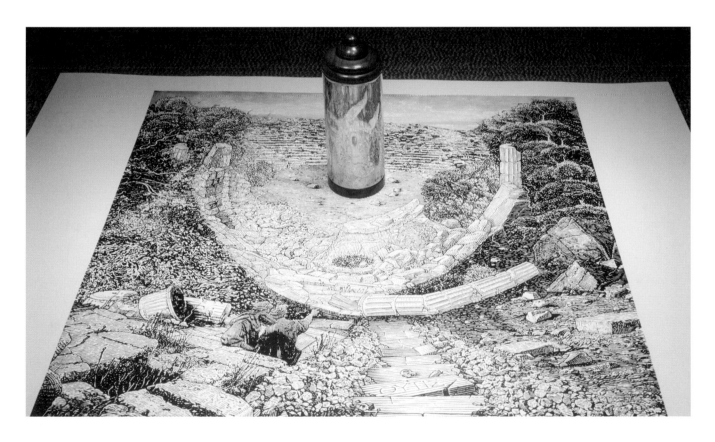

Two travelers come across the ruins of an ancient Greek theater. When the reflective cylinder is appropriately placed in the center of the abandoned stage, the head of the Minotaur can be seen.

"LABYRINTH OF THESEUS," ETCHING WITH REFLECTIVE PYRAMID, 1986, 19^1/$_2$ × 27^1/$_2$ INCHES (50 × 70 CM)

Theseus is revealed in the reflective pyramid.

"LABYRINTH OF THE MINOTAUR," ETCHING WITH REFLECTIVE CONE, 1986, 19^1/$_2$ × 27^1/$_2$ INCHES (50 × 70 CM)

This is the first of a series of labyrinth anamorphoses devoted to the ancient Greek legend of the hero Theseus and his battle with the Minotaur, a powerful creature with a human body and the head of a bull, in a labyrinth designed by the legendary artificer Daedalus. This prison was created to contain the monster—a place from which none could return unless they knew the secret way through its tortuous passageways. Theseus extracted the secret of the passageways from Minos' daughter Ariadne, who fell in love with him. Theseus used a ball of thread and unwound it as he entered so that he could retrace his steps. Theseus killed the Minotaur, emerged from the labyrinth, and immediately set sail for Athens with Ariadne and his fellow sailors.

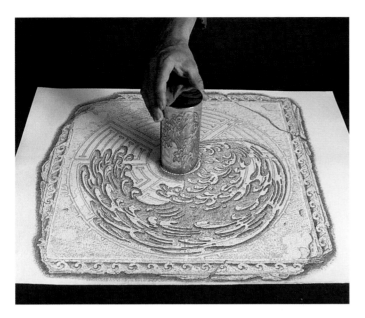

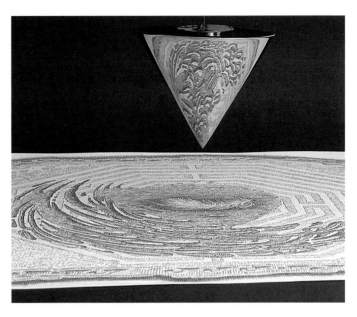

"ATLANTIS I," ETCHING WITH CYLINDER, 1999, 27¹/₂ × 27¹/₂ INCHES (70 × 70 CM)

"ATLANTIS II," ETCHING WITH INVERTED HANGING CONE, 1999, 27¹/₂ × 27¹/₂ INCHES (70 × 70 CM)

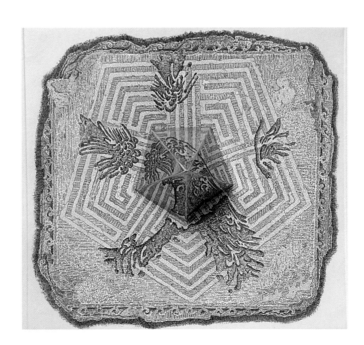

"ATLANTIS III," ETCHING WITH FIVE-SIDED PYRAMID, 1999, 27¹/₂ × 27¹/₂ INCHES (70 × 70 CM)

These three anamorphoses that depict the sinking of the lost continent of Atlantis, use differently configured reflecting anamorphoscopes to represent the ocean overtaking the famed land.

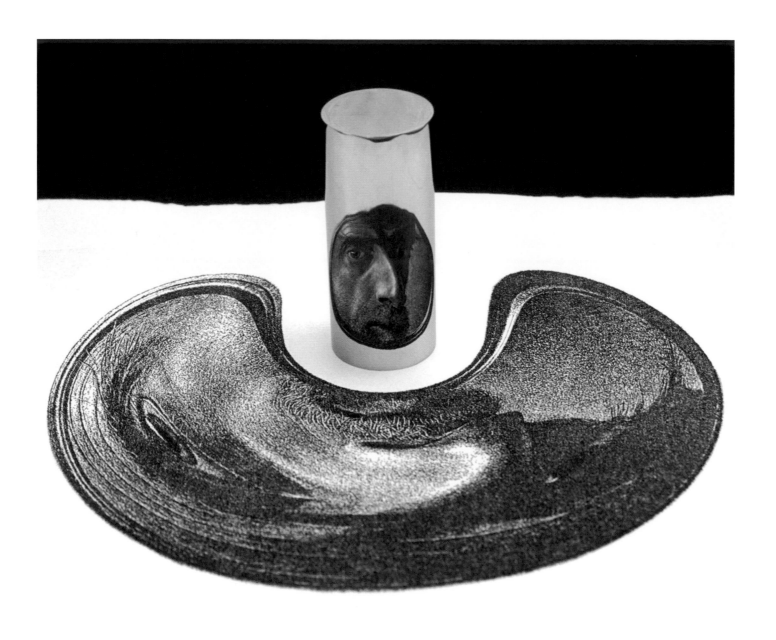

"Self-Portrait of Escher in an Anamorphic Cylinder," etching with reflective cylinder, 1998,
$11^1/_2 \times 15^1/_4$ inches (29×39 cm), $5^1/_2 \times 2^1/_4$ inches (14×6 cm)

This anamorphic portrait was created for the Escher Centenary Congress celebrations held in Italy in 1998. It is based on one that Escher created himself.

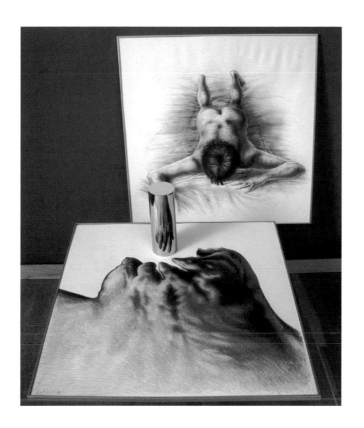
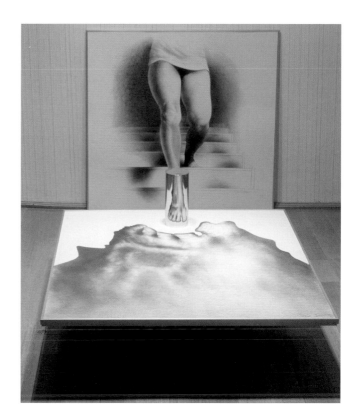
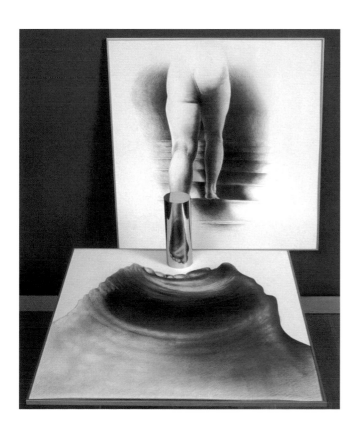
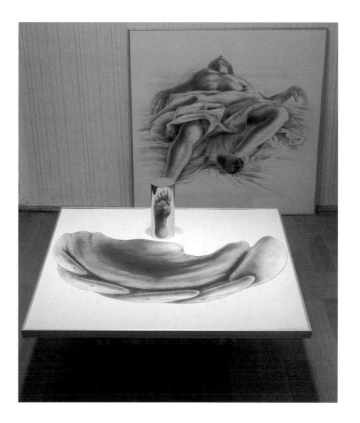

"Anamorphic Body Landscapes I, II, III, IV," pencil drawings, 1989, 23^1/$_2$ × 23^1/$_2$ inches (60 × 60 cm)

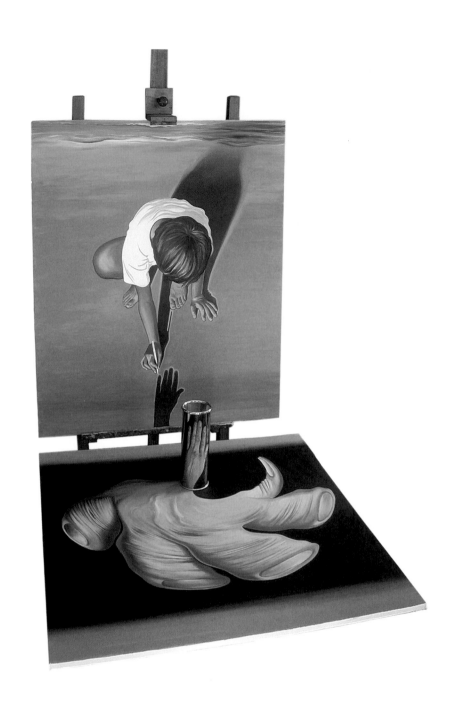

"Anna in Seaside," acrylic on canvas with reflective cylinder, 2001,
55 × 39¹/₂ × 39¹/₂ inches (140 × 100 × 100 cm)

"Shakespeare Theater," etching, 2001-2002,
$23^{1}/_{4} \times 8$ inches (59 x 20 cm)

Orosz was inspired to do this oblique anamorphosis of Shakespeare after reading a short passage from Shakespeare's Richard II:

> For sorrow's eye, glazed with blinding tears,
> Divides one thing entire to many objects;
> Like perspectives, which rightly gaz'd upon
> Show nothing but confusion, ey'd awry
> Distinguish form.

The word "perspective" had wider meaning at that time, and referred to every strange and new method for opening up spaces, and to all anamorphic pictures, i.e., those that change their meaning if seen from another viewpoint or distance. Orosz's self-portrait can be seen at the bottom of the top image.

John Pugh

(1957–)

TROMPE L'OEIL

"The Webster's dictionary definition of monumental *most suitably describes the murals of John Pugh. They are massive and imposing, exceptionally great in both conception and execution, and are most assuredly of historical and enduring significance."*

—KEVIN BRUCE

"It seems almost universal that people take delight in being visually tricked. Once captivated by the illusion, the viewer is lured to cross an artistic threshold and thus seduced into exploring the concept of the piece. I have also found that by creating an architectural illusion that integrates with the existing environment, both optically and aesthetically, the art transcends the 'separateness' that public art sometimes produces."

—JOHN PUGH

JOHN PUGH'S *TROMPE L'OEIL* MURALS are so lifelike that they cause mishaps and confusion for the unsuspecting. In 1981, after the completion of his first major project, the mural in Taylor Hall on the California State University, Chico campus, several fender benders occurred because motorists were distracted by what looks like a gaping hole in the building.

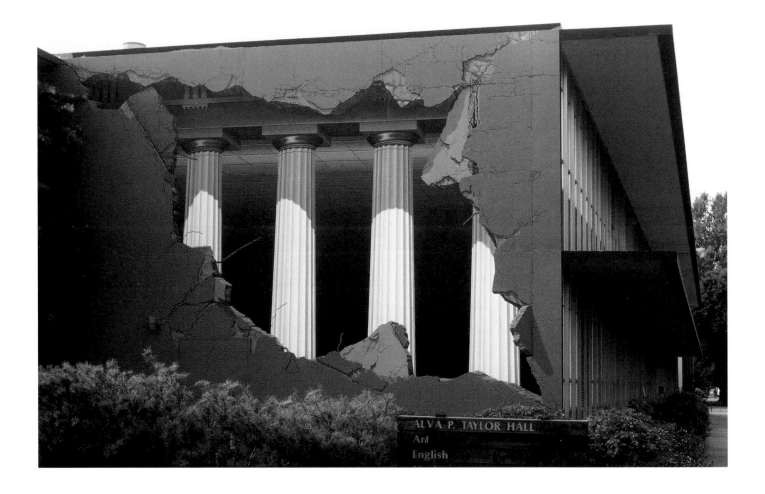

"Taylor Hall," acrylic on stucco, 1981, 24 × 36 feet (7.3 × 11 meters)

Taylor Hall is a local landmark at the California State University located in Chico. Pugh's mural has received international attention, because so many people have been bewildered by what they saw as they went past; in fact, the mural has caused a number of fender benders.

Pugh reminisces about his painting on Taylor Hall: "I kept eyeing that particular wall. It has a northeastern exposure with little sun, a smooth surface, and it is perpendicular to traffic—better for a perspective illusion. Plus, it is the downtown entrance to the university with a lot of pedestrian traffic."

Pugh's idea for the mural was inspired by a dream he had in which he witnessed the wall "breaking open." He also considered what people passing that corner might imagine was inside Taylor Hall. "I liked the idea of visually excavating the building to expose a particular imagined vision," he says. "The modern educational façade is broken away to reveal the ancient Greek academe—the essence of our educational system."

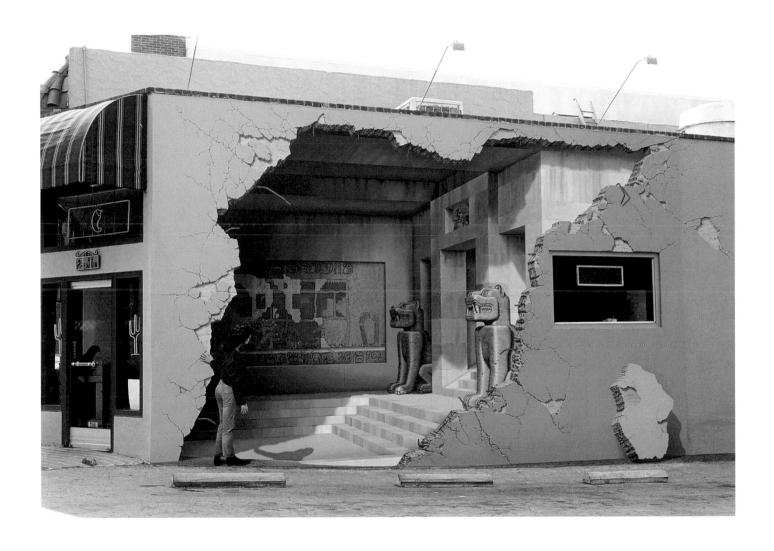

"Siete Punto Uno," acrylic on M.D.O. board, 1990, 16 × 24 feet (4.9 × 7.3 meters)

In 1989, the town of Los Gatos, California, suffered significant damage from an earthquake that measured 7.1 on the Richter scale. The mural, "Siete Punto Uno" (Spanish for "7.1"), is located on the outside of Pasteria restaurant on Main Street in downtown Los Gatos. Considered the propitiator of earthquakes, the Mayan jaguar god (as represented in the mural) is grafted with the "cats" of Los Gatos, becoming one of the image's key metaphors.

The woman standing in the street and looking into the room is also painted.

"SILENT STREAM," ACRYLIC ON CANVAS, 1999, 8 × 14 FEET (2.4 × 4.3 METERS)

This mural was conceived to comfort and inspire, and can be found in the main lobby of the Kaiser Permanente Hospital in Santa Clara, California. The mural invites the viewer to set adrift in a meditative water garden. The Hepworth-like bronze and marble sculpture—reminiscent of a seashell with a blue pearl—serves as a sacred centerpiece. The harp strings seem to echo a distant melody like an ancient song of the sea.

"STUDY WITH SPHERE AND WATER," ACRYLIC ON NON-WOVEN MEDIA, 1999, 12 × 29³/₄ FEET (3.7 × 9.1 METERS)

This mural, located in the University Center of the University of Florida, Jacksonville, depicts a meditative space of learning and inspiration.

"VALENTINE'S DAY," ACRYLIC ON STUCCO, 2000, $49^3/_4$ × 15 FEET (15.2 × 4.6 METERS)

This mural is located in Twentynine Palms, California. Obviously, the historical theme of "Cattle Days in Hidden Valley" is not the only subject of this mural. It also depicts an artist falling asleep while finishing the mural. Of course, the artist, his scaffolding, the buzzard, and the cow standing nearby are all painted illusions.

The subtle two-dimensional qualities of the "unfinished" mural provide a contrast with the foreground and heighten the sense of illusion. If the background were less complete, there would not be enough colors or shapes for a full composition. If it were more complete, it would be a distraction and render the illusion less effective. This work also provides the viewer with a journey through all the different steps of mural painting—from wall grids and sketched images to blocked-in colors and finished painting.

"Woman in Café," acrylic on canvas, 2000, 6 × 5 feet (1.82 × 1.52 meters)

This is Pugh's homage to Edouard Manet's famous painting "Le Bar aux Folies-Bergère." "I tweaked [the painting] by superimposing a contemporary woman in front of the woman who is normally in the painting," says Pugh, "so it's shifting time within the piece and playing off a classic piece"—a technique that artists have used for centuries.

"Light Walk," acrylic on Non-Woven Media (left portion), 2001, 6 × 26 feet (1.82 × 7.92 meters)

"Light Walk," acrylic on Non-Woven Media (right portion), 2001, 6 × 26 feet (1.82 × 7.92 meters)

This mural, located in the patient area of the oncology department in the Palo Alto Medical Foundation in northern California, was designed to create a healing and reflective environment. The viewer is invited on a dreamquest into this exotic underworld—a spiritual path with reflecting pools, sacred sculptures, and bridges that lead up into the treetops. Before the moss wall stands a young woman made of bronze, in sublime rapture. On the left, as an homage to Rodin's sculpture of Victor Hugo, is a prophet of white marble.

Detail of "Light Walk"

"Bath of Venus," acrylic on canvas, 2002, $5^1/_2 \times 9^1/_4$ feet (1.7 × 2.8 meters)

Everything in this image is painted, including the bowl, ledge, and wine glass. Art patrons at the show where this painting was displayed actually spilled their wine trying to set their own goblets on the "ledge."

"THE DIRT ON BISHOP," ACRYLIC ON M.D.O. BOARD, 2002, 10 × 10 FEET (3 × 3 METERS)

DETAIL OF "THE DIRT ON BISHOP"

This mural, located in Bishop, California, represents a sedimentary survey of the town's heritage. Digging down through the bullets, spurs, horseshoes, railroad spikes, rusted water valves, and old keys, we unlock different parts of Bishop's history. Following the Bristlecone pine roots we dig deeper: past Paiute arrowheads and beads, and through fossilized Mammoth tusks and Sabertooth skulls. Delving even deeper we pass fossils of ancient roots, prehistoric leaves, and trilobites to reach layers that date back to the beginning of the world. On the lighter side, a dog named Hunter helps to "ground" this piece as he sniffs the air for a bone from the floor above, but picks up the scent of an eon.

"REVERSE, LATERAL, AND LOOP," ACRYLIC ON MDO BOARD, 2002, 13 × 70 FEET (396 × 2134 CM)

This mural, located in downtown Tehachapi, California, makes reference to two subjects that highlight the colorful history of the town The first, "Reverse and Lateral," refers to the type of faults that caused a 7.4 magnitude earthquake in 1952 that destroyed most of this small downtown. Many lives were lost, and the wall on which this mural is painted was one of the only two structures left standing.

The second subject is the internationally celebrated "Tehachapi Loop." The loop concept was suggested by a nine-year-old water boy when railroad engineers were trying to solve the problem of maintaining a required train grade on the steep Tehachapi ascent. As depicted in the mural, the trains literally circle over themselves as they climb up to the pass.

The interplay of the train and the vertical rift as they bisect each other creates a different kind of pathway shape, and a different way of perceiving the town's heritage.

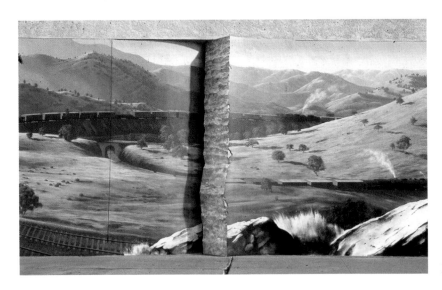

DETAIL OF "REVERSE, LATERAL, AND LOOP."

Oscar Reutersvärd

(1915–2001)

IMPOSSIBLE FIGURES

"Reutersvärd's work is still unbeatable in its substructure, clarity, and economy of expression."
—ZENON KULPA

"I give the phenomenon of absurdity a kind of existence." —OSCAR REUTERSVÄRD

SWEDISH ARTIST OSCAR REUTERSVÄRD is generally considered "the father of impossible figures." Although impossible figures in works of art have appeared sporadically since Roman times, either as mistakes in perspective or as visual jokes, Reutersvärd was the first to see them as new and worthy of a serious subject to explore. His systematic approach to exploring impossible figures could justifiably be called "artistic research." His drawings are the intuitive, sensual, and informal work of an artist, and at the same time a systematic approach of a scientist exploring a new dimension—a world that does not exist, a theoretical world that in our terms can only be called "impossible."

Oscar Reutersvärd was born in Stockholm in 1915. At an early age, he had trouble learning, the result of a severe problem with dyslexia. He also had great difficulty estimating the size and distance of objects.

In his early teenage years, Reutersvärd developed a passion for art. In this regard he was fortunate, because he was greatly encouraged by an artistic family. Reutersvärd's sister was also interested in pursuing an artistic career. Together the family worked at home, painting and creating various sculptures.

In 1934, while doodling in a Latin grammar notebook during class, Reutersvärd formed an impossible triangle from a peculiar arrangement of cubes. As he was elaborating on a six-pointed star with a circle of cubes, he discovered that the cubes had formed a strange and impossible construction. After the class, he showed the drawing to one of his classmates, Jan Cornell, who told him that it appeared quite original. They tried researching the topic at the local library, but they were not able to find any similar examples. However, they regarded the figure as only a curiosity and did not attempt to publish it.

During the mid- to late 1930s, Reutersvärd started experimenting with various impossible designs, which resulted in the creation of the first impossible staircase (1937) and concepts related to the well-known impossible fork. However, at the time these were labeled as nothing more than oddities, and no one took them seriously.

It wasn't until 1958 that his old friend Jan Cornell showed him the now classic article on impossible figures and objects by Lionel and Roger Penrose, which featured their independently created versions of an impossible triangle and staircase. The fact that the article was published by two distinguished scientists in a reputable scientific journal gave a great deal of credence to experimenting with such figures—someone other than Reutersvärd was taking them seriously.

In the years 1961 to 1962, Reutersvärd was introduced to the work of M. C. Escher. Reutersvärd was particularly intrigued by Escher's two prints of impossible buildings—"Waterfall" and "Ascending and Descending," which were directly inspired by the impossible triangle and staircase featured in the Penrose article.

Reutersvärd was particularly intrigued by Escher's "Waterfall." For the first time, he could see that impossible figures were being incorporated into serious works of art. This completely renewed his interest in impossible figures, and he started exploring them in a rigorous fashion. He created other original impossible figures, and in 1963 had a first showing of his work at a distinguished gallery in Stockholm. Unfortunately, local art critics reacted to the new form of drawing with either complete lack of interest or total disdain. As they left the gallery, many people shook their heads in disappointment. For Reutersvärd, this show was a total artistic setback.

Moreover, Reutersvärd did not receive any encouragement from his wife Britt, who was herself a serious abstract artist. She didn't like his drawings either and thought that he was wasting his time on ridiculous things. As it turned out, his wife became his best critic. Every time he showed her a

new drawing, and she did not find anything amiss with it, he knew that it was wrong. Conversely, if she found something wrong with the image, then he knew it was correct.

Reutersvärd always preferred to draw with India ink on Japanese rice paper or Swedish linen rags. He never allowed himself to draw with a ruler or to employ any mechanical devices. He preferred to draw freehand, which he did when he went by train from Lund to Stockholm—a ten hour journey. As a result, all the lines in his drawings, which he called "living lines," are a bit shaky. He would explain that the shaking from the train helped give more life to his drawings. Their color came from Japanese colored chalk, but sometimes he preferred not to paint them at all.

In 1963 and 1964, Reutersvärd wrote Escher two letters in which he expressed his great admiration for his work, but Escher did not reply. Reutersvärd also sent him extracts from articles on his work appearing in Swedish newspapers. Once again, Escher failed to respond. The only slight bit of encouragement came from a meeting with the famous surrealist painter Marcel Duchamp in Stockholm. At that time Duchamp had drawn a kind of impossible figure, and encouraged Reutersvärd to publish his own work.

By 1964, Reutersvärd had accepted the fact that his drawings were not going to achieve any recognition, much less provide an income. So he accepted a more prestigious professorship in art history at the Royal University of Lund, where he taught for over seventeen years.

However, in the late 1960s, Reutersvärd began to attract a following and his influence started to grow, especially after some books on impossible figures were published that featured his work. Exhibitions were arranged for him in Paris, London, Holland, Japan, Poland, Switzerland, Italy, and Russia. Books featuring his impossible figures were published in English, Swedish, Russian, Polish, and German.

In 1980 the Swedish government recognized his artistic achievements by commissioning three of his impossible drawings for postage stamps. These stamps were produced in 1982 and issued for about two years, until the Swedish government changed the rate of postage. The remaining unused stamps were subsequently destroyed by the Swedish government; they are now quite scarce and eagerly sought by stamp collectors.

Throughout the 1980s and 1990s, Reutersvärd continued to create literally hundreds of impossible figures. He was particularly fond of creating impossible meanderings and paradoxes within a window. He filled many notebooks with impossible figures, each one a new variation. He also started experimenting with impossible anaglyphs, drawings which, when seen through a pair of blue/red filtered glasses, would suggest the figure in 3-D.

In the mid 1990s, he began to be recognized for his work, some of which was commissioned for public buildings in Sweden. The greatest honor came when his drawings and paintings were

nently displayed in the National Museum as well as in the Modern Museum, both in Stockholm. Even so, what always gave him the greatest joy was introducing children to the paradoxes of impossible figures. It was during this period that he also became interested in designing mazes and constructing metallic sculptures made from chains.

In the late 1990s his health sadly started to decline rapidly, and he passed away in 2001.

PHOTO OF REUTERSVÄRD BY BRUNO ERNST

new drawing, and she did not find anything amiss with it, he knew that it was wrong. Conversely, if she found something wrong with the image, then he knew it was correct.

Reutersvärd always preferred to draw with India ink on Japanese rice paper or Swedish linen rags. He never allowed himself to draw with a ruler or to employ any mechanical devices. He preferred to draw freehand, which he did when he went by train from Lund to Stockholm—a ten hour journey. As a result, all the lines in his drawings, which he called "living lines," are a bit shaky. He would explain that the shaking from the train helped give more life to his drawings. Their color came from Japanese colored chalk, but sometimes he preferred not to paint them at all.

In 1963 and 1964, Reutersvärd wrote Escher two letters in which he expressed his great admiration for his work, but Escher did not reply. Reutersvärd also sent him extracts from articles on his work appearing in Swedish newspapers. Once again, Escher failed to respond. The only slight bit of encouragement came from a meeting with the famous surrealist painter Marcel Duchamp in Stockholm. At that time Duchamp had drawn a kind of impossible figure, and encouraged Reutersvärd to publish his own work.

By 1964, Reutersvärd had accepted the fact that his drawings were not going to achieve any recognition, much less provide an income. So he accepted a more prestigious professorship in art history at the Royal University of Lund, where he taught for over seventeen years.

However, in the late 1960s, Reutersvärd began to attract a following and his influence started to grow, especially after some books on impossible figures were published that featured his work. Exhibitions were arranged for him in Paris, London, Holland, Japan, Poland, Switzerland, Italy, and Russia. Books featuring his impossible figures were published in English, Swedish, Russian, Polish, and German.

In 1980 the Swedish government recognized his artistic achievements by commissioning three of his impossible drawings for postage stamps. These stamps were produced in 1982 and issued for about two years, until the Swedish government changed the rate of postage. The remaining unused stamps were subsequently destroyed by the Swedish government; they are now quite scarce and eagerly sought by stamp collectors.

Throughout the 1980s and 1990s, Reutersvärd continued to create literally hundreds of impossible figures. He was particularly fond of creating impossible meanderings and paradoxes within a window. He filled many notebooks with impossible figures, each one a new variation. He also started experimenting with impossible anaglyphs, drawings which, when seen through a pair of blue/red filtered glasses, would suggest the figure in 3-D.

In the mid 1990s, he began to be recognized for his work, some of which was commissioned for public buildings in Sweden. The greatest honor came when his drawings and paintings were

nently displayed in the National Museum as well as in the Modern Museum, both in Stockholm. Even so, what always gave him the greatest joy was introducing children to the paradoxes of impossible figures. It was during this period that he also became interested in designing mazes and constructing metallic sculptures made from chains.

In the late 1990s his health sadly started to decline rapidly, and he passed away in 2001.

PHOTO OF REUTERSVÄRD BY BRUNO ERNST

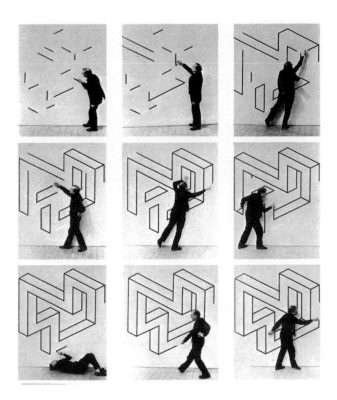

REUTERSVÄRD HARD AT WORK FINISHING A PICTURE
FOR HIS 1979 SHOW IN THE GALLERY OF
SAINT PETRI IN LUND, SWEDEN.

ANOTHER WORK FINISHED, 1996

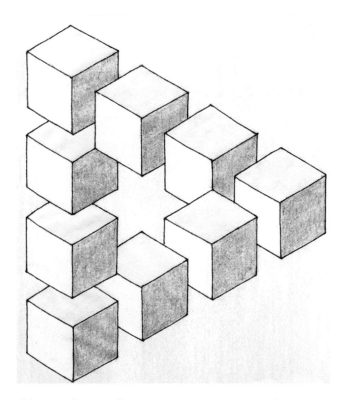

"AFTER OPUS 1," FELT-TIP PEN DRAWING, JAPANESE
RICE PAPER, 1981, 12 × 9 INCHES (30.5 × 23 CM)

This drawing was based on the first impossible figure that
Reutersvärd created in 1934.

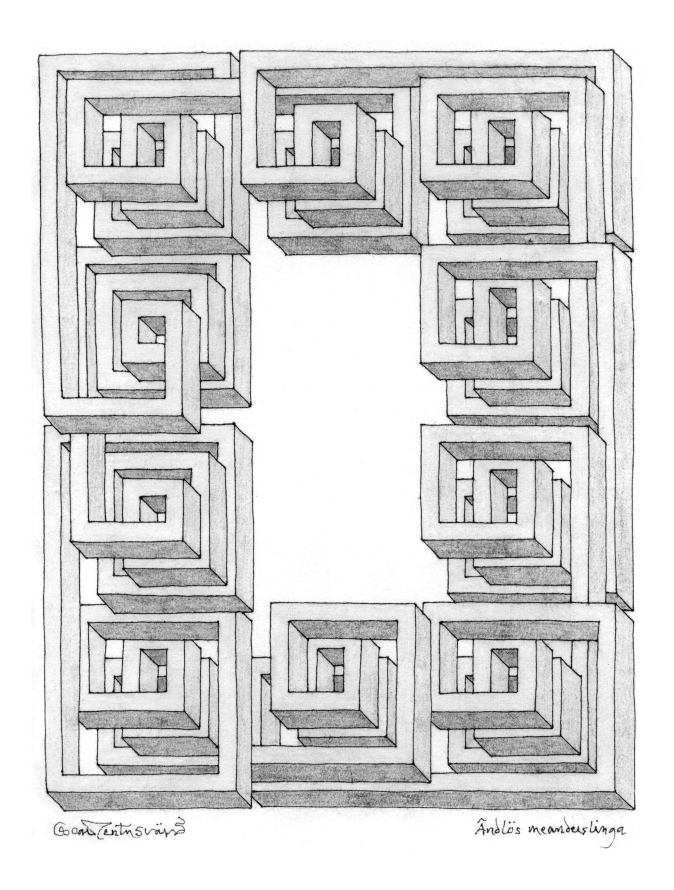

"ENDLESS MEANDERINGS," COLORED FELT-TIP PEN DRAWING, JAPANESE RICE PAPER, UNDATED,
12 × 9 INCHES (30.5 × 23 CM)

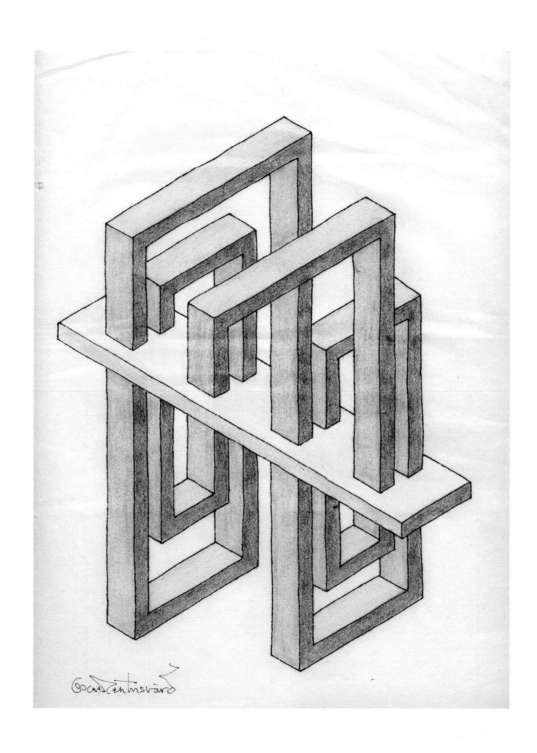

"CRISS-CROSS PARADOX," COLORED FELT-TIP PEN DRAWING, JAPANESE RICE PAPER, UNDATED,
12 × 9 INCHES (30.5 × 23 CM)

perspective japonaise n° 270 ab

"An Impossible Configuration with Three Cubes," colored felt-tip pen drawing, Japanese Rice paper, undated, 12 × 9 inches (30.5 × 23 cm)

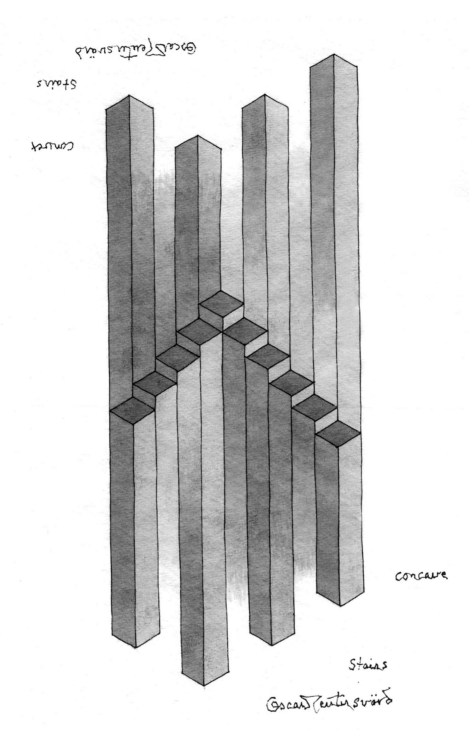

"Topsy-Turvy Paradox," colored felt-tip pen drawing, Japanese rice paper, undated,
12 × 9 inches (30.5 × 23 cm)

This is one of the few known topsy-turvy impossible figures. In one orientation the stairs are concave, while in another they are convex.

"Twisted Sides," colored felt-tip pen drawing, Japanese rice paper, undated,
12 × 9 inches (30.5 × 23 cm)

"VARIATIONS ON AN IMPOSSIBLE TRIANGLE," COLORED FELT-TIP PEN DRAWING, JAPANESE RICE PAPER, UNDATED, 12 × 9 INCHES (30.5 × 23 CM)

There are many paradoxes contained within this figure.

"FOLDING UPON ITSELF," COLORED FELT-TIP PEN DRAWING, JAPANESE RICE PAPER, UNDATED,
12 × 9 INCHES (30.5 × 23 CM)

"Paradox 189," colored felt-tip pen drawing, Japanese rice paper, undated,
12 × 9 inches (30.5 × 23 cm)

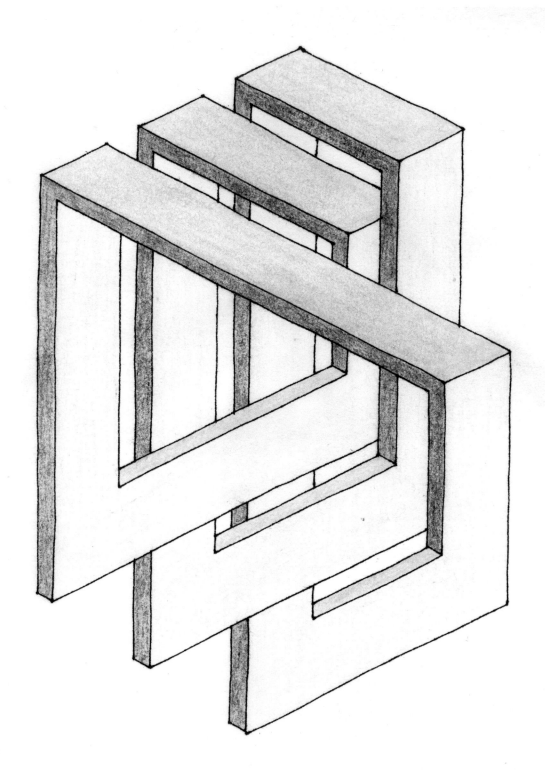

"Paradox 135," colored felt-tip pen drawing, Japanese rice paper, undated,
12 × 9 inches (30.5 × 23 cm)

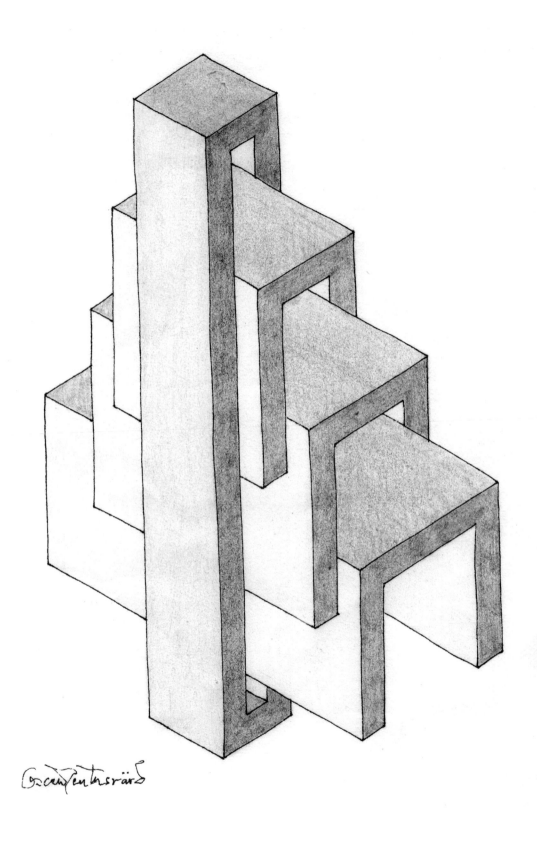

"LARGER PIECES FITTING WITHIN SMALLER PIECES," COLORED INDIA INK, UNDATED,
22 × 14 INCHES (56 × 35.6 CM)

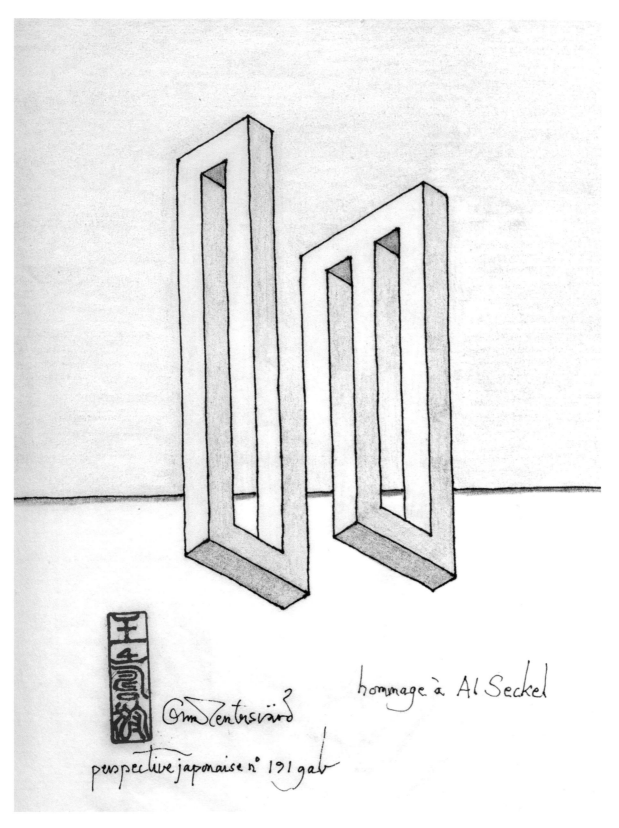

"IMPOSSIBLE MEANDER, #191," COLORED FELT-TIP PEN DRAWING, JAPANESE RICE PAPER, 1994,
12 × 9 INCHES (30.5 × 23 CM)

"My devil's fork was slightly different, by the way, to the figure subsequently published by Schuster [in 1965]; mine was derived from impossible meanders."

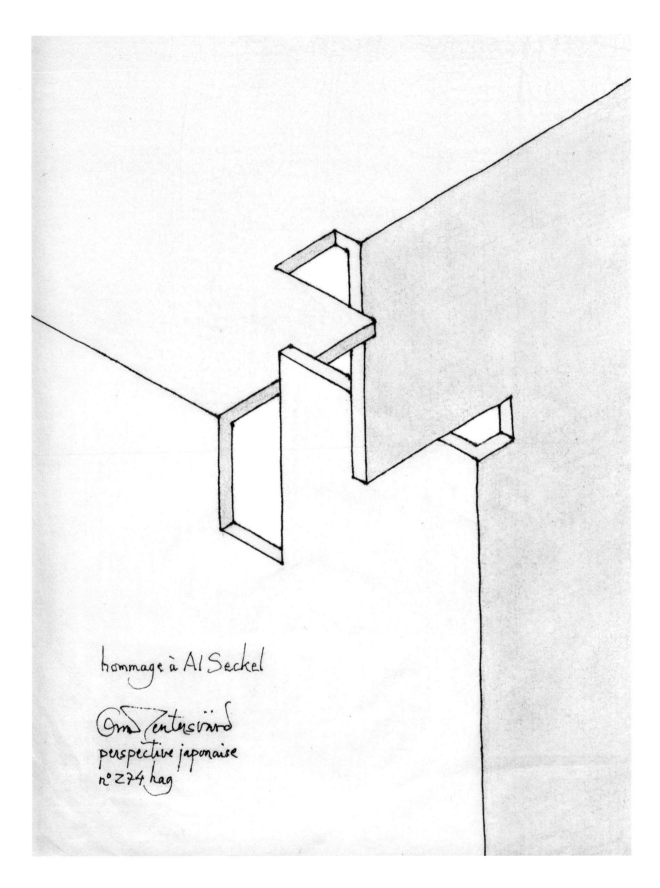

hommage à Al Seckel

[signature]

perspective japonaise
nº 274 hag

"IMPOSSIBLE CORNER, #274," COLORED FELT-TIP PEN DRAWING, JAPANESE RICE PAPER, 1994,
12 × 9 INCHES (30.5 × 23 CM)

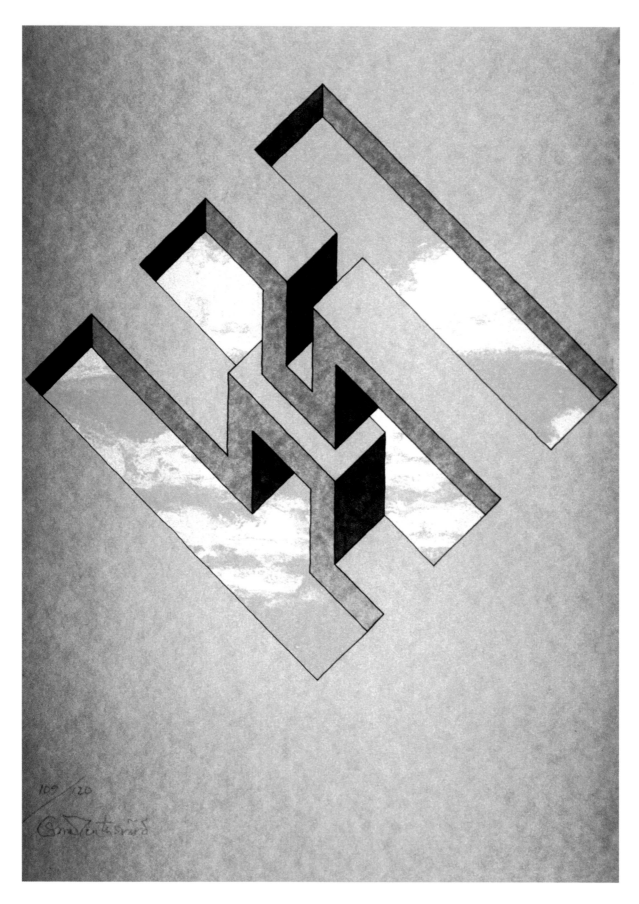

109/120

"An Impossible Paradox in a Window," colored India ink, 22 × 14 inches (56 × 35.6 cm)

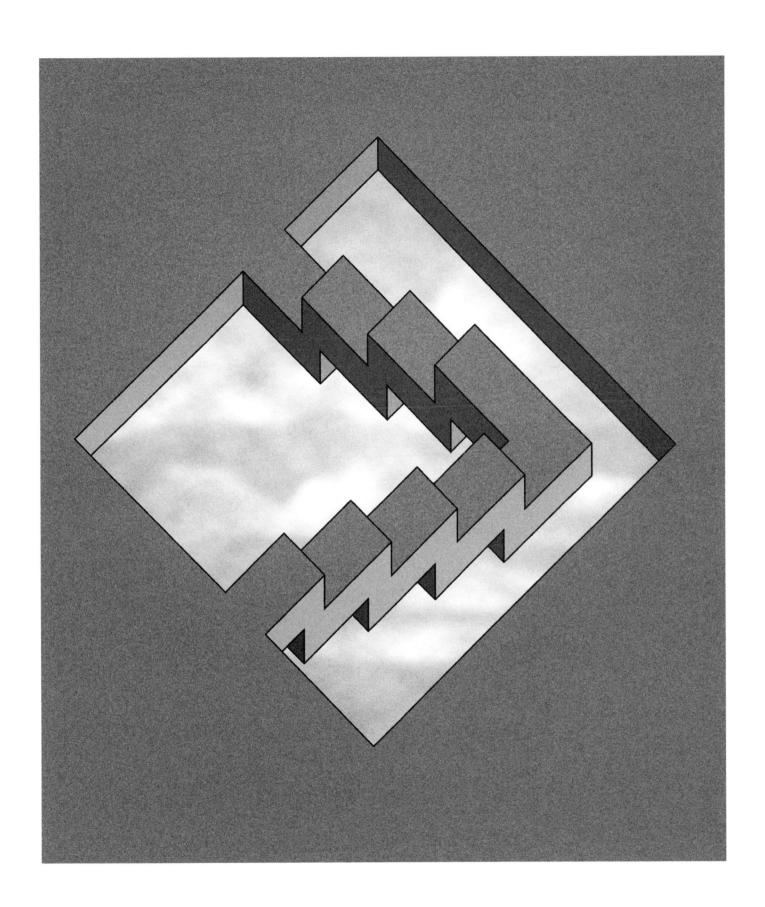

"Stairs Keeping their Own Level," colored India ink, undated, 22 × 14 inches (56 × 35.6 cm)

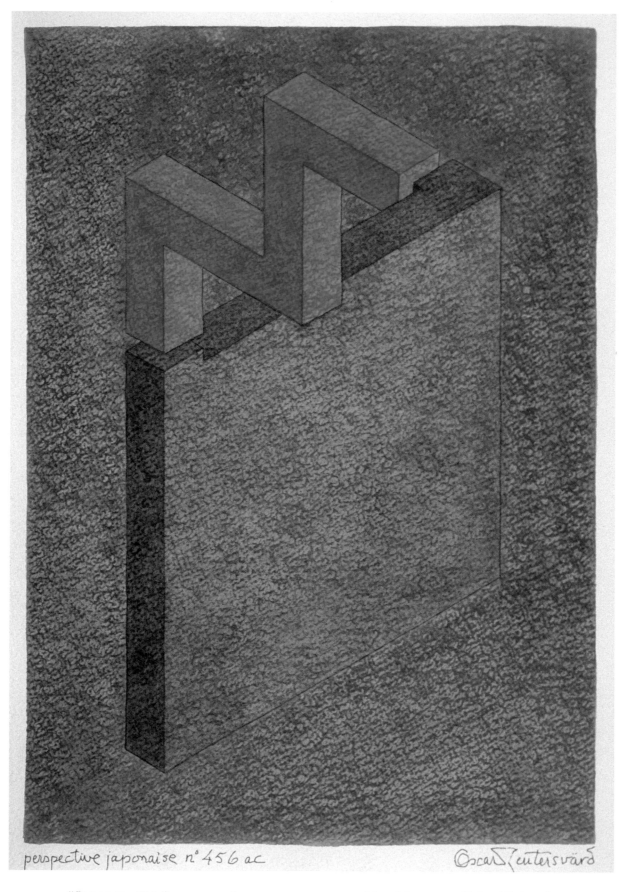

perspective japonaise n° 456 ac Oscar Reutersvärd

"Paradox 456," colored India ink, undated, 22 × 14 inches (56 × 35.6 cm)

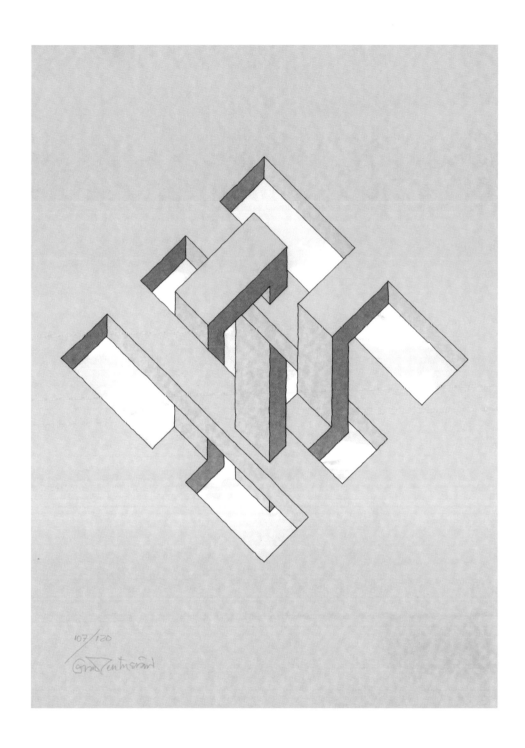

"MEANDER IN WINDOW," COLORED INDIA INK, UNDATED, 22 × 14 INCHES (56 × 35.6 CM)

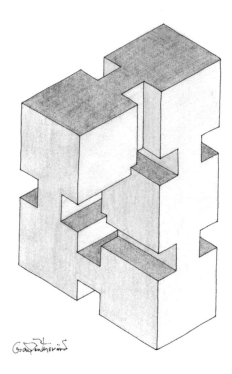

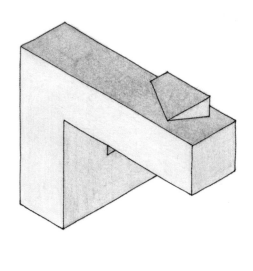

"PARADOX 6," COLORED FELT-TIP PEN
DRAWING, JAPANESE RICE PAPER, UNDATED,
12 × 9 INCHES (30.5 × 23 CM)

"PARADOX 161," COLORED FELT-TIP PEN
DRAWING, JAPANESE RICE PAPER, UNDATED,
12 × 9 INCHES (30.5 × 23 CM)

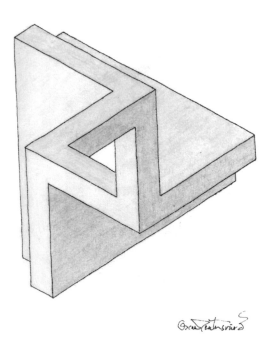

"PARADOX 29," COLORED FELT-TIP PEN
DRAWING, JAPANESE RICE PAPER, UNDATED,
12 × 9 INCHES (30.5 × 23 CM)

"PARADOX 219," COLORED FELT-TIP PEN
DRAWING, JAPANESE RICE PAPER, UNDATED,
12 × 9 INCHES (30.5 × 23 CM)

Reutersvärd filled many of his notebooks with impossible figures like these, where each impossible variation always suggested a new impossible figure to him.

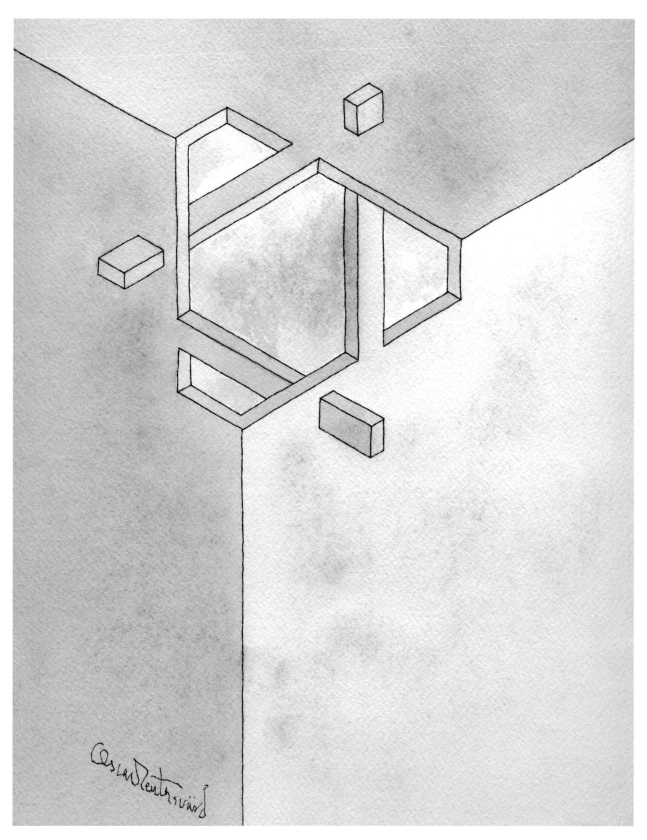

"Cornering an Impossibility," colored felt-tip pen drawing, Japanese rice paper, undated, 12 × 9 inches (30.5 × 23 cm)

The more you examine this corner, the stranger it becomes.

Roger Shepard

(1929–)

MIND SIGHTS

*"Psychologists know Roger Shepard as one of the most imaginative of their kind. . . .
How delightful to discover that he is an equally inventive artist: his drawings are as
witty and as thought-provoking as those of Escher himself."*

—PHILIP JOHNSON-LAIRD

Roger Shepard has always been a prankster. As a young boy, he delighted in playing visual tricks; one time he surreptitiously moved all the furniture out of his sister's room. Shepard went on to have an extremely distinguished career that included appointments at Harvard, Stanford, and U.C. Berkeley, all the while continuing to play visual tricks on people. By recording and analyzing their reactions, he would always discover new and astonishing truths about mental processes and human nature in general.

Roger Shepard was born in Palo Alto, California, in 1929. His father, a professor in materials science at Stanford, greatly encouraged and stimulated his son's interest in science and observing the environment. Shepard attended Stanford University, received his bachelor's degree in 1951, and earned his doctoral degree in experimental psychology from Yale in 1955. After a year of post-doctoral research at the Naval Research Laboratory and two years as a research associate at Harvard University, he became a member of the technical staff at Bell Labs, where he stayed until 1966. From

there Shepard joined the faculty at Harvard as a full professor. Two years later he moved back to the Stanford campus where he remained for the next thirty years. After retiring from Stanford, he was appointed to the Hitchcock Professorship at U.C. Berkeley. In 1995, Shepard was awarded the nation's highest scientific honor: the National Medal of Science for his pioneering work in cognitive and evolutionary psychology.

Shepard is best known for developing a computer-based method of identifying hidden patterns in data, and for synthesizing an auditory illusion of endlessly rising pitch. His particular research field lies in the "mental rotation" of objects. In addition to his scientific pursuits, Shepard takes an interest in art, music, and illusions. In 1990 he published the classic work *Mind Sights: Original Visual Illusions, Ambiguities, and Other Anomalies*, which contained many of his delightful pen-and-ink drawings. He wrote,

> The drawings . . . achieve their effects by means of various visual tricks. But to call them tricks is not to imply that they are without psychological significance. The tricks work by taking advantage of fundamental perceptual principles that have been shaped by natural selection in a three-dimensional world. Our ability to make pictures, which emerged only recently on an evolutionary time scale, enables us to present the eyes with visual patterns that systematically depart from the patterns that we and our ancestors experienced in nature. In considering the ways pictures can trick the eye, we can gain insight into the nature and ultimate source of the principles of visual perception.

Shepard's work has been a tremendous inspiration to many optical illusion artists, including, among others, Sandro Del Prete, Shigeo Fukuda, and István Orosz.

Shepard has since retired from teaching at Stanford and lives in Texas.

ROGER SHEPARD, 1979

"STEAM-POWERED ANOMALOMOBILE," PEN AND INK, 1974, $6^{1}/_{2} \times 8^{1}/_{2}$ INCHES (16.5×21.5 CM)

Can you find what is impossible about this engine? Note that the water tank is in the shape of a Klein bottle, which is a surface that has neither an inside nor an outside.

"Beckoning Balusters," pen and ink, 1984

Can you see the figures (a play on the word "figure" in figure and ground) in between the columns? A life-sized row of three-dimensional columns of a similar design was constructed by David Barker for display in San Francisco's Exploratorium.

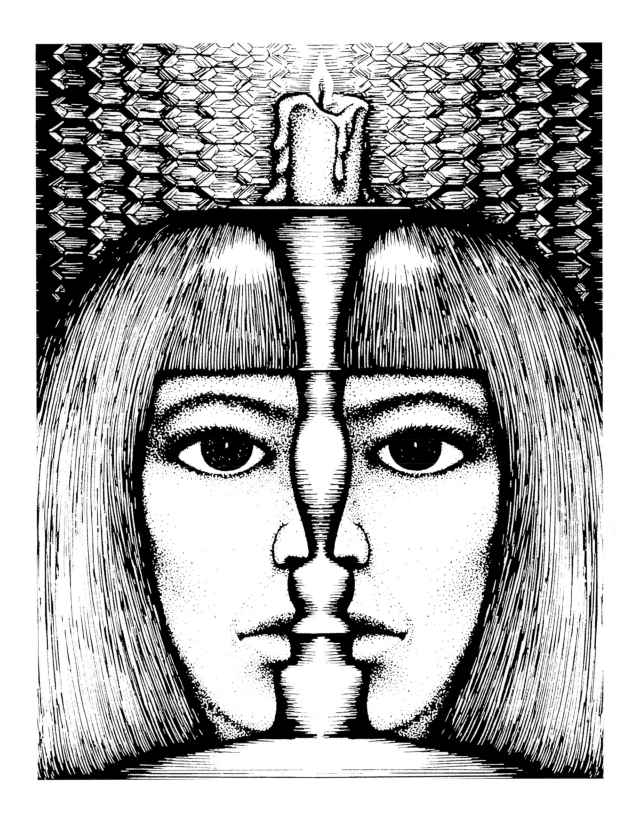

"Egyptian-Eyezed Tête-à-Tête," pen and ink, 1974

Which do you see: two heads in profile on either side of the candlestick, or one head behind the candlestick? This is a clever adaptation of the famous Dutch Gestalt psychologist Edgar Rubin's figure/ground illusion of two profiles on either side of a vase.

"GLEE TURNS GLUM," PEN AND INK, 1974

Notice that Glee remains at the top and Glum on the bottom even when the whole picture is turned upside down.

"L'egs-istential Quandary," pen and ink, 1974

Shepard created an interesting variation on the impossible fork in his depiction of an impossible elephant. To avoid the counting paradox with the number of legs, Shepard introduced the more conspicuous line discontinuity at the far right. Both these figures have discontinuous boundaries, but the impossible fork exhibits no unclosed lines.

"Periodic Stable of the Elephants," pen and ink, 1974

A stable of impossible elephants as depicted from front to back.

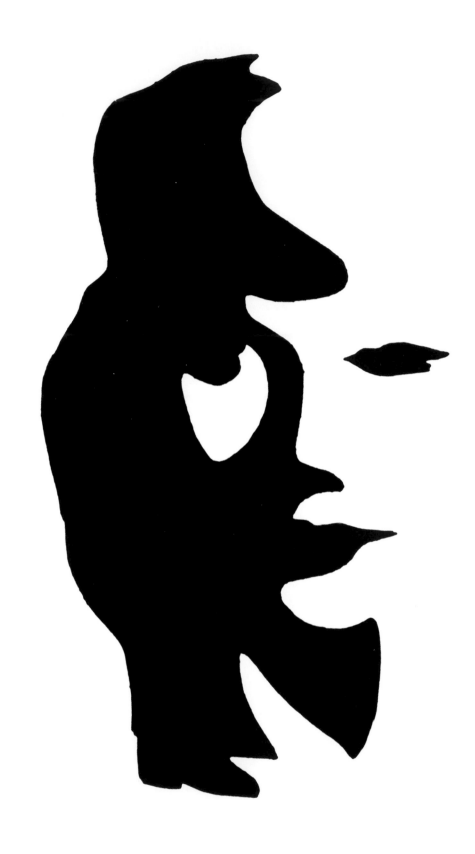

"SARA NADER," PEN AND INK, 1974

According to Shepard, "'Sara' Nader exemplifies a somewhat different type of figure/ground ambiguity in which the two alternative figures are not strictly complementary. While the black area constitutes the figure in the other interpretation (with the black areas then corresponding to dark or shadowed portions of the figure)."

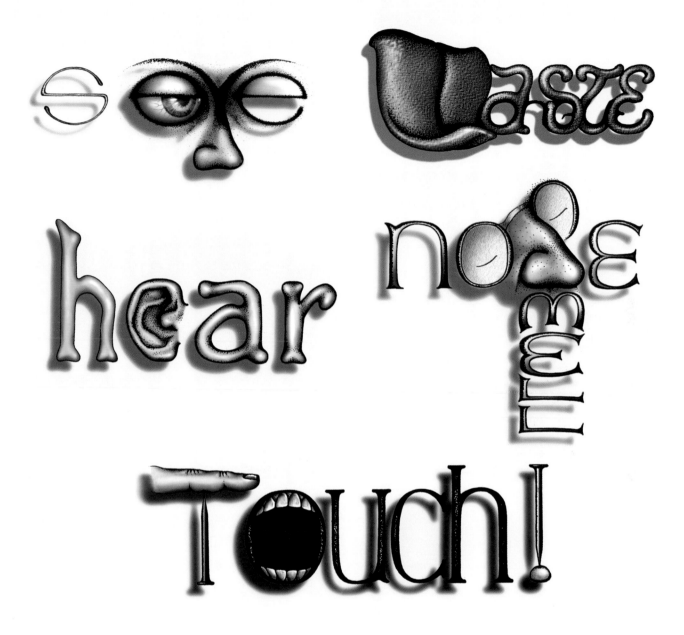

"THE 5IVE 5ENSES," PEN AND INK, 1974

About "THE 5IVE 5ENSES" Shepard writes, "Here, I set myself the challenge of integrating into one picture, for each of the five senses, (a) the verb appropriate to that sense (for example, see, for the sense of vision); (b) the noun for the organ of that sense (for example, eye); and (c) a graphic portrayal of that organ itself (for example, a picture of an eye). I gave myself license to depart from this constraint only for the fifth sense. For that, I incorporated the verb touch, but instead of a noun for the organ of touch, I included the expletive that may follow too sharp a touch: 'Ouch!' Also, in rendering the 'O' of Ouch!, I portrayed the organ for emitting that expletive. The organ of the sense of touch is represented by the sharply 'touched' finger—both in side view (as the top of the T) and in end view (as the dot of the exclamation point)."

Can you also find the hidden word "tongue" in the word "taste"?

"TERROR SUBTERRA," PEN AND INK, 1974

The two figures are identical in size, although the one in the background appears to be larger than the one in the foreground. This drawing is based on the classic Hallway perspective illusion.

Dick Termes

(1941–)

SPHERICAL WORLDS

"The sphere allows me to express ideas which are above, below, and all around me."

—DICK TERMES

TERMESPHERES ARE SPHERICAL PAINTINGS that hang and rotate from ceiling motors. They provide the viewer with a most wonderful and unique illusory experience. While watching a Termesphere in motion, your perception will suddenly switch: one moment you are on the outside looking at a slowly turning painted sphere, and the next moment you are on the inside of the sphere looking out! The motion of the sphere even reverses. People explain this illusion in many different ways. Some feel like they are looking through the sphere to the back side. Some say the images in the rooms become dimensional and turn richer in color and are fluid or jelly looking. Termes thinks the illusion happens because we are more comfortable with having the room around us on the concave surface. While he puts the room on the outside or convex side of the sphere our minds work to push it back to the real, or the concave. Realistic subjects have been found to work better than abstract ones. This could be because abstract paintings might seem alright being on the sphere but real worlds should be around us. A nice thing about the Termes illusion is that it gets people personally involved with the painting.

The spheres are painted on the outside using a six-point perspective system in which the total up, down, and all-around environment is depicted on its surface. To help understand this concept,

imagine you are inside a transparent ball. You copy everything you see outside the sphere onto the inside surface of the sphere and then move to the outside of the sphere to look in at what you were looking out at. This is the Termesphere. Termes says,

> I think of myself inside the sphere even though I am on the outside painting.
> When people see this illusion where the sphere seems concave they are seeing it
> as I imagine it.

This system of perspective attracts many mathematical and geometry thinkers to Termes' work. They are interested in how this system of perspective can allow the subjects to read correctly from any angle. They are interested that all lines drawn on the sphere are bisections of the sphere. They also like the idea that all parallel lines project to two vanishing points or poles and all cubical objects painted in these paintings project to all six points. The strong perspective cues helps to create the illusion because it is always pulling you into that far away vanishing point. Many of his spheres give the viewer the feeling they are "floating" in the middle of the room. Termes has painted over three hundred Termespheres in the last thirty-three years.

Termes was born in 1941 in San Diego, California while his father was in the shipyards for the war effort. He received his Bachelors degree in art from Black Hills State College, his Masters degree in painting from the University of Wyoming and an MFA in design from Otis Art Institute of Los Angeles. Termes started painting when he was a junior in high school in 1959. In 1969, as a graduate student at the University of Wyoming, Termes researched the idea of expanding perspective beyond the traditional one and two point perspective of the Renaissance artists. All of this work was done as drawings until one of the drawings seemed to bulge off the page. A fellow student suggested that this looked like a sphere so Termes decided to find a ball and see what it would look like painted as a spherical painting. The cube Termes painted on this ball gave him the feeling that he was inside the cube rather than looking at a cube on the outside of the ball. This was the beginning of a life time of work.

Termes has explored environments on the sphere from real worlds, to surreal, to geometric. He has created transparent spheres where you can see through to the back side. One of his transparent spheres is of the inside of St. Peters Basilica in Rome. An illusion happens with this sphere. The dark patterns across the transparent sphere will hardly read until the ball is spun. As soon as the sphere rotates your eye goes directly to the back side of the ball and the front side disappears. Termes says,

> This is one more example of how our minds would rather see the world on the
> concave around us than on the outside of a convex sphere.

Because of his fascination with illusions and geometry, he became very interested in the work of American architect Buckminster Fuller and the Dutch artist M. C. Escher.

Bucky Fuller gave me great spherical geometry to look at and Escher showed me ways to use that geometry in my artform.

He has traveled extensively, creating a series of spherical paintings devoted to great architectural interiors found worldwide. Termes states,

> Architecture, especially the interiors of great architecture , seems to have been ignored in art history. I find these interiors wonderful and great subject matter for my six-point perspective paintings; wrapping these real, total interiors onto the surface of the sphere is one of the hardest things I do. There is no room for error, if you get something wrong on one side, it will come around to the back side and not fit.

The sphere allows Termes to express ideas that have not been talked about before. he reminds us that patterns or geometry that fit on the sphere are totally different from the pattern or geometry that fit on the flat surface. The sphere is a different dimension. By adding motion to the sphere, one more dimension is added to the spherical paintings.

The sphere is a way of life for Termes. He makes his home with his wife, Markie Scholz (a noted puppeteer) in four geodesic domes that they constructed in the Black Hills of South Dakota.

The sphere has influenced both my work and my life. I have always thought the sphere was the most perfect shape the universe had to offer. If you are looking to create a beautiful art piece, why not start with the most beautiful canvas, the sphere?"

TERMES LOVES HIS CREATIONS, 2002

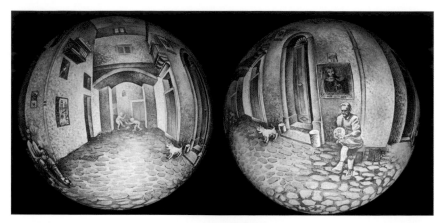

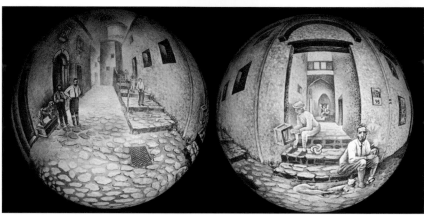

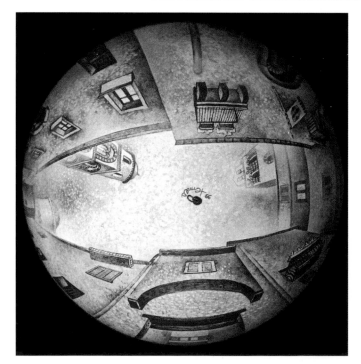

"INSPIRATIONS FOR ESCHER," ACRYLIC ON POLYETHYLENE PLASTIC, 1998, 15³/₄-INCH-DIAMETER SPHERE (40 CM)

The Dutch graphic artist M. C. Escher came upon many of his ideas in his favorite town of Ravello, Italy. According to Termes, "Ideas are around us all the time, but only some people see them. Most of the ideas around him are not what the images look like when he transformed them into his famous art pieces." This environment is one of the small roadways within Ravello, Italy, which was such a great source of inspiration for Escher.

"NOTRE DAME," ACRYLIC ON POLYETHYLENE PLASTIC, 1995, 24-INCH-DIAMETER SPHERE (61 CM)

This spherical painting was developed during Termes's visit to the Notre Dame cathedral in Paris in 1992. When viewing this painted sphere, the observer will get the impression that he or she is floating and revolving thirty feet above the floor in the center of Notre Dame. Usually Termes uses six-point perspective to make his spherical paintings work, but in this case the floor's diagonal tiling required four more vanishing points, which, when added, allowed for a ten-point perspective.

"ESCHER TO THE THIRD POWER," ACRYLIC ON POLYETHYLENE PLASTIC, 1983,
16-INCH-DIAMETER SPHERE (40.5 CM)

This spherical painting plays off M.C. Escher's 1938 self-portrait "Hand with Reflective Sphere," which depicts the artist holding a spherical reflective ball in his hand with his surroundings also reflected in the mirror. Escher was fascinated by the fact that the point between your eyes is always in the absolute center of the mirrored ball. Termes took up this thought and showed how the total picture Escher sought can be equally spaced or pulled around the sphere. The picture on the right was the only part Termes had to make up as the rest could be found in Escher's print. Escher's real hand was also removed to leave only the reflection.

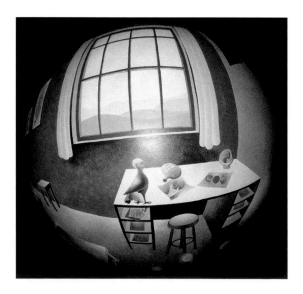

DETAILS OF "ESCHER TO THE THIRD POWER"

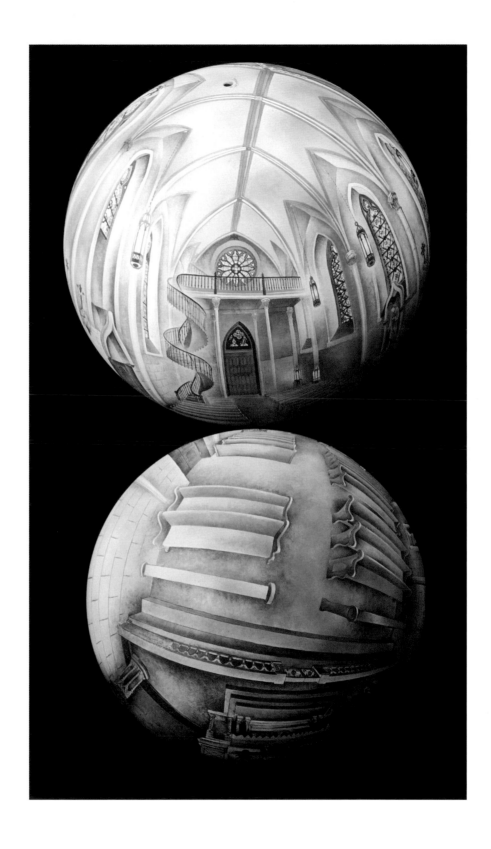

"LORETTO CHAPEL," ACRYLIC ON POLYETHYLENE PLASTIC, 1991, 24-INCH-DIAMETER SPHERE (61 CM)

The Loretto in the Round is a chapel in Santa Fe, New Mexico, which is famous for its spiral staircase. Termes spent seven days inside the chapel sketching the staircase's surroundings. The lines within this chapel are projected to six equidistant vanishing points. Each line, if extended, would target two different vanishing points and would create a great circle if fully extended.

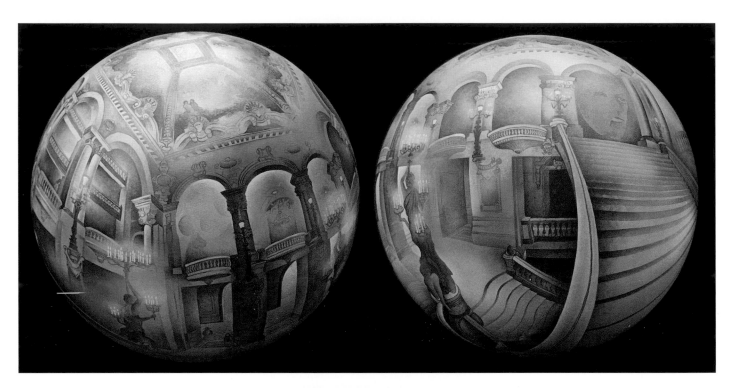

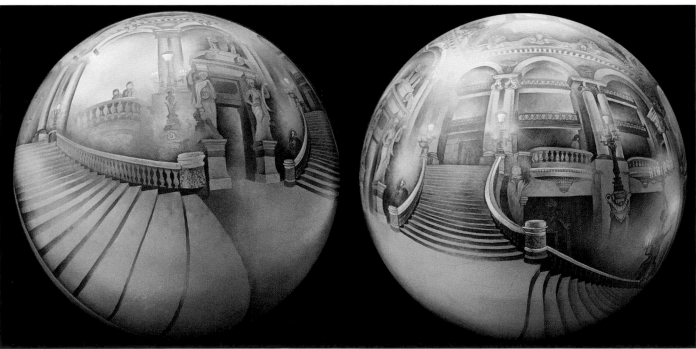

"PARIS OPERA," ACRYLIC ON POLYETHYLENE PLASTIC, 1992–1993, 15³/₄-INCH-DIAMETER SPHERE (40 CM)

If you were to put a mirrored ball on the post next to the staircase going into the Paris Opera house, and if you could freeze the image onto that ball, you would come close to this Termesphere. Termes also played off the musical *Phantom of the Opera*, which was based on this building. One of the masks of the Phantom is a double-image superimposed on the archway in the building. The bottom of the sphere shows the stairway circling and going back under itself.

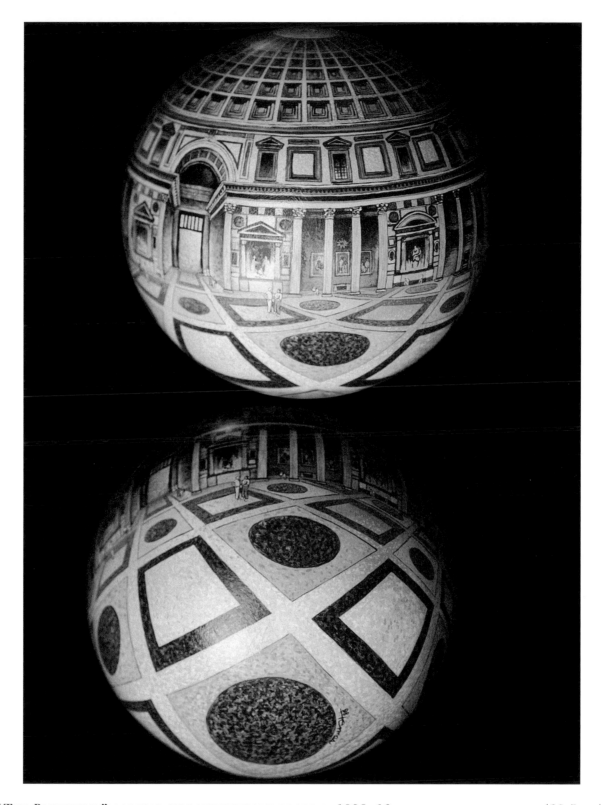

"THE PANTHEON," ACRYLIC ON POLYETHYLENE PLASTIC, 1998, 12-INCH-DIAMETER SPHERE (30.5 CM)

If you were inside this sphere, it would make perfect sense. You would be standing in the middle of the Pantheon where the floor and the ceiling geometry reads pure. It was possible to paint because Termes had taken panoramic shots of the entire cathedral the year before. For Termes, the Pantheon was a perfect subject because it was designed as a sphere itself, placed atop a cylinder wall. Standing on the floor in the center of the Pantheon puts you conceptually on the edge of the sphere. This sphere was painted in 1998 for the Escher Centennial Congress.

"Saint Mark's Square," acrylic on polyethylene plastic, 2001, 24-inch-diameter sphere (61 cm)

Imagine you had a transparent sphere on your head and you copied the Saint Mark's Square environment around you on the inside of the sphere. Now if you take that spherical painting off your head and move to the outside to look at it, this painting is what you would see, except it isn't backwards.

Rex Whistler

(1905–1944)

INVERSIONS

"Whistler's exquisite lightness of touch, delight in the odd world around him, and teasing sense of fun are all brought out by his paintings and drawings."

—C. WHITWELL

No one knows when inverted images were first created, but they started to become popular on coins during the Reformation. These early topsy-turvy images typically contained hidden political and theological statements. In the 19th century, they took on a more amusing motif and were very popular in advertisements and puzzle cards.

In 1948, the world was introduced to the delightful topsy-turvy drawings of an English artist Rex Whistler, who had brought his portraits to new heights in a children's book entitled *OHO!* To accompany the twenty-five different faces, the book also contained satirical and comic verses written by his brother Laurence, a respected glass engraver. The book had no front or back, or rather had two of each. Although almost all of the images are original to Whistler, he did modify some topsy-turvy images that been circulating on various popular puzzle cards of the late 19th century. Whistler found it easier to create male than female topsy-turvy portraits, because a head of hair could easily transform itself into a beard.

Whistler studied art at the Royal Academy School in London but was asked to leave after one term, apparently because his approach to art was considered too frivolous. His professor at the Slade School of Fine Art in London, where Whistler continued his studies, later wrote to the academy principal, thanking him for "sending me your best pupil!"

Whistler was also renowned for his *trompe l'oeil* decorations and fantastic storytelling murals. His mural "Pursuit of Rare Meats" in the Tate Gallery in London is a work of exceptional genius. He also designed furniture, buildings, theater sets, and costumes for national productions.

Whistler was a mature draughtsman at the age of twelve, and barely in his creative prime when he was killed at the age of thirty-nine: A mortar bomb exploded while he was trying to free a trapped tank on his first day of action in Normandy, France, in 1944. Before his untimely death, he had achieved some considerable fame for his illustrations of Jonathan Swift's *Gulliver's Travels* and Hans Christian Andersen's fairy tales.

REX WHISTLER, *SELF-PORTRAIT*

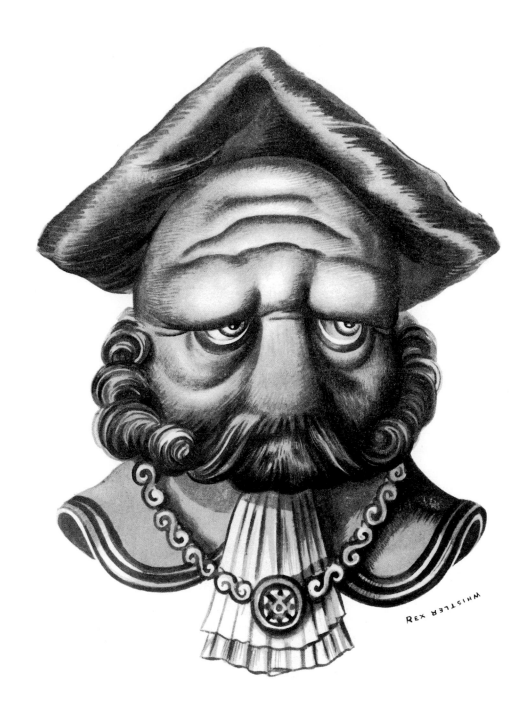

"A KING AND HIS QUEEN," PENCIL DRAWING, UNDATED, $6^{1}/_{2} \times 8^{1}/_{2}$ INCHES (16.5×21.5 CM)

The King is looking for his Queen. Can you find her?

"A Change of Expression," pencil drawing, undated, $6^{1}/_{2} \times 8^{1}/_{2}$ inches (16.5 × 21.5 cm)

A collar turns into a hat, and the mood changes.

"Surprise!", pencil drawing, undated, $6^{1}/_{2} \times 8^{1}/_{2}$ inches (16.5 × 21.5 cm)

The policeman looks surprised when you turn this drawing on its head.

"Growing Pains," pencil drawing, undated, $6^1/_2 \times 8^1/_2$ inches (16.5×21.5 cm)

A boy turns into a man when the drawing is rotated.

"Being Nosy on the Phone," pencil drawing, undated, $6^1/_2 \times 8^1/_2$ inches (16.5×21.5 cm)

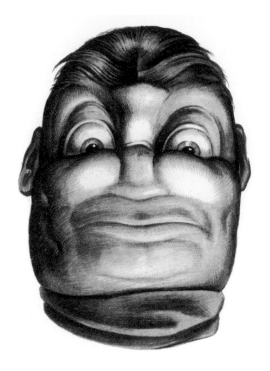

"GROWING A BEARD," PENCIL DRAWING, UNDATED, $6^1/_2 \times 8^1/_2$ INCHES (16.5 × 21.5 CM)

When inverted, the man has grown a beard.

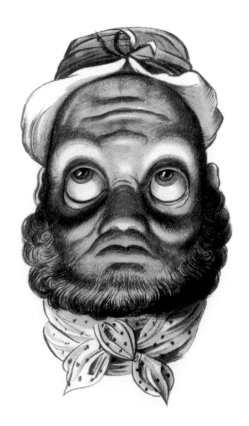

"CHANGING GAZE," PENCIL DRAWING, UNDATED, $6^1/_2 \times 8^1/_2$ INCHES (16.5 × 21.5 CM)

The direction of the gaze changes when the figure is inverted.

RECOMMENDED READING

Baltrusaitis, Jurgis. *Anamorphic Art*. New York: Harry Abrams, 1977.

——*Anamorphoses: Les Perspectives Dépravées*. Paris: Flammarion, 1984.

Block, J. Richard. *Seeing Double*. New York: Routledge Books, 2002.

Combs, Karen. *Optical Illusions for Quilters*. Shelton, CT: Image Graphics, 1997.

Dars, Célestine. *Images of Deception: The Art of Trompe- l'oeil*. Boston: Phaidon Press, 1979.

Dalí, Salvador, et al. Dawn Ades, ed. *Dalí's Optical Illusions*. New Haven, CT: Yale University Press, 2000.

Danto, Arthur. *The Art of John Cederquist: Reality of Illusion,* Exhibition at the Oakland Museum of California, Sept. 13–Nov. 30, 1997.

Del Prete, Sandro. *Illusoria.* Bern: Bentelli Verlag, 1987.

——*Illusorisme, Illusorismes. Illusorisms.* Bern: Bentelli Verlag, 1984.

de Meyere, J.A.L., and Hette Weijma, *Anamorfosen*. Amsterdam: Aramith Uitgevers, 1989.

d'Otrange Mastai, Marie-Louise. *Illusion in Art: Trompe L'Oeil: A History of Pictorial Illusionism*. New York: Abaris Books, 1976.

Emmer, Michele, and Doris Schattschneider (eds). *M. C. Escher's Legacy: A Centennial Celebration*. New York: Springer Verlag, 2003.

Emmer, Michele, ed. *The Visual Mind: Art and Mathematics*. Cambridge, MA: The MIT Press, 1993.

Ernst, Bruno. *The Eye Beguiled: Optical Illusions.* Cologne: Benedikt Taschen, 1986.

——*The Magic Mirror of M.C. Escher*. Norfolk: Tarquin Publications, 1985.

Escher, M. C. *Escher on Escher: Exploring the Infinite*. New York: Harry N. Abrams, 1989.

Fukuda, Shigeo. *Visual Illusion*, Rikuyoshi Publishing, 1982.

Füsslin, Georg, and Ewald Hentze. *Anamorphosen*. Stuttgart: Füsslin-Verlag, 1999.

Gombrich, E. H. *Art and Illusion: A Study in the Psychology of Pictorial Representation*. Boston: Phaidon Press, 1962.

Gonsalves, Rob. *Imagine a Night*. New York: Atheneum Books for Young Readers, 2003.

Gonsavles, Robert. *Imagine a Day*. New York: Atheneum Books for Young Readers, 2004.

Gregory, Richard, and E. H. Gombrich. *Illusion in Nature and Art*. New York: MacMillan, 1980.

Hofstadter, Douglas. *Gödel, Escher, Bach: an Eternal Golden Braid*. New York: Basic Books, 1979.

——*Metamagical Themas: Questing for the Essence of Mind and Pattern*. New York: Basic Books, 1985.

Hammond, Paul. *Upon the Pun: Dual Meaning in Words and Pictures*. London: W. H. Allen, 1978.

Hughes, Patrick. *Vicious Circles and Infinity: A Panoply of Paradoxes*. New York: Doubleday, 1975.

Kim, Scott. *Inversions: A Catalog of Calligraphic Cartwheels*. Emeryville, CA: Key Curriculum Press, 1996.

Kince, Eli. *Visual Puns in Design: The Pun Used As a Communications Tool*. New York: Watson-Guptill, 1982

Langdon, John. *Wordplay: Ambigrams and Reflections on the Art of Ambigrams*. Orlando, FL: Harcourt Brace Jovanovich, 1992.

Leeman, Fred, *Hidden Images: Games of Perception, Anamorphic Art, Illusion: From the Renaissance to the Present*. New York: Harry N. Abrams, 1975.

Livingstone, Margaret, *Vision and Art: The Biology of Seeing*. New York: Harry N. Abrams, 2002.

Locher, J. L. (ed.), *M.C. Escher; His Life and Complete Graphic Work*. New York: Abradale Press, 1992.

Néret, Gilles, and Robert Descharnes. *Salvador Dalí: The Paintings 1904–1989*. Cologne: Benedikt Taschen, 1993.

Parola, Rene. *Optical Art: Theory and Practice*. Weatogue, CT: Reinhold Books, 1969.

Penrose, Lionel, and Roger Penrose, "Impossible Objects: A Special Type of Visual Illusion," *British Journal of Psychology*, 1958, vol. 49, pp. 31-33.

Rothstein, Julian, and Mel Gooding. *The Playful Eye: An Album of Visual Delight*. San Francisco: Chronicle Books, 1999.

Schattschneider, Doris, and M. C Escher. *Visions of Symmetry: Notebooks, Periodic Drawings, and Related Work of M. C. Escher*. New York: W. H. Freeman, 1990.

Seckel, Al. *The Great Book of Optical Illusions*. Westport, CT: Firefly Books, 2002.

——*Incredible Visual Illusions: You Won't Believe Your Eyes*. Port St. Lucie, FL: Arcturus Books, 2003.

Shepard, Roger. *Mind Sights: Original Visual Illusions, Ambiguities, and Other Anomalies*. New York: W. H. Freeman, 1990.

Stafford, Barbara Maria and Frances Terpak, *Devices of Wonder: From the World in a Box to Images on a Screen*. Los Angeles: Getty Research Institute Publications, 2002.

Velhuysen, W. F. *The Magic of M. C. Escher*. New York: Harry N. Abrams, 2000.

Wade, Nicholas. *Visual Allusions: Pictures of Perception*. Mahwah, NJ: Lawrence Erlbaum Associates, 1990.

Zeki, Semir. *Inner Vision: An Exploration of Art and the Brain*. New York: Oxford University Press, 1999.

ARTIST INFORMATION & WEBSITES

Original signed prints, paintings, and sculptures may be obtained directly from the artists or their representatives. Please contact them via the information below.

SANDRO DEL-PRETE
Illusoria Land
Gewerbezone Ey 5
CH-3063, Ittigen, Switzerland
www.illusoria.com
e-mail: sandro@del-prete.ch

M.C. ESCHER
www.mcescher.com

SHIGEO FUKUDA
Fukuda Design Studio
3-34-25 Kamikitazawa, Setagaya-ku
Tokyo, Japan156

JOS DE MEY
Daalmstrasse 7
9930 Zomergem, Belgium

ROBERT GONSALVES
Discovery Galleries, Ltd.
4840 Bethesda Avenue
Bethesda, MD 20814
www.discoverygalleries.com

MATHIEU HAMAEKERS
Venlosesteen Weg 81
3640 Kinrooi/Ophoven
Belgium

SCOTT KIM
P.O. Box 2499
El Granada, CA 94018
www.scottkim.com
e-mail: info@scottkim.com

AKIYOSHI KITAOKA
www.ritsumei.ac.jp/~akitaoka/index-e.html
e-mail: akitaoka@Lt.ritsumei.ac.jp

KEN KNOWLTON
www.knowltonmosaics.com
e-mail: ken@knowltonmosaics.com

GUIDO MORETTI
www.guidomoretti.it/E_terzavia.htm
e-mail: modiug@libero.it

VIK MUNIZ
Brent Sikkema Gallery
530 W. 22nd Street
New York, NY 10011
www.vikmuniz.net
e-mail: gallery@brentsikkema.com

OCTAVIO OCAMPO
www.amazingartimages.com
e-mail: info@amazingartimages.com

ISTVÁN OROSZ
Reviczky U.20
H-2092 Budakeszi, Hungary
www.utisz.net
e-mail: utisz@axelero.hu

JOHN PUGH
John Pugh Studios
P.O. Box 1332
Los Gatos, CA 95031
www.artofjohnpugh.com

AL SECKEL
http://neuro.caltech.edu/~seckel
e-mail: seckel@klab.caltech.edu

DICK TERMES
Dick Termes Studios
1920 Christensen Drive
Spearfish, SD 57783
www.termespheres.com
e-mail: termes@blackhills.com

INDEX

CREDITS

ABOUT THE AUTHOR

Al Seckel is the leading authority on visual and other types of sensory illusions. He lectures extensively on this topic at many of the world's most prestigious universities. He is the author of several best-selling and award-winning books on the science of optical illusions and perception. He is the author of the Brain Teasers column in *National Geographic KIDS*. In addition, he designs interactive galleries on illusions for science museums. He has researched the neural correllates of visual illusions at the California Institute of Technology in Pasadena.